Country Carving

By Tom Wolfe

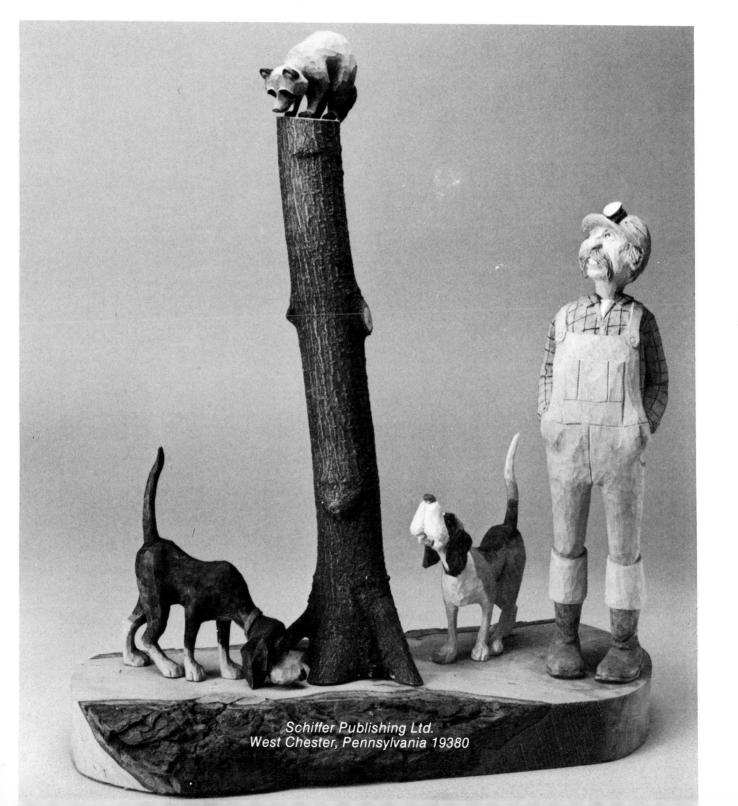

Schiffer Publishing Ltd.
West Chester, Pennsylvania 19380

Dedication

To the good Lord for giving me the ability to carve and the guidance to use my talent to make a better life for me and my family. Also, to my wife, Nancy, for sweeping up a thousand truck loads of wood chips.

Photographed and edited by Lyngerda Kelley
Copyright © 1987 by Tom Wolfe.
Library of Congress Catalog Number: 87-61435.

Printed in the United States of America.
ISBN: 0-88740-105-8
Published by Schiffer Publishing Ltd.
1469 Morstein Road, West Chester, Pennsylvania 19380

This book may be purchased from the publisher.
Please include $2.00 postage.
Try your bookstore first.

Acknowledgments

My thanks and appreciation go to my very good friends, Orville Bledsoe and Jim Watson. Both men are super craftsmen in their own right and have made the knives that enable me to enjoy and succeed in my carving.

Forward

Talent, humor and dedication to his craft are some of the basic resources that Tom Wolfe calls upon when carving. Coming from a family of wood-crafters, Tom has been carving since the age of twelve. He began with a neck slide for his Boy Scout neckerchief. Today, his mother still has several examples of his work. From there his carving progressed to whittling magical looking wood spirits—old men with long flowing beards, whose faces were carved into walking sticks. Eventually Tom turned to fashioning wonderful detailed sculptures of people and animals which are representative of his work today.

Throughout Tom's work his sense of humor is prevalent. The exaggerated features, the glint of the eyes, and the whimsical expressions are all part of his special style. Tom feels that this is where the artist shows up in his work. "I have a happy personality."

Being a real mountaineer, Tom creates scenes which are typical of country people in real life situations such as hunting, fishing, water witching, milking or riding a mule. When in doubt he researches his subjects to be sure of authenticity in dress and stature.

Now in his workshop at Mystery Hill in Blowing Rock, North Carolina, Tom sells his original work as well as reproductions of some of his most appealing carvings. All this he does with the help of his wife, Nancy. In addition, the Wolfe's attend several craft events during the year at which Tom most certainly adds to his collection of awards. He shares his knowledge and talent with local school children, teaching craft seminars at the local schools in the North Carolina school system. Speaking of his hectic schedule, Tom has said, "When I've carved the tenth stick of the day, when my hands are so sore, yeah, I'd rather be fishing. But I like to work. When work seems like play it's not too much like work." "But I really don't work as hard these days, I only work half the time now—just twelve hours a day!"

Table of Contents

Acknowledgments . iii

Forward. iv

Introduction . 6

Coon Hunting the Tom Wolfe Way 7

Supplies and Tools. 11

The Basics:
General Suggestions for Bandsawing and Carving. 13

The Pattern Making Process . 14

The Treeing Walker Dog . 21

The Black and Tan Hound . 43

The Coon . 53

The Coon Hunter . 67

Making the Base . 111

Painting Instructions. 113

Introduction

The method of carving described in this book is called by Tom Wolfe, *Chip Carving.* In this book chip carving means to literally make cuts in the wood and chip them off, leaving a facetted surface. This method is also referred to as whittling. Tom believes this gives the carvings a more primitive and "old-timey" look.

The figures included here are two types of hound dog, a coon, and a coon hunter. They are presented individually with instructions from the first step of pattern tracing through the final step of painting. Tom views carving as a continual growth process. He feels "If you don't get better, there's no point in going on." His hope is that his book will inspire novice as well as experienced carvers to take his examples and expand on them with their own ideas and talents. According to Tom, there is no right or wrong way to carve a given subject. Each carving will have its own personality and traits. As long as the craftsman is satisfied with the results of his or her carving, the goal has been achieved.

In his book, Tom provides information on the techniques he uses as well as the supplies, tools and products needed to complete these carvings. The characters created in these pages can stand alone or be combined in any number of groupings. The creation of bases for mounting the figures and making a natural setting is also detailed in, *Country Carving.* How the figures are finally displayed is the carver's own decision. Tom provides examples, however there are numerous possibilities. It is hoped that the instructions presented here and the resulting carvings bring as much satisfaction to all who endeavor to try chip carving as it has to Tom to have shared his knowledge with the reader.

Coon Hunting the Tom Wolfe Way

Tom has always enjoyed night coon hunting. Ever since he can remember he has had some kind of hound dog. Most of the time they have been tree dogs because they have especially good dispositions and are suited for night hunting. The following is a stories about some of those dogs.

Tom and his friend, Emerson, usually called Boar Nose, were on their way to Akron, Ohio to do some hunting with Boar Nose's brother who owned a famous coon dog named Sonny. Tom didn't have a dog he felt was good enough to take along on the trip so he and Boar Nose planned to hunt with the other dogs and of course, with Sonny.

On the way to Akron the two men stopped in a rest area to stretch their legs. Along the interstate, Tom saw an "old plug looking hound that looked like a crossed up dog that didn't amount to too much." Tom and Boar Nose decided to catch the dog so it wouldn't get hit by a car or hurt and thought maybe they could find the name of the owner on the dogs collar and get it back to its rightful home. Tom called the dog and it came right to him and jumped up into the car. It had no collar on and actually looked much better up close than it did out on the interstate.

Tom suggested to Boar Nose that they take the dog to a safer place before they let him go so at least he wouldn't get hit by a car. Boar Nose had a better idea. He said they should take the dog with them up to his brother's house and "tell a great big lie" and have a little bit of fun with him. Boar Nose wanted to tell his brother that they had just bought the dog for a big outrageous amount of money. Then they would hunt the dog with Sonny and the other dogs and when the dog didn't come back they would have a big laugh and a lot of fun out of it. Back in those days, Tom was ready for just about any kind of a joke, which isn't too far from the truth today. So Tom and Boar Nose headed on to Akron with their new, expensive hunting dog.

The hunt began; Tom, Boar Nose, their new dog, Boar Nose's brother, Sonny and the rest of the hunting dogs. In no time at all they heard a dog strike. Naturally, neither Tom or Boar Nose knew which dog had struck because they had never heard any of the dogs bark before. Boar Nose's brother told them it was their dog who had struck first. "Hey, that's your dog, he struck the first tracks and he might be a good dog. It isn't often that a dog can go into strange country and strike first." To strike means that the dog gets the coon scent first and makes the first bark. Whenever there are field trials it will earn a lot of extra points to have the dog that strikes first. It was not long before the dogs had treed a coon. Again it was Tom and Boar Noses "new" dog that treed first. Boar Nose's brother was pretty impressed with this new dog and asked Tom if it was "always that good, because it was doing real well as a straight coon dog." Tom, had to laugh, and said he "didn't know, they were just planning on buying him and they had no idea how good he was or at what."

They treed four coons during that hunt and Tom's dog struck first and treed first in everyone that was treed. Tom had a good coon dog, and no way of knowing how to get it back to the owners, so he kept it and took it home. Since Boar Nose lived in the city and Tom lived in the country, Tom kept the dog at his house.

Tom hunted around his house a few times, and everytime he let the dog out it treed a coon. So, Tom and Boar Nose decided to take the dog to a better place where there were more coons and really get in some good hunting with this new dog they had acquired. They took the dog out and turned him loose and naturally he struck a coon right away. The dog took the scent and ran down across a highway and was killed by a car, "deader than a door nail." Tom found it to be ironic that they had acquired the dog through rather shady means and it ended up with no good coming of it.

Sparky

Tom had another dog named Sparky, who was a water dog. Sparky wasn't too much on hunting but he was a big strong dog that liked to swim. There are coon trials with swimming races where all of the competition is in the water. Now Sparky would go out at night and run down every fox, and deer doing what is called "trashing." He would run down every scent except coon. However, if you got Sparky to a coon trail when all he could see or smell were coons then he became a real coon dog. Sparky won every water race that he was entered in and eventually Tom sold him at a nice profit.

South Carolina Hunting

Tom moved from West Virginia on down into the Carolinas and started hunting in the swamps. Tom had never hunted in the swamps before but a friend he had met had some coon dogs and they got to talking and planned to go out coon hunting together one night.

Tom's friend had a "good old" coon dog named Brothel, how he got that name is still unclear. The two men and Brothel went out hunting, down into the swamps and had gone about a "city square" when Brothel treed a coon. He never barked or tracked, he just treed. Usually when this happens the dog has treed an opossum or some other creature that isn't exactly right. So the men went to have a look and sure enough, Brothel had treed a great old Big Boar Coon sitting on a limb no higher than twenty feet in the air. He had proven himself to be a real good coon dog.

Tom was so impressed with Brothel that the dogs he owns today come from Brothels blood lines.

Coon Hunting with a Pit Bull

At one point Tom got himself a pit bull as a yard dog, or so it started. Tom would go out hunting and come back empty handed to find the pit bull had treed a coon in the yard. So Tom started hunting with the dog. The only bad thing was that he couldn't hunt the dog with any others because all the pit bull would want to do was fight with the other dogs and not hunt coons. Tom hunted the pit bull by itself and it was one of the finest coon dogs he ever had.

It was while hunting with this dog that Tom caught the biggest coon of his life. It weighed 22 pounds on the scale. Most people will think a coon is heavier while they are carrying it out of the woods. "They will think it weighs between eighteen and twenty pounds but when they get it on the scales it only measures up to eleven or twelve."

The story Tom tells is that the old guy goes hunting and kills a coon and is carrying it out of the woods when he is asked by another hunter how much the coon weighs. The old man responded saying it weighed about twenty pounds. The other hunter took one look at the coon reached over and took hold of it and began to doubt the old man saying there was no way that the coon the old man was carrying could weigh anything close to twenty pounds. The old man looked at him and said, "You carry him about three miles and he gets heavier as you go." An easy twenty pounds .

A hunt that stands out in Toms mind with the bull dog is evidence of what a dedicated coon dog she really was. Tom was hunting with her and she treed a coon. He headed in the direction he had heard her but she was suddenly quiet and Tom couldn't hear where she was. Tom kept hollering and hollering and listening for the bark that never came which was very unusual. Tom continued looking and then heard a kind of choking, gurgling and scratching sound and knew right away that something was wrong with his dog. He began to shine the light around and finally shined it up into the trees. There, about as high up as Tom could reach with his hands was his pit bull's hind end. She had "gotton herself hung up in the forks of a tree limb and was about choking herself to death." Tom reached and pushed her up and she fell back down on top of him and both of them hit the ground practically killing themselves. This was typical of Tom's pit bull, "she would try to chew the tree down or climb it, just about anything to get to the coon."

One time the pit bull treed a coon at Tom's home. Tom heard her and grabbed his gun and two shells and went out to see what she had found. The pit bull was going back and forth between three different trees, running and jumping from one to the other. Naturally, Tom thought she had been fooled and didn't know which tree had the coon. He started looking around and finally found that the tree in the middle where she was barking the most did really have a coon in it. Well, Tom thought maybe there was more than one coon after all.

Tom shined his light up in another tree and found another coon. Tom used his two shells and shot both coons. As he shot the second coon a third one came down out of a tree and jumped on the pit bull and began fighting with her. So the pit bull had been right all along with three coons treed, each in a separate tree.

The coon and pit bull fought and fought and fought "plum over into the swamps." The swamp was full of mud and when Tom spotted them with the flashlight all he saw was one big rolling mud ball where the two continued their battle. The coon was a big one.

Tom made his way after the pit bull and coon because he didn't want the dog to tear up the coon too much. He wanted to "save the coon meat for eating and sell the skin to help pay for dog food, and stuff like that." By the time Tom got to them it looked like the coon was dead. Tom called his pit bull off, which took some persuading because she wanted to keep fighting. When they were finally apart the coon came to life again, making a pass at the dog and Tom, biting both of them and then running further into the swamp with the pit bull right on "its hind end."

Tom followed them both deeper into the swamp. The dog caught the coon about 100 yards away and the fight was on again. It went on and on and on until it became obvious to Tom that the coon was finally dead. When Tom tried to get his dog off the coon, she refused knowing it would try to run off again and being sure that this time it didn't happen. The pit bull wasn't going to trust anybody and let that coon get away. Finally, Tom got a stick and pried her mouth off the coon. The end result was a tired, muddy, bloody, trio of Tom, his dog and the now dead coon.

Roscoe P. Coaltrain

Originally, Roscoe P. Coaltrack, Roscoe P. Coaltrain, was renamed by Tom's son Charles. Roscoe was an average sort of dog, who has just recently been stolen from Tom. He had taken Roscoe with him to a friends house and somebody took off with the dog. He was one of the dogs who served as a model for Tom's carving and will be missed for a long time.

Hitler and Reckless

Another outstanding hound that Tom fondly remembers was, Reckless. He was a "cross dog," a pure bred hound but not a pure tree bred dog. Reckless was "a good old dog" and did well in the field trials winning ribbons and trophys. Tom hunted him with another dog named Hitler who was a great big mean old dog, appropriately named.

These two dogs, Tom, his oldest son Charles, Bobby and Bobby's daddy, old Joe all went coon hunting together. The dogs treed first in a big hollowed out tree. By the time the men had gotten there the dogs had gone on to strike up another track and head for a different tree. Tom and Charles stayed at the hollow tree to see if they could punch out an old coon from inside the hollow.

Tom got a long stick and twisted it up the inside of the tree and rattled it around. Something white came down a little ways and stuck its head out. Tom saw the white head and thought it was an old boar opossum, which usually have white heads, so he began to walk away from the tree. Charles, who wasn't very old at the time, maybe eleven or twelve, said, "No Dad, that's a coon. I seen its foot and it has a coon foot on it." Well Tom didn't know how much to trust a kid who says he saw a coon foot so Tom said, "Naw, it ain't nothing but an old boar opossum, let's go." Charles stood firm and told his dad he wasn't leaving until he saw the coon again.

Tom twisted the stick around again inside the hollow of the tree and sure enough the animal stuck its head way out this time and Tom got a good look at it. He pinned its head against the tree with the stick he had been using and held it in place. It was a white coon, not albino, but a rare "mutant." The coon had normal eyes, black feet, normal skin, but the fur was a very pale blond and the bands around the eyes and tail were real red, like red hair. Tom says, "it was the prettiest thing I had ever seen in my life."

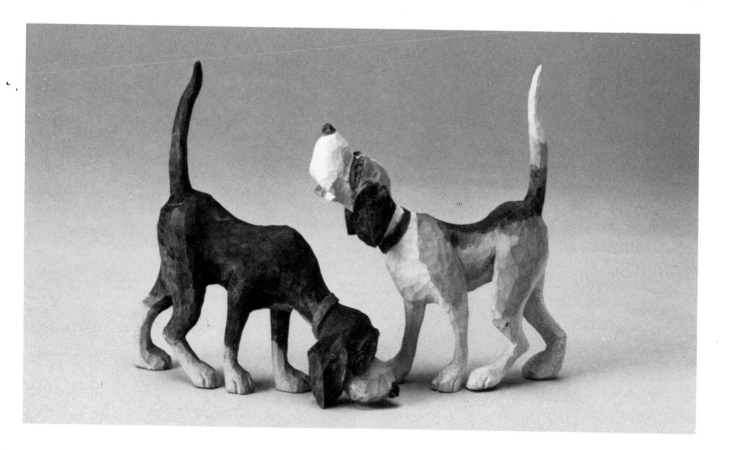

Tom held the coon against the tree and began to holler for old Joe and Bobby to come back and see the white coon. When Bobby and Joe got there Bobby said, "I got to have me that coon, I'm going to catch that thing alive and put it in a cage and keep it." Tom reminded Bobby that it was a full grown coon and he would rather try to catch a wild cat than take on a full grown coon, because "they are mean and will bite and scratch and everything else." But nothing would do and Bobby was determined to get that white coon.

Bobby proceeded to climb up on old Joe's shoulders. The reason he was called old Joe was because he was at least 65 years old and just a bit beyond his prime even though he was still a "stout fellow." Bobby was "as lean as a rake" and climbed practically every tree he saw. So Bobby climbed up on old Joe's shoulders.

Charles was holding a light and Tom was still holding the coon against the tree. Nobody could help Joe or Bobby, they were on their own. Bobby took off his big hunting coat and said they could put the coon down inside the sleeve of the coat and tie him all up when they finally got him out of the tree. Bobby started after the coon, telling Tom not to let go with the stick until he had a good hold of it around the neck. Tom tried to warn Bobby that the coon would "eat him up alive" but Bobby said he didn't care he was "going to catch that coon even if it does eat me up."

Bobby pulled the coon out of the tree. It was squalling and Bobby was hollering and Joe was holding onto one arm of the coat to shut off the sleeve. Bobby began to put the coon down into the sleeve of the coat, all the while, still standing on Joe's shoulders. "Blood was flying everywhere." Everytime the coon would make a scratch it would bring more blood. It was hitting with its paws, "scratching, digging, fussing, cussing, screaming and squalling." The coon got its paw through the sleeve of the jacket that Joe was holding so the coons paw was through Joe's hand and the arm hole of the coat. The coon would reach up Joe's bare arm and rake it with its claws just like slicing it with a razor. The old mans arm was cut all to pieces and he was squalling and telling Bobby to let the coon go, "turn it loose," Bobby would not hear of it and continued to wrestle with the coon.

Finally they got the coon down and tied it all up and rolled it up inside the coat and home they went with it. That was years ago now and up until recently, as far as Tom knew, Bobby still had that white coon in a cage in his house. He had tried to raise some small ones from her in hopes of getting another white one but was not successful. Tom is sure that if he had been able to make a video of that coon hunt he would be a rich man today.

Coon Hunting With Bobby

Tom and Bobby went into the swamp one time to hunt. They turned their dogs loose and it wasn't long before they had treed way down in the middle of the swamp. It was summertime and coon hunting season wasn't even in, but you could run your dogs, just not shoot the coon.

The men decided that they would have to go down into the swamp to get the dogs and bring them out because they wouldn't come out on their own after treeing a coon. They could be waiting all night for the dogs. Tom said to Bobby, "as dry as it is and as hot as it is, them rattlesnakes and copper heads will be thick in there." Bobby understood but thought they would just "have to be careful and watch where we put our feet." According to Tom, in that part of South Carolina there are rattlesnakes that he personally has killed which were over "5 feet long and bigger around than his right forearm." "I'm talking about some humungeous rattlesnakes."

Tom and Bobby walked into the swamps and began looking around, trying to make sure they didn't "step on no rattlesnakes." All of a sudden Tom heard something that sounded just like an old rattlesnake buzzing. They make a hissing, buzzing sound. When Tom heard that he took off running, which he admits was the worst thing he could do. At the same time, Tom took off running so did Bobby and they ran head-on into each other. They both fell flat down and Tom could hear the buzzing right by his ear. Again, Tom jumped up and Bobby jumped up and they bumped heads and fell right back down again. Tom and Bobby ran into each other four or five times trying to get up and get away from the snake.

Everytime Tom fell down he could hear the buzzing right beside his ear. The last time Tom fell down and heard the buzzing sound, he looked and noticed the lantern right next to his head. The lantern was still burning and if the snake was still there he should be able to see it. Well Tom didn't see any snake and as he got to looking he realized it was the lantern that had started hissing and making a sound just exactly like a rattlesnake buzz. At this point Tom said to Bobby, "Lets quit, we are going to kill each other trying to get away from a lantern."

Supplies and Tools

For chip carving there are three general types of hand tools required, knives, gouging tools and nail sets. Tom also frequently uses a device for honing his knives which he feels is important to maintain the razor sharp quality necessary for good carving. In addition it is handy to have a coping saw available. These items are the only hand tools Tom uses to do his carvings.

The power tools used in chip carving are the bandsaw, drill and belt sander. They are for the initial carving stages as will be explained in the individual chapters to follow.

There are no definitive rules for what tool to use. The best tool is the one that best completes the task. Each carver will develope individual preferences for specific methods and tools to use in carving. The tool will not be the deciding factor in distinguishing a good from a great carving. As experience and knowledge grows, the variety of tools can be expanded as necessary. These carvings were originally accomplished with a simple pocket knife so it is evident that there is a vast spectrum to choose from. Begin with the basics and add to your supplies as the need and desire arise.

The coping saw is used by Tom only to saw out the tail on the hound dog pattern. This is a fragile cut and the power of the bandsaw could cause the entire tail to break off. The coping saw can be used elsewhere however this is really the only step in which it is essential. This will be fully detailed in the chapter on carving instructions for the Treeing Walker Dog.

Hand Tools
Knives: Chip carving examples discussed here were carved using two basic types of knives, upon which there are many variations. One type is a knife having a flat cutting edge with an end that is turned down and the other having a flat cutting edge with an end that is turned upward. Variations of these types can be used

having thinner or wider blades to make carving in large or small areas easier.

Chip carving can also be done with a pocket knife as it was originally. Tom began his carving in just this way. However, the wider the variety of knives, the more one is able to perfect the carving. As experience in carving is gained, there will be particular knives that are more comfortable to use and most successful.

Knives, like the other tools, are a matter of preference and no one knife is more correct to use than another. Variations work and so do changes so do not be afraid to experiment. Make each carving a unique personal creation.

Whatever knives are chosen, they must be razor sharp and must be kept that way. Tom tests his knives by seeing if they will shave off a little hair from his arm. If they are sharp enough, they shave the hair easily. While carving, it is very helpful to periodically hone the knives to keep the edge at its sharpest.

To better hone his knives, Tom created a simple variation of a hand drill which he finds excellent for honing. First, you will need to buy a heavy duty variable speed reversable hand drill. The drill should have a reversible auxiliary

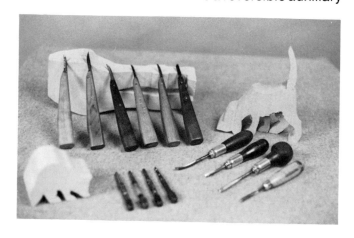

handle which can go on one side or the other. Using machine bolts, secure the mounts for the auxiliary handle. Make a wooden box with three sides to hold the drill in place. Bolt the drill into the box with the drill pointing up. Using a round wooden block, approximately 1½-2" in width and 6" in diameter, secure it to the face plate so it will rotate when the drill is turned on. Cover the top of the block with leather and glue it down. Coat the leather heavily with jewelers rouge, a polishing compound that is available in square blocks. Making sure the leather is well saturated with the compound. Now the honing machine is ready for use. The best feature of this honing wheel is that it is reversible, which is very convenient for carvers. Of course it is possible to also hone the knife on a leather boot, which is something Tom does frequently.

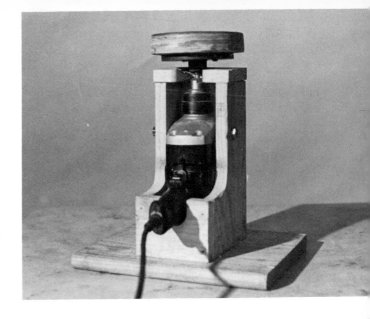

Gouging Tools: Once again, use what is already on hand. For these carvings Tom uses two gouging tools, ¼" and ⅜" in size. These are the most common. The only other gouging tool needed is a veiner, also a common carving tool. Gouging tools are used primarily in the area of the eyes and to add detail around the head of the carving. As the carver becomes more experienced, the use of tools such as these will expand.

Nail Sets: The nail sets are used for making the eyes. Four sizes are recommended. Tom uses nail sets of 2/32", 3/32", 4/32" and 5/32". Properly used this tool can really bring life to a carving. The four sizes are a matter of preference for Tom so he is able to create different expressions and looks in his various characters.

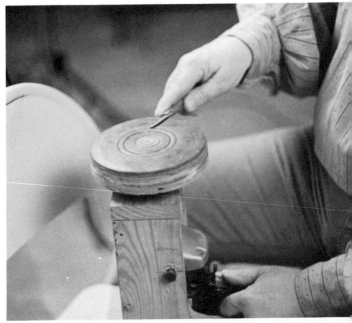

Power Tools
The three power tools that Tom uses in his carving, the bandsaw, drill and belt sander, are listed below.

Bandsaw: This is used for the initial step in the carving process. Use of a bandsaw also speeds up these beginning stages and makes it much easier than sawing the patterns out by hand. For some figures the bandsaw is also used to remove excess wood quickly. Finally it is helpful in shaping the wood to be used as a base for the sculptures. If a bandsaw is unavailable, local lumber yards or cabinet makers workshops will cut out the patterns for you at a small charge.

Drill: To make the necessary hole in the body of the coon hunter for attaching the head, a drill is needed. It is also used for removing excess wood from the carvings of the hound. For these steps a power drill is much more efficient than the manual type.

Belt sander: This is not essential to the carving process. It is used here to smooth the surfaces of the base on which the carvings will be mounted. This can be done by hand, however it is faster and more efficient if the power sander is utilized.

The Basics: General Suggestions for Bandsawing and Carving

As Tom prepares to carve and paint his characters, there are many facets of each step that need to be recognized by the carver prior to starting. Some of these are safety, some are convenience and some are technique. All are important and should be noted before delving into the carving process.

Carving

When preparing to carve there are some general thoughts that may be helpful. Where a pen has been used to mark the blanks now switch to a pencil for drawing any necessary carving lines. These lines need only be lightly drawn for which a pencil is much more appropriate. Also a pencil can be erased if necessary. If lines happen to be carved off, they can easily be re-drawn.

While carving, it is possible to run the risk of creating a flat area or a spot that is out of balance. Keep rotating the carving in your hands and continually look at it with a sharp eye for maintaining consistent shape.

If an area or spot appears that is not quite right, make the adjustment at that time. Continually adjust and correct the carving as the need arises.

While carving, always hold the wood in a way that is comfortable and easiest to carve. As can be seen in the illustration, Tom uses his lap as a work bench and his left hand as a vice, which is most comfortable for him. Be sure to listen to the wood, it will "talk", especially if the carving is going against the grain. The wood, and the sounds it makes while being carved are good indications of the carving direction.

When carving people, use real clothes and people as models. Notice how the actual clothes hang and look on the person. Sharp details in a carving make the difference between good and best. Do not expect the paint to do the work that should be in the carving.

The childrens' section of the library is an excellent source for photographs of animals. Also drawings are available which can be more beneficial for the carver. The eye can better reproduce the image from a simple line drawing because it is less confusing then a detailed drawing or photograph. Keep the pattern available while carving for easy, quick reference. Breed books have good profile pictures of dogs from which to make different patterns and to use as a carving guide. A good dog book is the best reference. Over the years Tom has collected a large library on different subjects, birds, animals, and designs and costumes of various periods.

Bandsawing

When using a band saw keep the heels of your hands on the table and guide the wood with your fingers. If you have difficulty, stop. Never force anything. Turn the saw off, pull the wood away and begin again.

The bandsaw will be used to cut out the blanks for all the carvings done here. The only exception to this will be in the tails of the hounds which, because of their more fragile nature, will be cut out using a coping saw.

The Pattern Making and Tracing Process

Photographs, drawings, and real life models, are only a few of the possibilities to use for examples to fashion a carving pattern after. Tom began carving hound dogs using his own hound, Roscoe P. Coltrane, as a live model. The patterns for the characters presented in this book are included here, but future ideas can come from any inspiration.

The first thing to determine before beginning a drawing for a pattern is what the subject will be. The example Tom uses here is how to draw a mans' head.

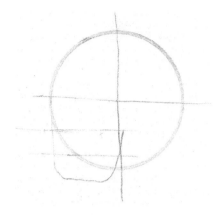

Draw a line halfway between the center horizontal line and the bottom of the circle. Between that line and the bottom of the chin draw an additional horizontal line. These lines will act as a guideline for drawing the nose and upper lip.

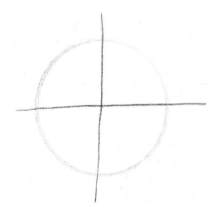

To begin the head, draw a circle and divide it into four equal parts as shown.

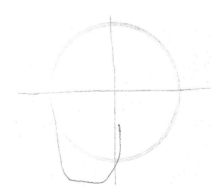

Here the jaw has been added.

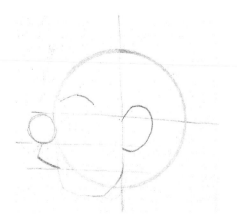

Begin to draw the nose and the beginning of the top lip or mustache. Add an eyebrow. The ear is drawn behind the center line and at the base of the jaw. It is important to note here that in human beings as well as in all animals, the botton of the ear is at the base of the jaw bone. The top of the ear is even with the eye brow.

14

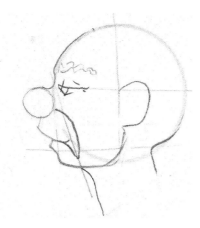

This drawing continues to add detail. Correct the lines as you go, if it isn't right the first time, erase it and draw it again until the desired look is achieved.

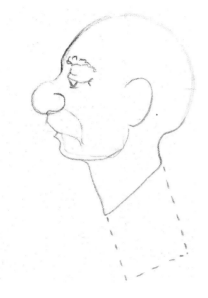

The lines have been erased and more detail has been added to the drawing. The dotted line designates the necessary length of the neck providing enough space in the pattern for attaching the head to the body of the carving.

Once the drawing of the pattern is complete, trace it onto a piece of shirt board or flexible cardboard that is sturdy and able to be used and saved for additional carvings. Tom usually draws a pattern and then cuts it out and pastes it onto the cardboard to be cut out again. This becomes a templet or overlay pattern that will be kept and used to trace the drawing right onto the wood. Keep the pattern so you can do more than one carving or create variations of it by altering the pattern slightly.

The hound dog pattern is a good example of a pattern that can be used to create more than one figure of a dog. The head can be moved in different angles, the body can be shortened by reducing the space between the front and hind legs or it can be lengthened by doing just the opposite. The angle of the tail can be changed as long as care is taken to

This is the final drawing of the outline of the pattern. Keep adjusting the drawing until it is just right and then add the final details.

be sure the grain is still running up and down the tail to maintain the strength of the wood. Any number of variations on a pattern are possible once you have gained some experience in working with it.

The copy machine is a handy device to change the size of a pattern. When Tom started carving the only way to enlarge or reduce the size of a pattern was the grid method which involved redrawing the pattern. The copy machine allows you the ability to easily enlarge or reduce the pattern as desired.

All carvers have a different size they work with that best suits their hands, eye and mind. That size will usually stay in proportion no matter what subject is being carved. If Tom begins to carve something that is larger or smaller than is normal for him, it becomes difficult and seems awkward to carve.

When making the pattern, keep in mind the actual anatomy of the subject. Be sure your pictures or drawings are correct anatomically. In drawing humans be sure the illustrations used as examples have the correct proportions for the arms, legs and trunk of the body.

When Tom carves a man he makes the head a little larger than is actually correct. He feels that sometimes it is necessary to dramatize certain characteristics so they work well and add to the carving. The carver must use his own judgement for this, and remember that the relationships between proportions are still very important.

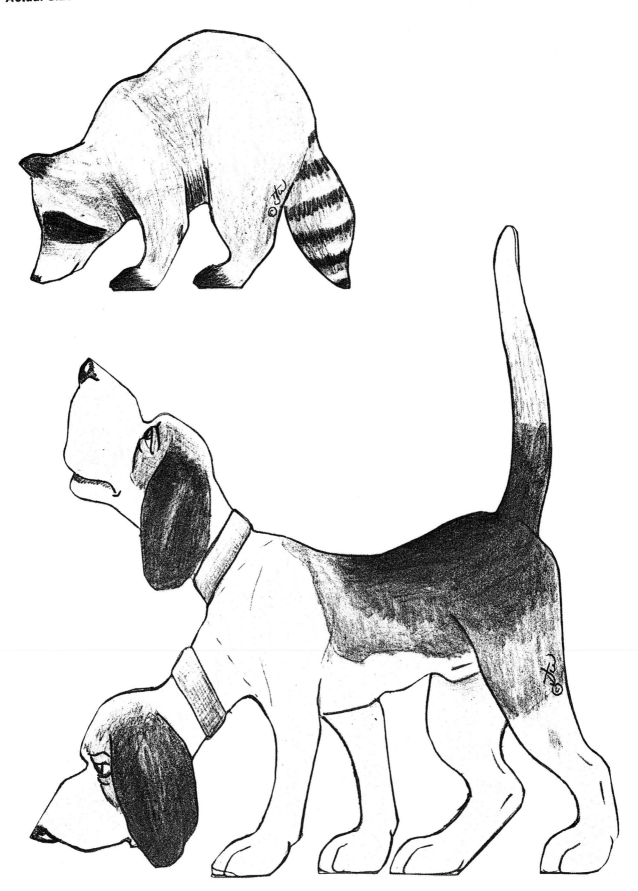

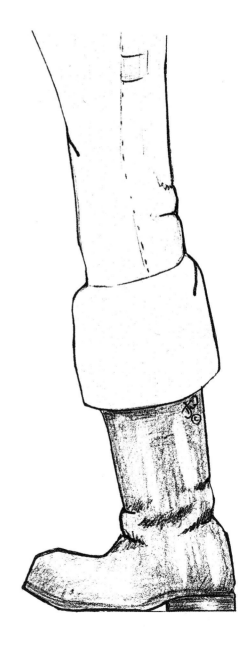

Pattern Tracing

Once the pattern is completed the next step is to prepare a piece of wood to carve. The wood should generally be about 4" thick. Tom uses basswood for these particular carvings because it has an even texture. Basswood has no high or low places and absorbs the paint evenly. Keep in mind the length and width of the wood should be such that it is easy to maneuver with the band saw.

Prior to placing the pattern on the wood be sure to note the grain and place the pattern so that the carving will be done in the same direction as the grain runs. Carving with the grain creates strength in the carving. If you are using a pattern of a dog with long legs and a long tail, the majority of the grain should be running along these characteristics to make it easier to carve and sturdier. If you plan to trace more than one pattern on the wood leave enough space between the patterns for easy cutting. Also place the patterns far enough from the end of the wood to avoid sawing into any air cracks which may be in the wood. The rule of thumb is that it is better to waste a little wood than to lose a carving.

Trace one figure at a time when doing multiple patterns. It is important to use only a fine tip felt pen to trace on wood. The "Flair" pen has been the best to use as the ink works well with oil or turpentine based paint. It should not be used with acrylic paint because it will bleed with a water based paint. The patterns can be used on either side to create a different perspective. Each pattern tracing will be slightly different because they are being done by hand, this creates a unique carving in each figure. Variation is to be expected, there are no mistakes, just changes. However, corrections can be made if it is necessary.

Tracing the Patterns Onto Wood

Before beginning to trace the pattern onto wood be sure to notice the direction the grain of the wood is going. In this case, the arrow is showing the grain direction. Place the pattern pieces on the wood.

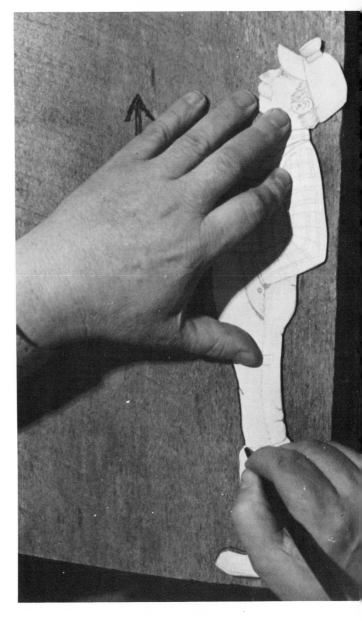

When tracing the pattern of the man do the head separately from the body. First trace the body.

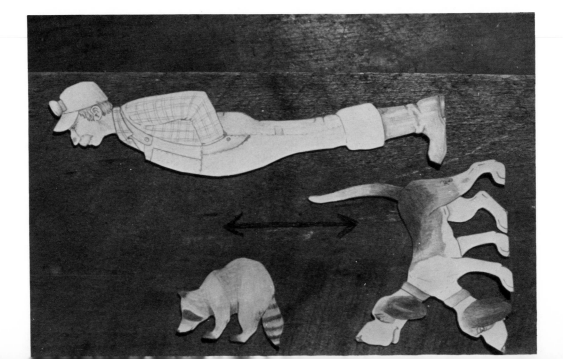

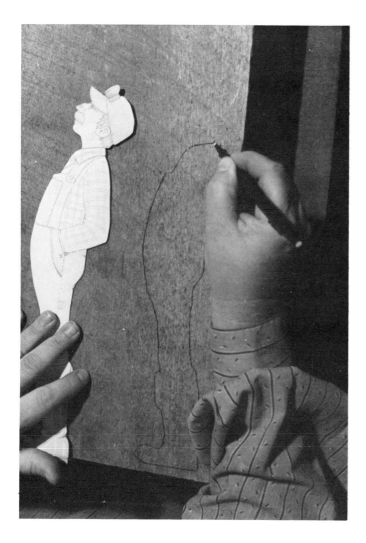

Remove the pattern from the wood and draw a line connecting the front and back of the body. Do this free hand.

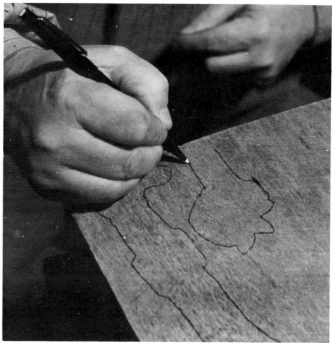

After tracing the head, by free hand add the neck and connect the front and back of the neck at the base.

Place the head and neck portion of the pattern in an appropriate place on the wood. In this case we have placed the pattern around the knee area of the body. Be sure the grain runs up and down the neck. It will be necessary to tilt the head back a little to get the grain straight.

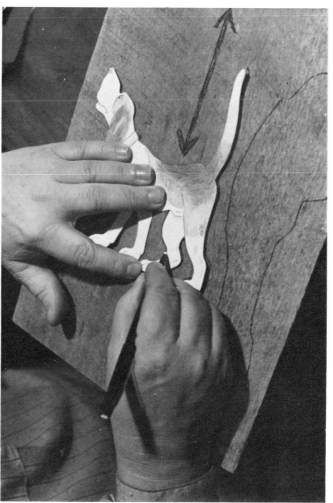

Trace the dog pattern with the head up.

The angle of the head can be varied as desired by simply tilting the angle of the pattern along the shoulder line.

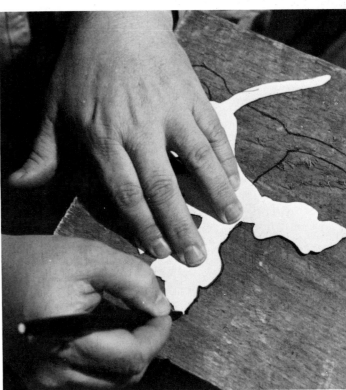

Turn the wood around and place the dog pattern down again to trace the carving with the head down.

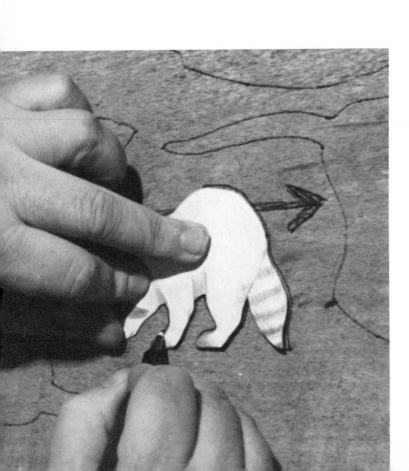

Trace the raccoon body.

The Treeing Walker Dog

Bandsawing

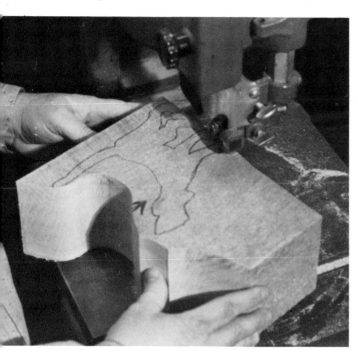

Take each piece individually and saw out along the tracing lines. Band saw the dog figure.

Carefully saw between his legs.

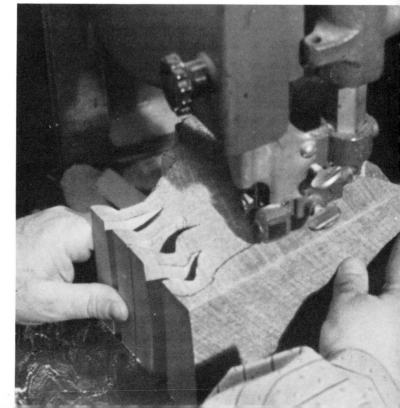

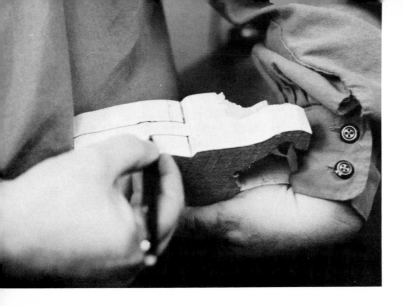

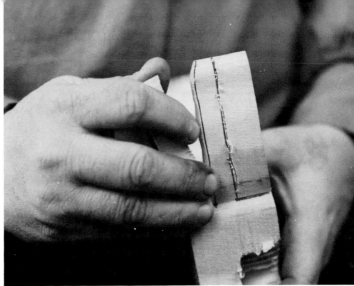

To cut out the tail of the hound, first draw two lines down the center of the blank tail, approximately ½" in width.

Pop off the excess wood on both sides of the tail.

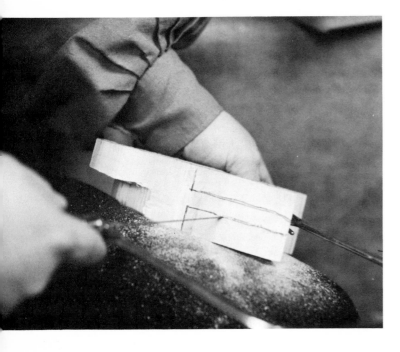

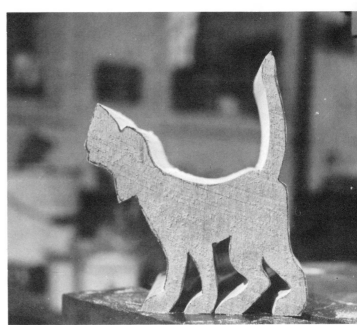

Saw down both lines with a coping saw.

Completed dog.

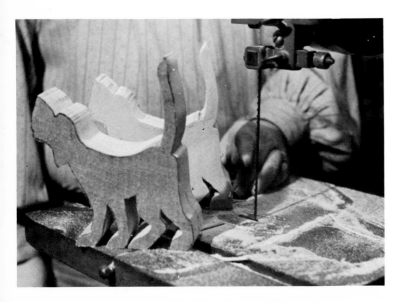

A 4" dog form should be split and can make two or three dogs, depending upon how thin or fat the dogs are going to be.

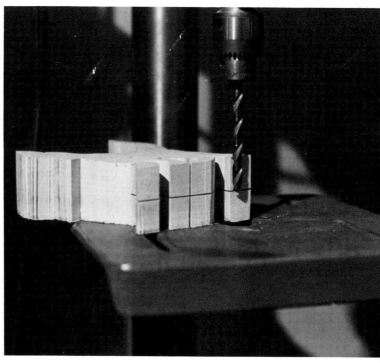

Draw two lines on either side of the tail and band saw along them to create a stop cut for future carving. Draw a line down the center of the hind leg area from the crotch to the bottom of the paws, and along the bottom of the paws.

Set the depth gauge of the drill to cut down no farther than the center line in the middle of the dog's legs. The drill is used to drill away the extra legs.

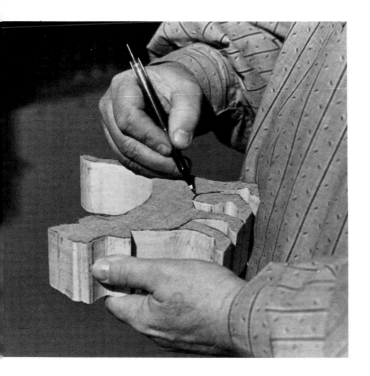

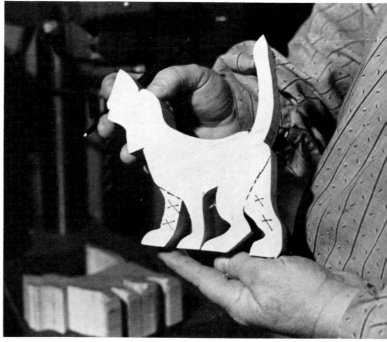

The position of the legs will vary depending on how the dog is to look. Use the felt tip pen to draw in the guidelines for the legs to be removed on both sides of the blank.

Draw an X on the legs to be drilled off to eliminate any confusion.

 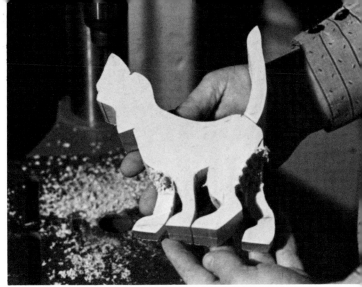

Drill along the guidelines and remove the desired legs.

The blank with the legs drilled away on one side of the body.

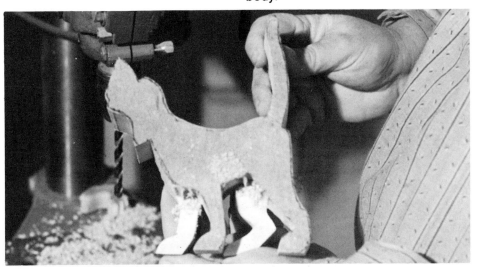

The blank with all the extra legs removed.

CARVING INSTRUCTIONS

Begin carving by using a curl and slice motion to round off the back of the dog. A knife with a straight blade is used for this. Starting with the back, create a round place and the ability to comfortably hold the carving while working.

Round out the area on one side and repeat on the other. Be sure to cut away enough wood to prevent the carving from having a square look to the back. (Hound dogs look very bony. Tom always had a hound dog in his yard to look at as he carved. Now, using photos works well.)

24

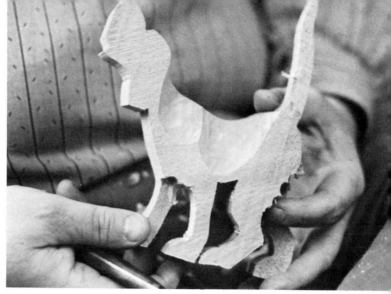

Remember to carve with the grain. If the cut feels like it is getting deeper instead of curling out, the cutting is being done against the grain.

Continue to carve out the neck and the hip. Note the lump between the shoulder and hip indentations.

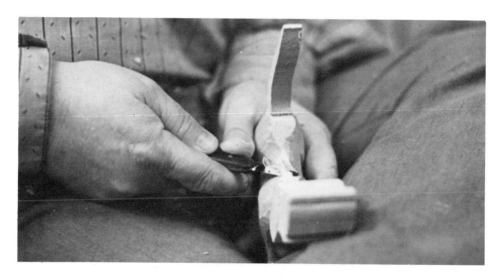

Change to a knife with a curled up blade and use a "thumb-push" method to continue carving.

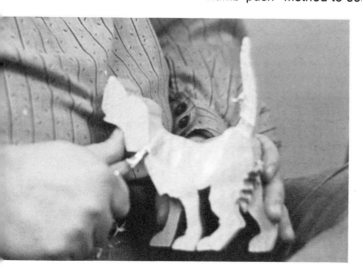

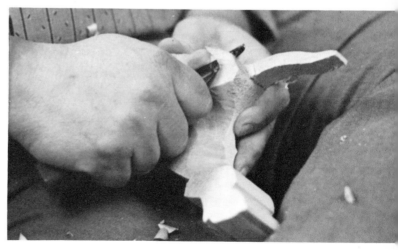

Use the same knife in the "thumb-pull" motion.

Use both the push and pull methods to round out the hip of the dog. Repeat on the other side.

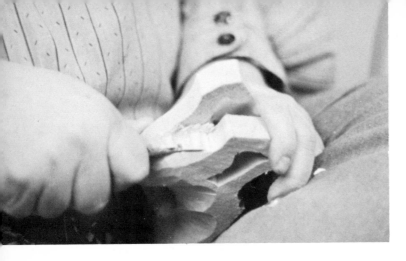

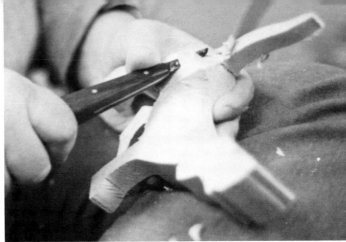

The long knife handle makes it easy to use a "pry-bar" technique, giving the carver more strength and more speed, making it possible to move a lot of wood quickly.

Tom usually starts at the back of the hound and moves forward in carving the figure. One characteristic of a hound is crooked hind legs. Leave enough width in the back leg area to be able to carve between the legs to create this crooked look.

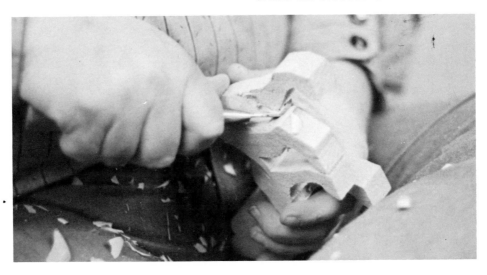

Clean off the mark from the drill press and carve the back of the hind legs.

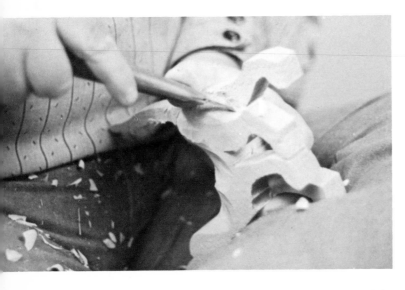

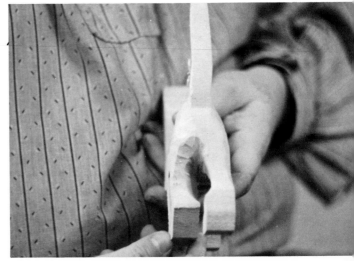

Change to the thin knife with a turned down edge which is easier to use to carve between and inside the back legs.

Open up the area between the legs. Carve the inside of both hind legs.

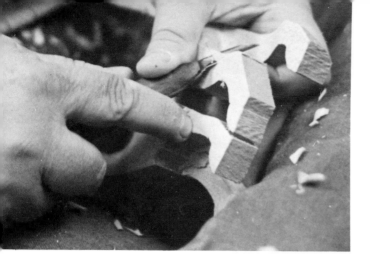 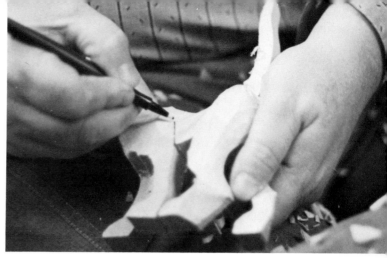

Begin the outside of the hind legs, carving the roundness of the outside bowed appearance.

Draw a line from the front leg up to the shoulder.

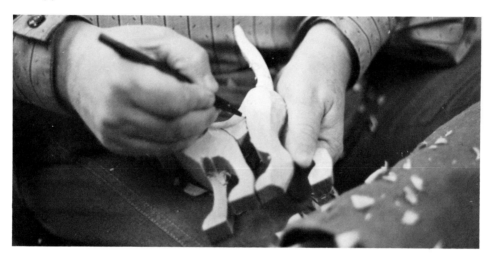

Draw another line from the hind leg up to the hip. It is important to keep the anatomy of the dog in mind, so the leg connects to the shoulder and hip areas properly.

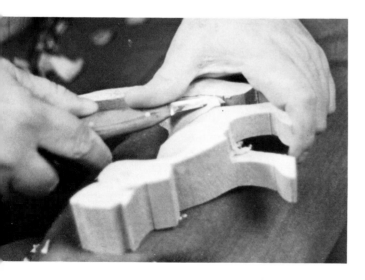 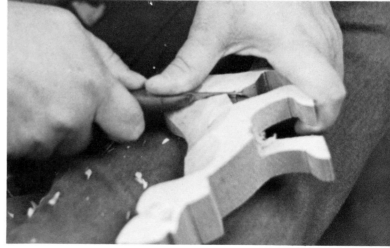

Press the knife into the wood along both of these lines.

Rock the knife back and forth until the width of the blade is completely embedded in the wood, roughly ¼". This creates stop cuts to prevent carving too far in these areas.

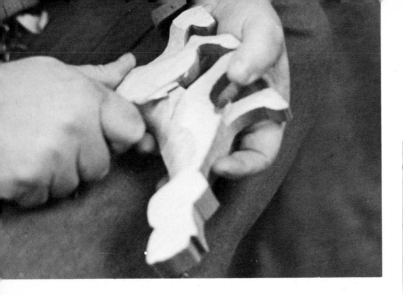

Shape and round the stomach area by carving into the stop cuts. The fully rounded and contoured stomach.

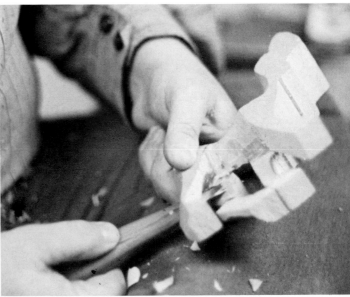

Carve around the inside of the back legs and open up the area between the hind legs. Again the knife with a long handle is useful in getting between the legs and prying out large pieces of wood quickly.

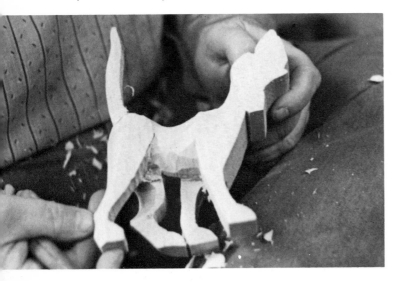

Using the same knife, clean up the underside of the dog.

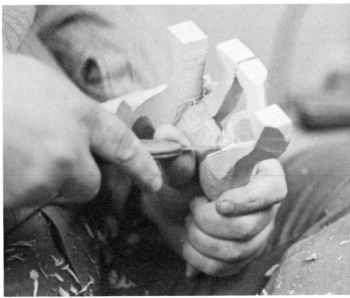

The flat surfaces on the hind legs now need to be rounded out.

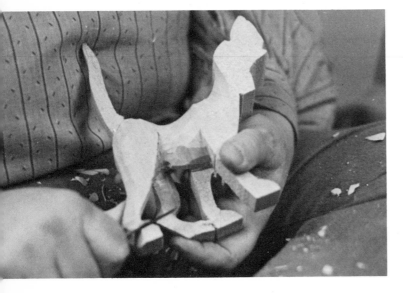

Make a shallow stop cut at the bottom of the leg just above the paw.

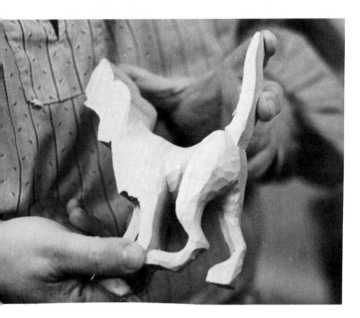

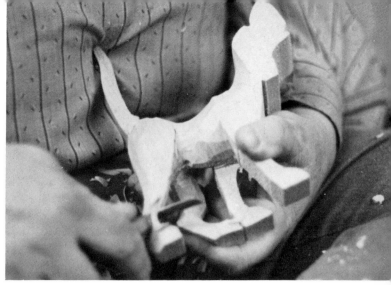

Carve down the leg to the stop cut. Keep turning the leg while carving to be sure the leg does not become too thin on any one side.

The leg has been shaped down to the paw. Repeat the process on the other side. Remember to keep turning the carving until the best contours in the legs are achieved.

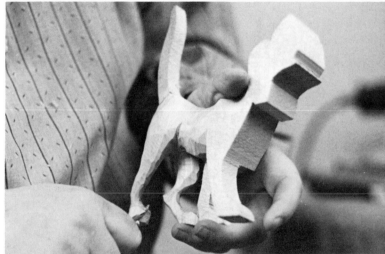

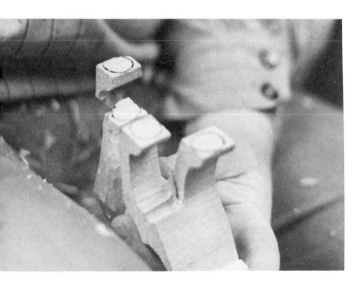

Chip away around the paws. Chop the wood off, taking advantage of the direction of the grain of the wood.

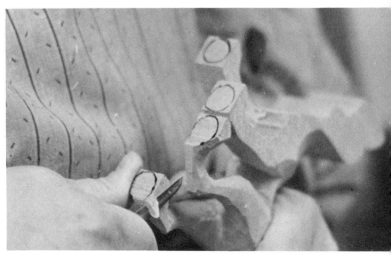

To determine the size of the paws, look at the bottoms of the paws and see which will have to be the smallest. Draw the circumference of the smallest paw on the bottom of the other paws so they will all be approximately the same size. Draw free hand and use "a good eye". The shape does not have to be exact or perfect.

Round out the top of the paws.

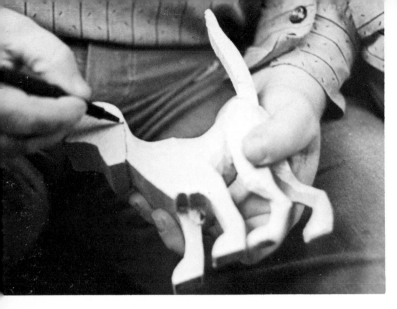 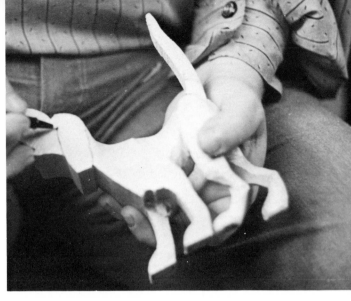

Draw a line along the back of the ear. Do the same along the front of the ear.

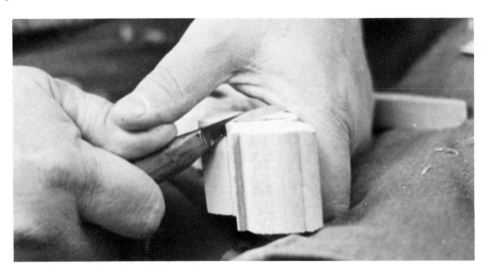

Using the knife with the turned up blade (which is useful
for carving on the outside of the body), make stop cuts
along the lines in front of and behind the ears, roughly ¼"
deep.

Cutting into the stop cut, chip away the wood around the Round out the area all the way around the neck.
shoulders and neck.

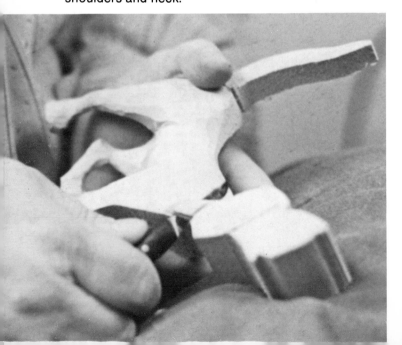 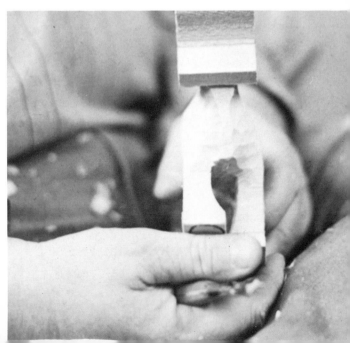

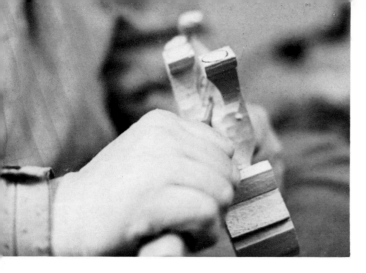 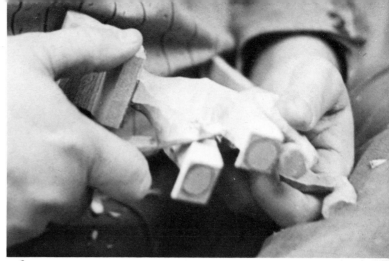

Using the knife with the turned down blade, chip away inside of the front legs and create an open area between them.

Chip away the outside of the front leg. Carve at a 45° angle until the flat plane of the leg is the desired width.

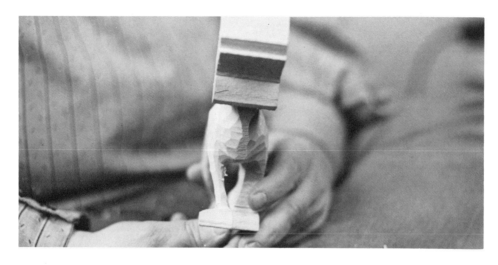

Keep in mind, the front legs are thinner than the back. Carve at an angle from the back to keep the shape of the elbow and keep the ability to carve the paws pointing out slightly as shown.

Several small shavings can be carved at once and then all cut off together at the stop cut on the top of the paw.

Carve from the top side of the front leg. First making a stop cut at the top of the paw and carving down the leg into the stop.

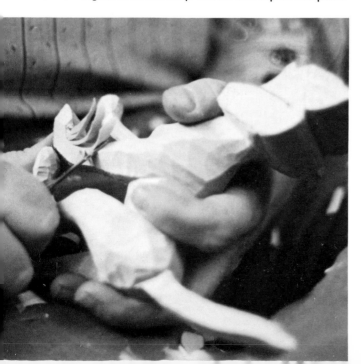 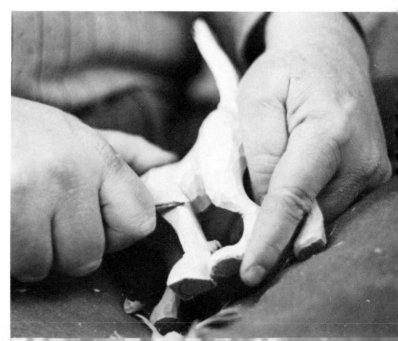

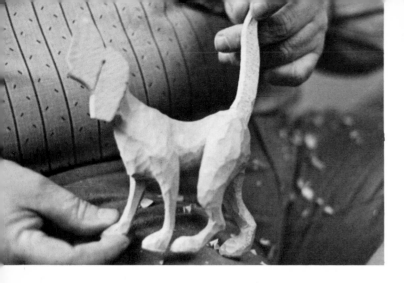

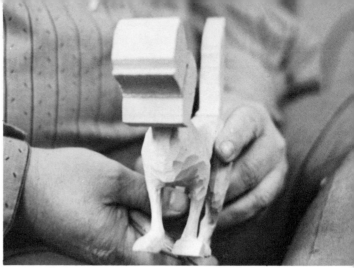

Carving all the way around the leg. Round it off to the desired shape as shown. The silhouette should never change and the width of the leg should be the same all the way around, based on the pattern.

One front paw has been chipped away. Refer to the circle drawn as a guide on the bottom of the feet.

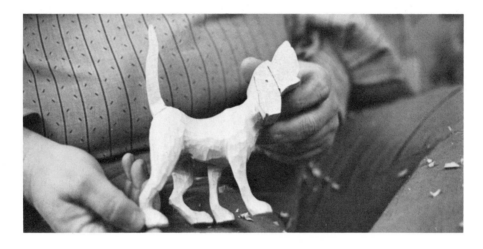

This process has been repeated on the other front leg. Remember, the carving should be from the elbow up and then from the elbow down to the paw. Shown here is the finished leg carving.

Using the knife with the turned up blade, "dress-up" the carving. Carve off all the extra areas and lumps that were overlooked the first time. Carve in the muscle tones and body dimensions around the shoulders and legs.

Draw a line down the center of the dog's face to use as a guide to keep the carving symetrical. The line should run down the front of the nose and muzzle.

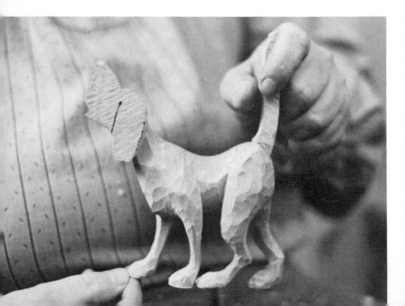

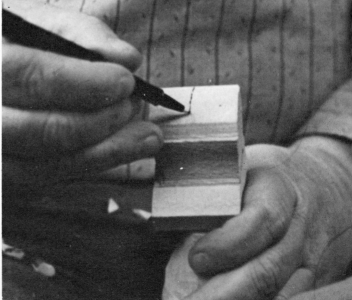

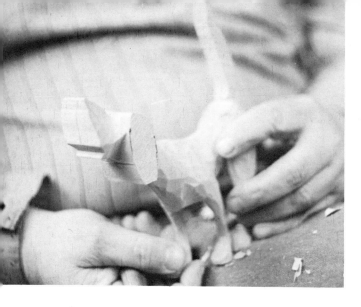

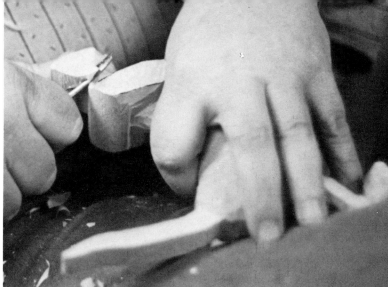

The ear of the hound becomes more prominent as wood is removed between it and the side of the face.

Round out around the muzzle by carving away from the eyes.

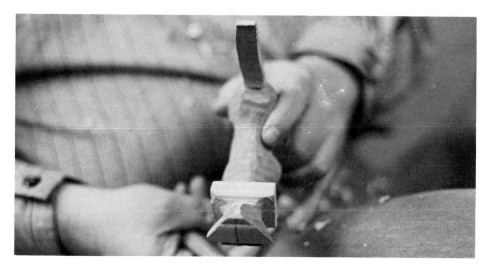

The area around the jaws should have a puffy appearance as would be seen in a real hound.

Shape the muzzle.

Draw the nose on the blank.

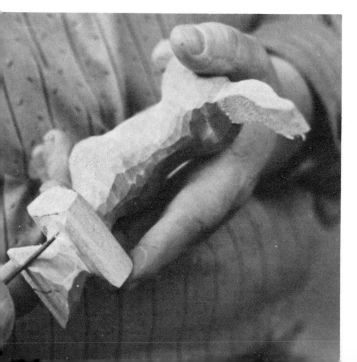

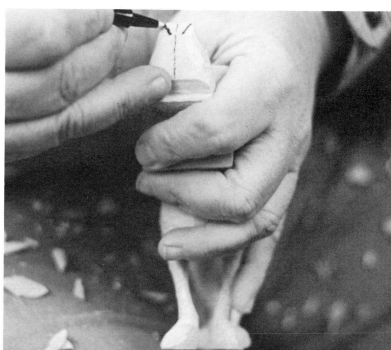

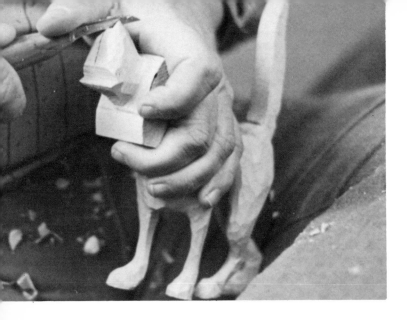

Cut out a notch at the end of the nose.

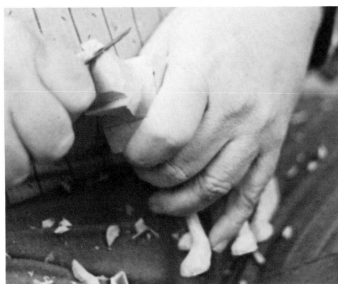

Carve around the nose to make it stand away from the rest of the muzzle.

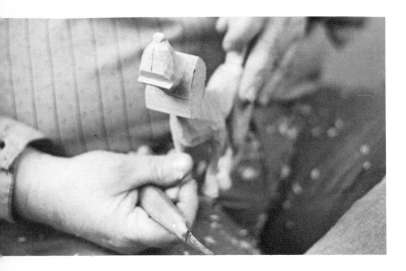

The finished nose and muzzle.

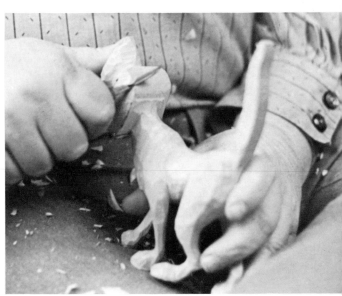

Carving at a 45° angle, round off the top of the ear.

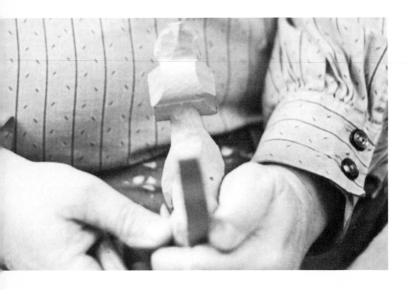

Note the ear is really not at the top of the head, but almost 1/3 of the way from the top. Carve out the tops of the ears only.

34

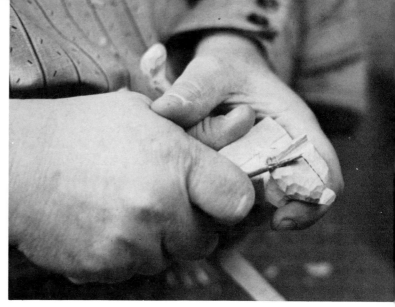

Chip out lips on both sides of the mouth.

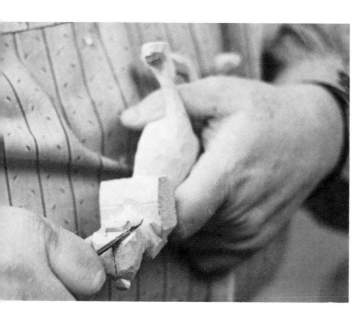

Whittle out an indentation from the chin to the upper jowl.

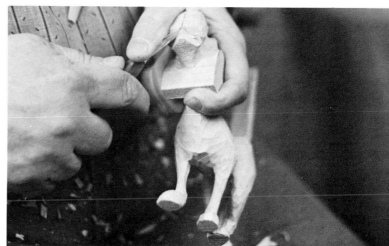

Carve a V-shaped clef in the upper lip and carve out under the lip to create the look of two separate lips and a chin.

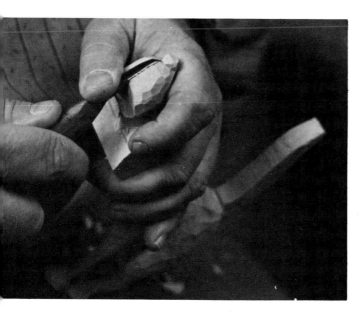

Carve out a long thin notch along the line drawn on the muzzle.

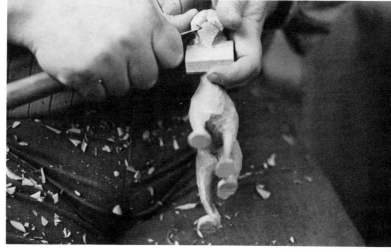

Carve out the tongue by putting small notches on either side.

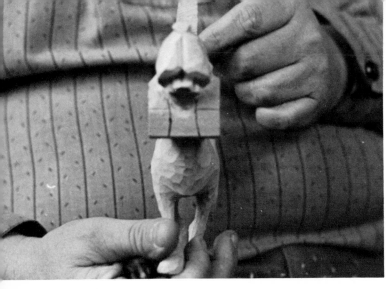

Draw lines to designate the opening between the ears.

Cut in stop cuts on both sides along the lines.

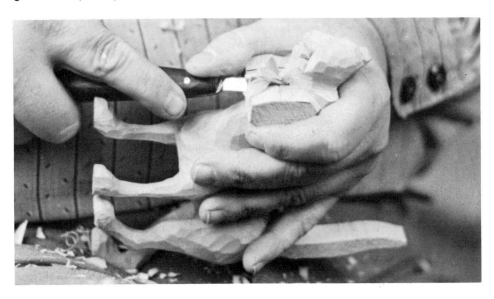

Carve out the area between the ears.

Use a gouge to get to the smaller hard to reach areas between the ears.

The final shape of the neck area.

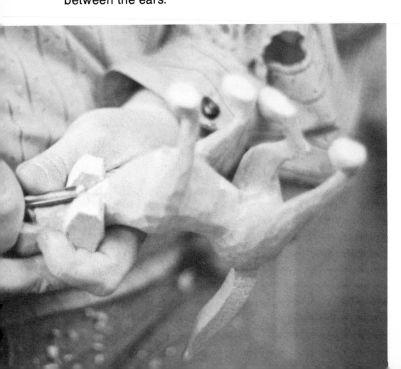

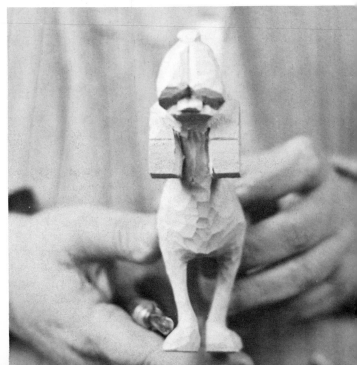

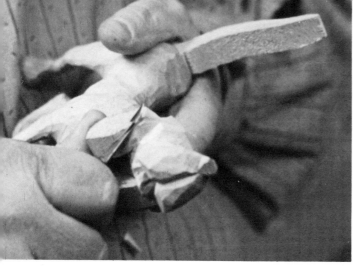

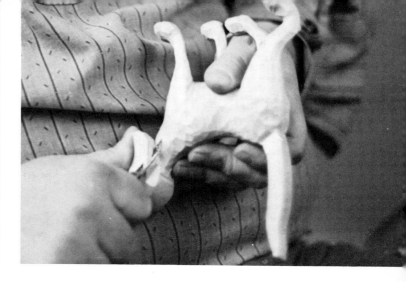

Use the thinnest knife available with a turned down blade and carve a fold in the front at the bottom of each ear. This adds character and creates realism.

Carve a fold in the top at the back of each ear.

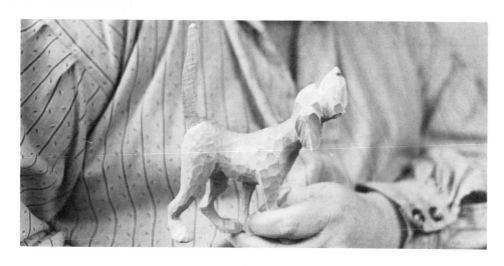

Finish carving around the back of the ear and "dress it up" as was done for the body of the dog with a final carving.

Using the knife with a turned up blade, notch out an area in the back of both ears.

Insert the blade behind the ear and roll it forward to create the back of the ear stop cut.

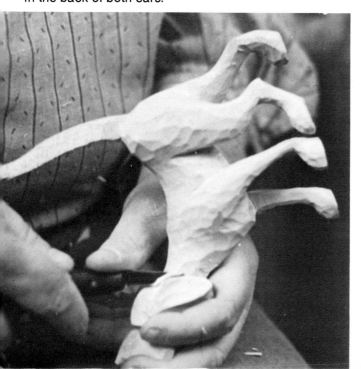

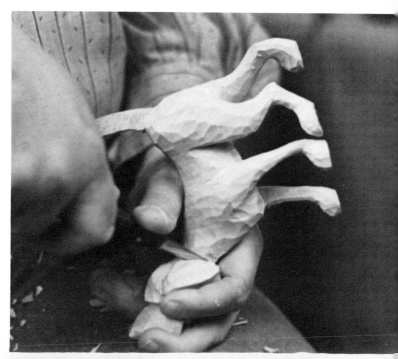

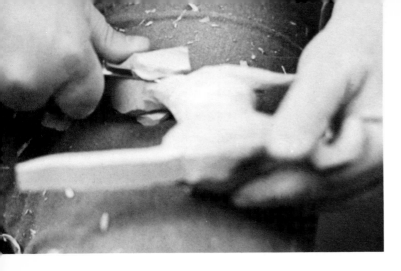

Cut out behind the ears.

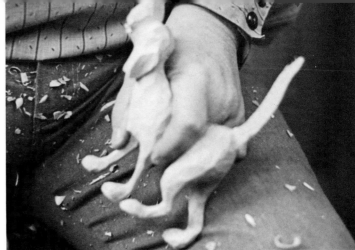

The knife with the thinnest turned down edge has been used to create a fold at the top of the ear, between the other two big folds. This is done at the top of both ears.

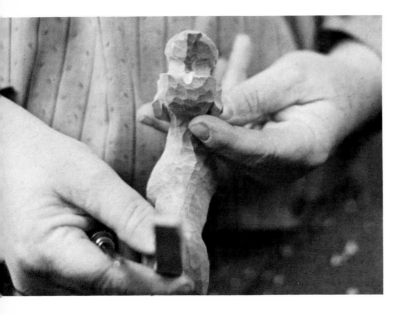

The ⅛" gouge has been used to make a dimple at the bridge of the nose between the eyebrows.

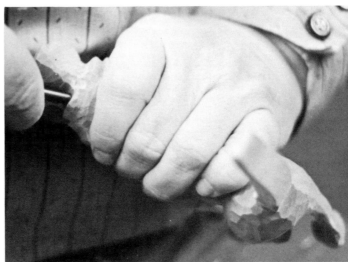

The ⅜" gouge has been used to carve out a place for the eyes, on both sides of the head. Using this tool will make the shape symetrical.

Still using the ⅜" gouge, make a heavier eyebrow along the top of the head.

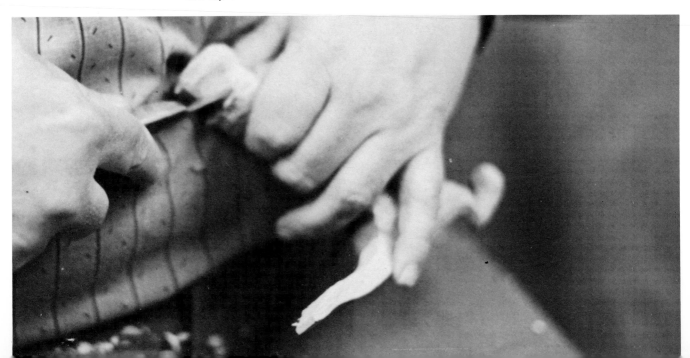

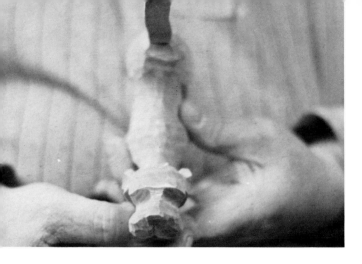

The eyebrow becomes an accent.

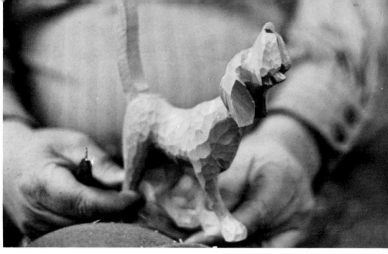

A knife with a turned up blade was used to finish the top of the head, smoothing the areas where the gouge and knife were used. The head is now finished with the exception of the eyes.

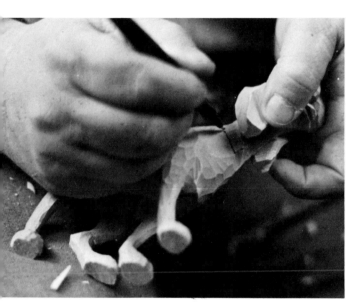

To create the collar, draw a line around the neck showing where the collar will go.

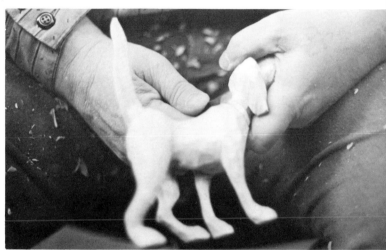

Using the knife with a turned up blade, make stop cuts all the way around the collar. These stop cuts are more like a score mark, not deep.

The area around the collar has been carved away to create the contour of the collar on the neck.

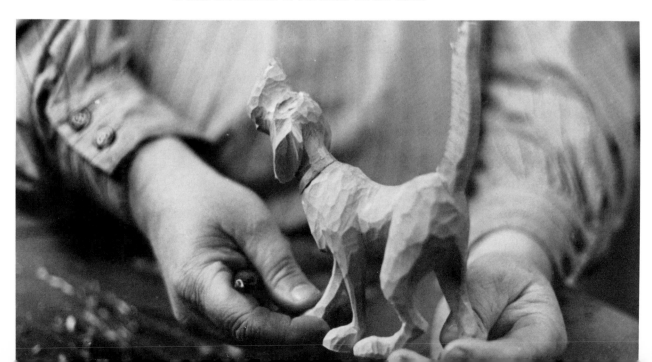

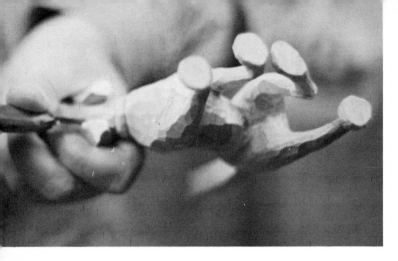

Finish rounding out the bottom of the ears.

To complete the eyes, use the 3/32 nail set. Rock back and forth and rotate the nail set to depress the wood and dent an area for the eyeball. If you are right handed, it is best to do the left eye first and then match up the right eye. Holding the carving to do the left eye is awkward. When doing the right eye it faces you easily. A left handed carver will do the opposite. Use the 3/32 nail set in the same way to create the eye pupil.

Using the knife with the longest, most clean point, make notches at the corner of the eyes. First make a straight cut into the inside corner of the eyes. Then a V-shape notch on the outside corner of the eyes which can be chipped out.

Taking the V-shape gouge or veiner, notch out between the toes on the paws as was done here. One notch in the middle and one on each side. Always do the middle notch first. Remember to do all four paws.

To round out the tail, use a knife with a turned down blade. Keep carving until the tail has been reduced to the appropriate width.

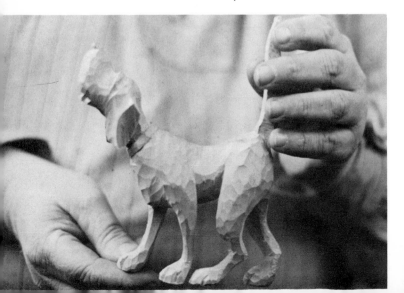

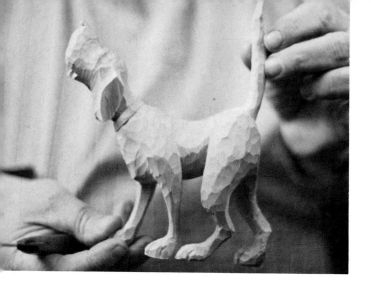

The tail can be curved along the grain of the wood. Use your eye to tell when the dimensions are right and the shape good. Again keep turning the carving to see all aspects. Here the tail is complete.

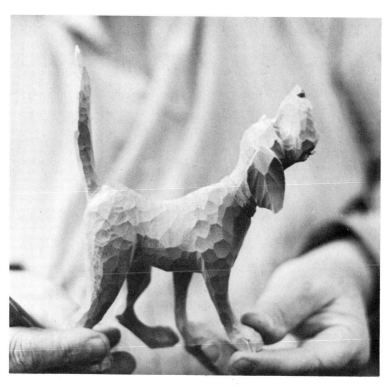

The hound is finished. It has had the chip facets smoothed and evened out using a knife with a turned up blade.

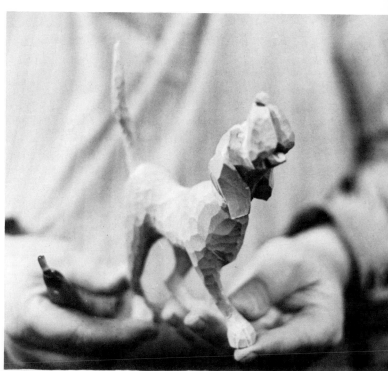

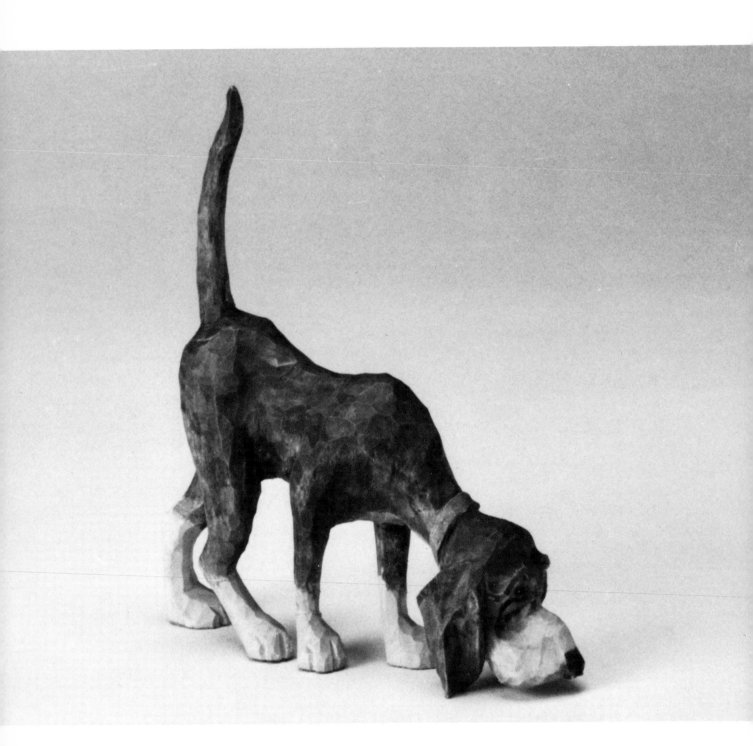

The Black and Tan Hound

CARVING

The instructions for the Black and Tan hound are identical to the Treeing Walker Hound up to the point where carving the head begins. Follow steps on pages 21 through 32 from the Treeing Walker Dog carving instructions. Once you are ready to begin carving the head start here.

Draw lines along the front edges of the ears on both sides.

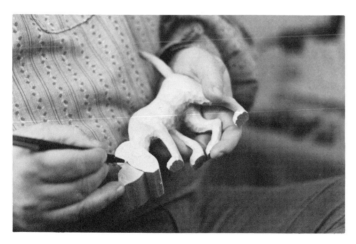

Make a stop cut along the line in front of each ear using the knife with the turned up blade. Push the knife in and rock it up to make the cut.

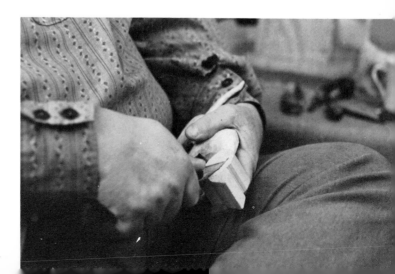

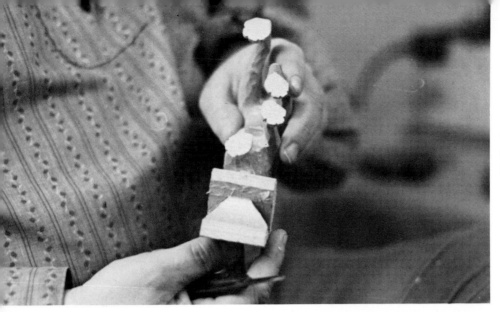

The ear has been carved back to the end of the stop cut so it is away from the face.

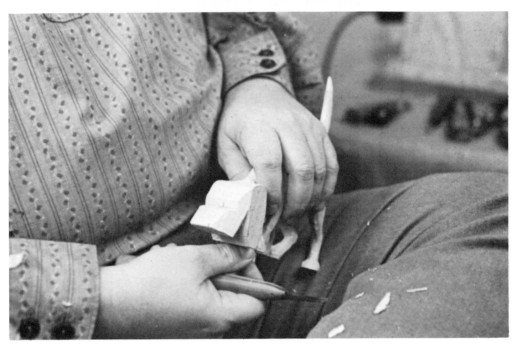

The excess wood has been carved away between the ears and face leaving enough wood for the width of the jaw.

After changing to a knife with a turned down edge, chip away at the side of the face to create sockets for the eyes.

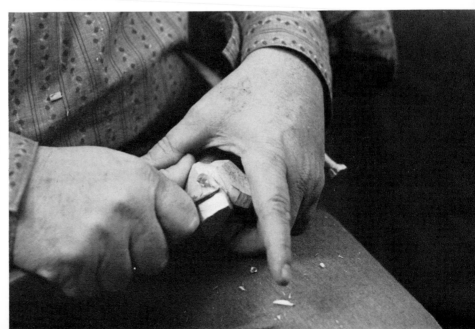

44

Chip close to the nose mark but leave enough wood to create the nose itself.

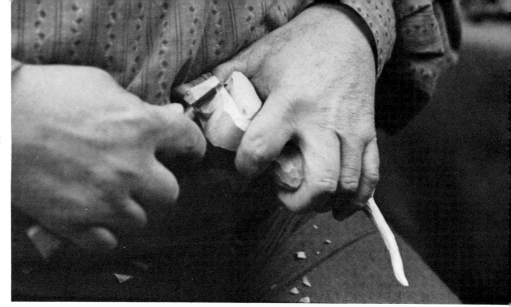

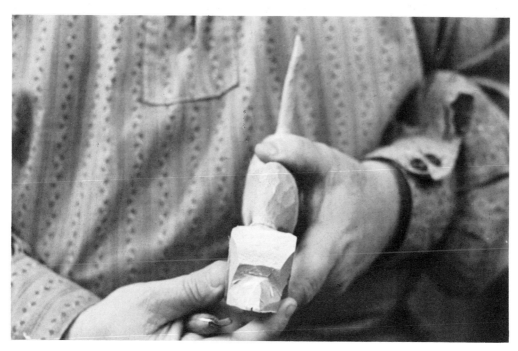

This has been repeated on both sides of the face.

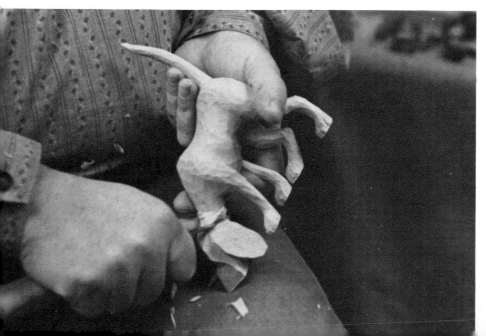

Carve the tops of the ears at a 45° angle. Note the hidden thumb is still in an area where the pressure can be applied.

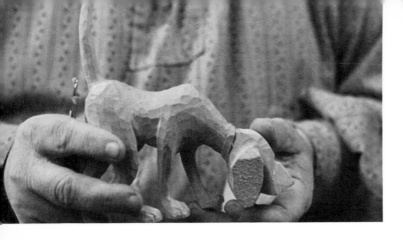

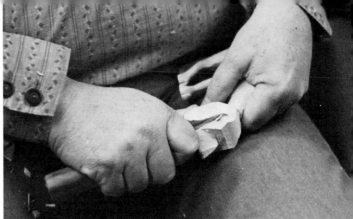

The top of the head and the ears have been finished.

Make a straight incision where the ear meets the head and carve away the extra wood in front of the ear.

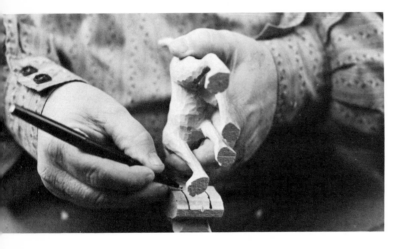

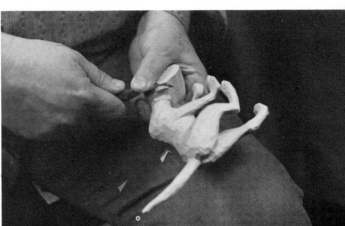

Draw lines on the underside of the ears. Use your finger as a gauge to keep the same width on both sides.

Do the same at the back of the ear and clear away the wood from the back of the neck. Repeat on both sides of the head.

Using a knife with a turned up blade, make stop cuts along the lines.

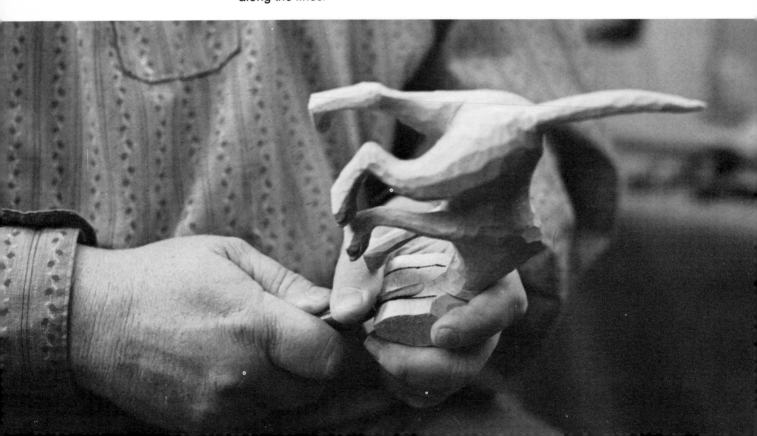

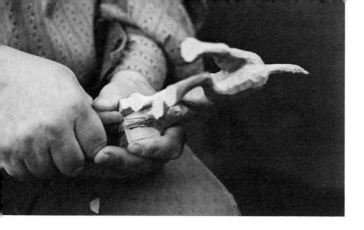

Cutting into the stop cuts, clear away the excess wood between the ears.

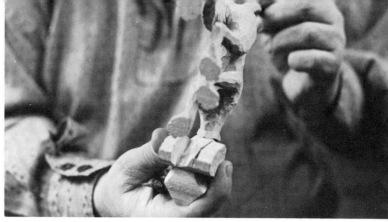

As the wood was cut away under the chin the stop cuts were repeated a little deeper each time. The area under the chin has been hollowed out making a straight line from the chin to the collar and along the neck creating a flat neck surface from collar to chin.

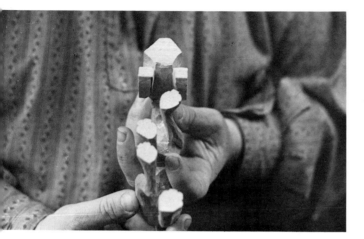

The most narrow knife with a turned down blade has been used to clean up the neck area.

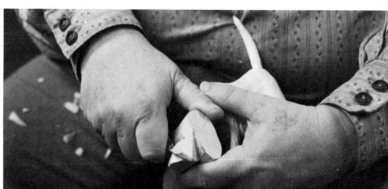

Shape the face and jowls. These hounds have fuller cheeks and a boxy muzzle.

Carve the eye area.

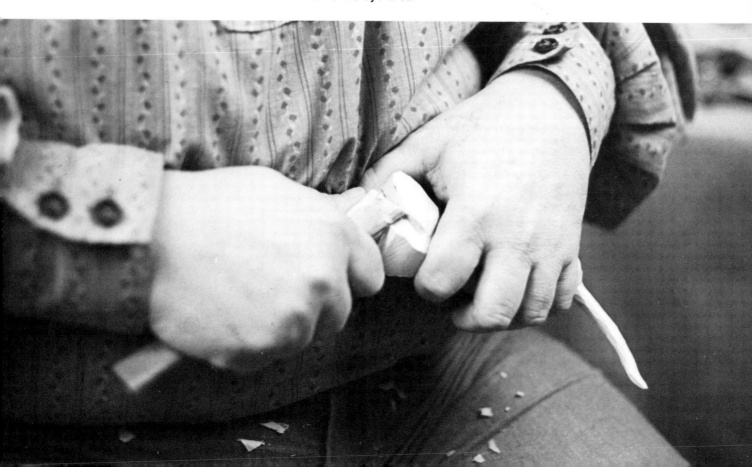

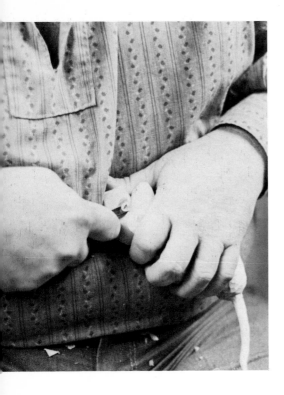

Change to a 3/16" gouge to hollow out the eye socket. Work from the top of the head into the stop cut at the ear.

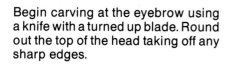

Begin carving at the eyebrow using a knife with a turned up blade. Round out the top of the head taking off any sharp edges.

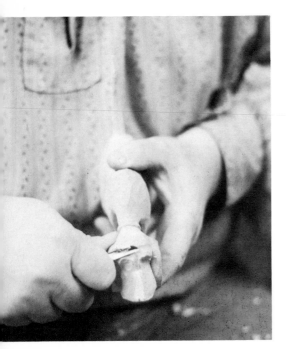

Carve from the bottom of the muzzle to hollow out the eyes.

Change to the 1/8" gouge and carve the dimple between the eyes at the bridge of the nose.

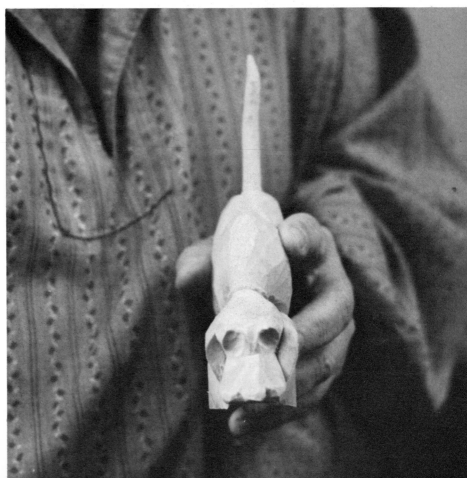

48

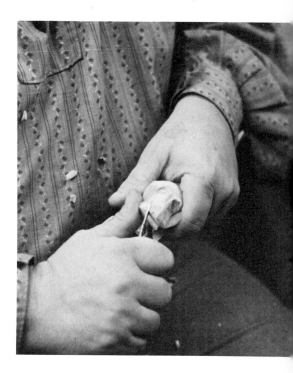

Carve a fold into the back of both ears also.

Using a knife with a turned down blade complete the ear by creating a fold in the front of both ears.

At the top of each ear chip out a notch between the two large folds.

To make the nose more prominent, make a stop cut into the front and cut a small notch from each side.

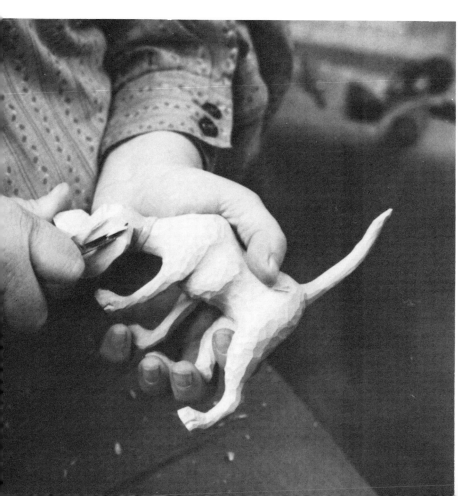

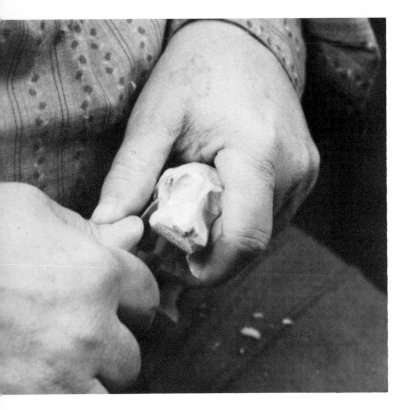 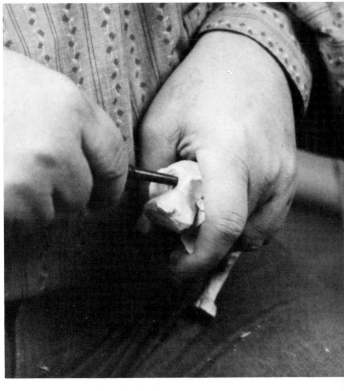

Use a long thin knife blade to cut out the front of the ears and give them a more floppy look.

Use the 5/32" nail set and make impressions for the left and right eyes. Remember to make the left eye first and line the right eye up with it that is, if you are right handed. A left handed carver will make the right eye first.

The completed face.

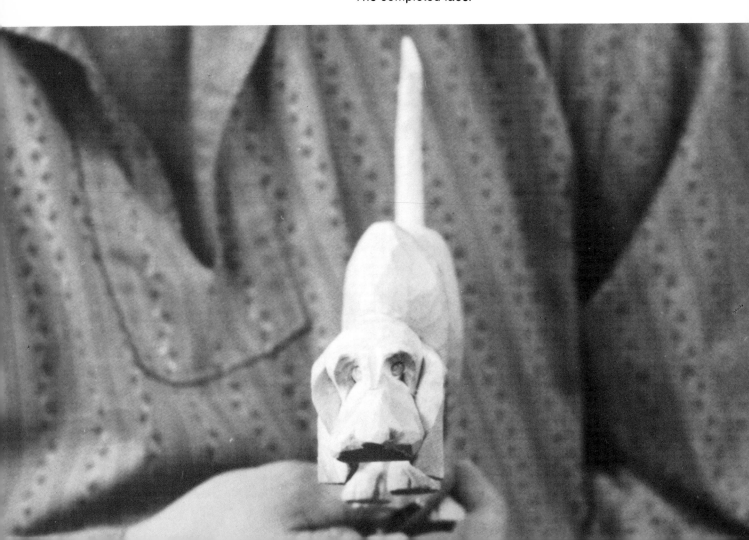

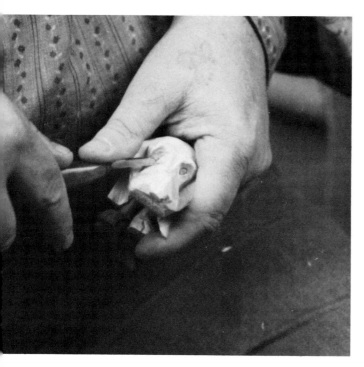

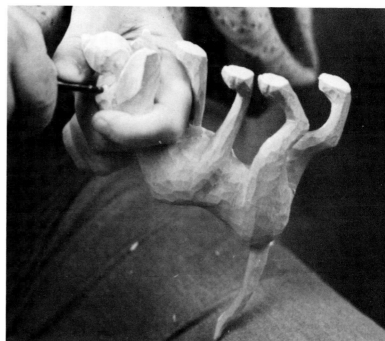

Take the thinnest knife with a turned down blade and a long clean point. Beginning at the corner of the eye make a notch and chip out just a little to create more eye dimension.

Use the nail set to redefine the eyeball and finish the eye. Use the 3/32" nail set to add the pupil. The eyes should be set a little close together and looking up to create a more natural appearance. However, the position of the pupil is up to the individual carver and the image that is being presented in the dog.

The completed dog.

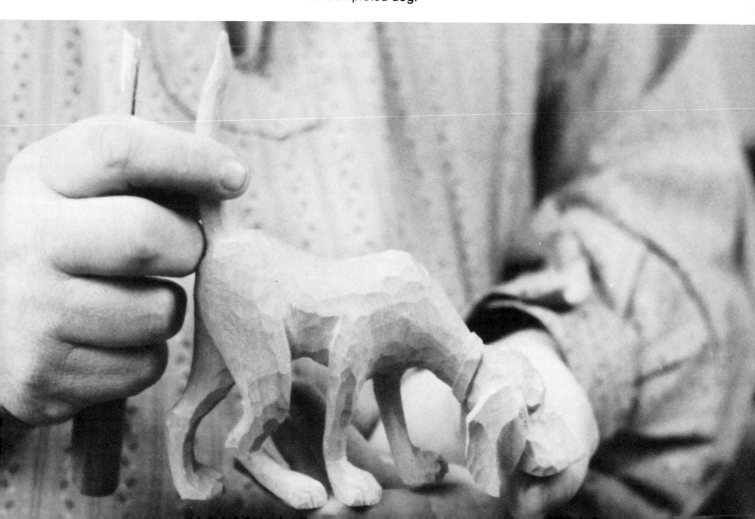

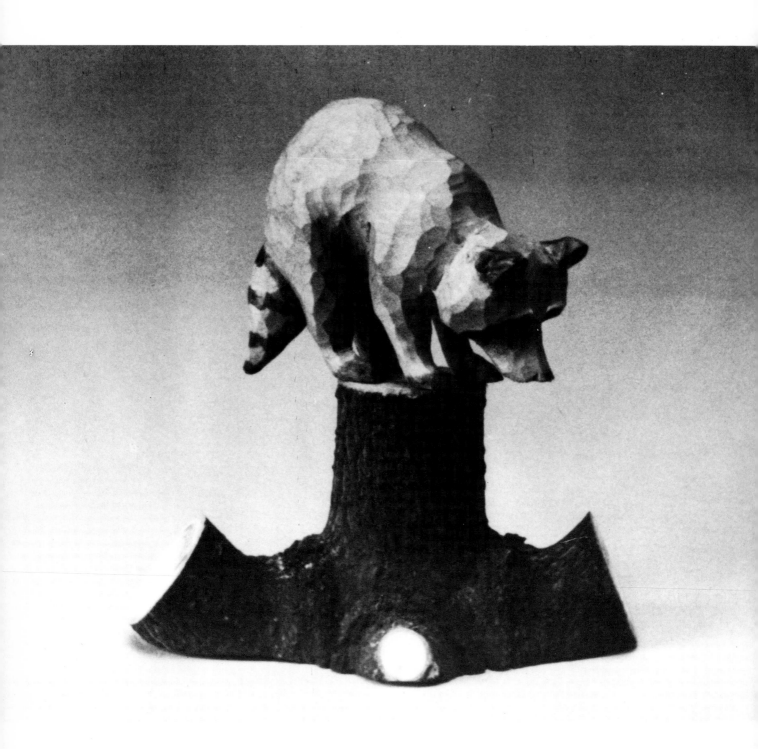

The Coon

Carving

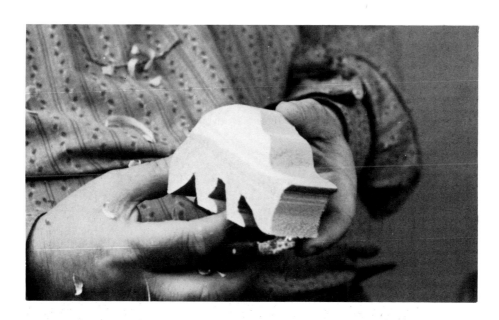

Using the bandsaw, separate the pattern of the coon from the rest of the wood.

Round off the back of the coon to make it easier to grip. The wood will pop off easily because of the direction of the grain. Round about half way around and halfway down the body.

Begin carving using a wide knive with a turned up blade.

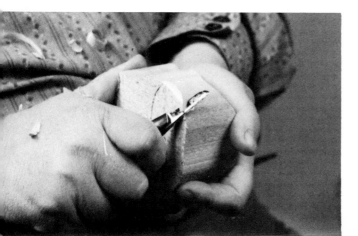

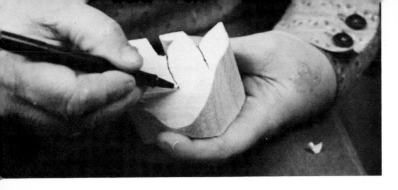 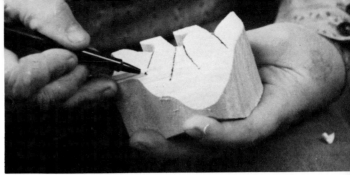

Draw in the legs on the coon.

Keep in line from the pattern all the way up the body.

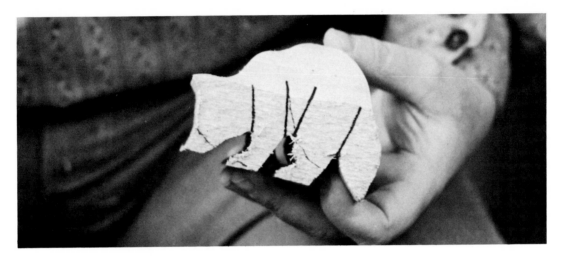

The back legs blend into the hips and the front legs into
the shoulder area.

Draw the tail starting with a line in the center where the tail will have its base. Add a curve to give it more character. Take advantage of the wood grain and put the tail where it is most effective as well as where it needs to be to avoid any flaws or problems in the wood.

Curve to either side as desired drawing a line on the left and right of the center line to create the width necessary in the tail. It is better to err on the side of too wide and reduce the size later.

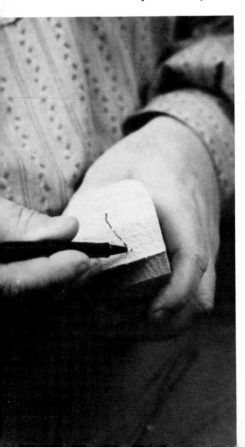 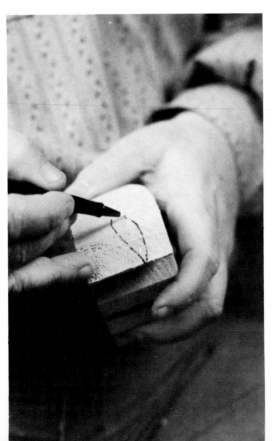 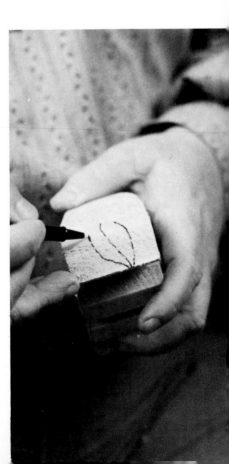

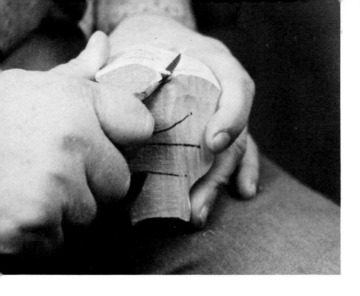 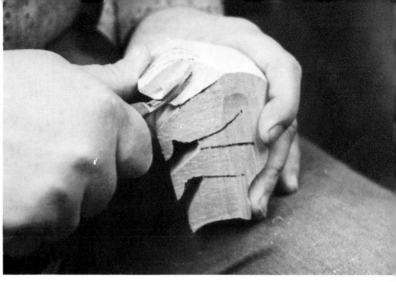

Using the marks on the back of the leg and tail as boundary lines, carve out the area inbetween.

Clean out the wood around the tail using a curl cut method.

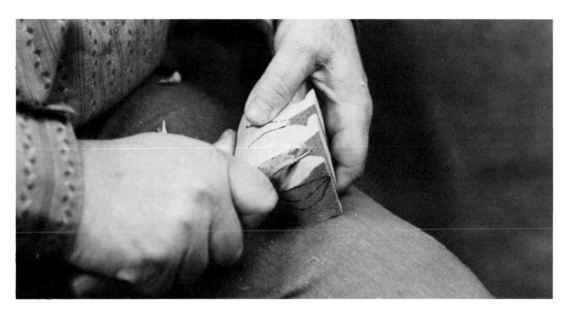

Also use the strait stop method of cutting along with the curl method to clear out wood. Repeat on both sides of the carving.

Using a knife with a turned up blade, round out the hips, as has been done here.

The tail has been completely carved out.

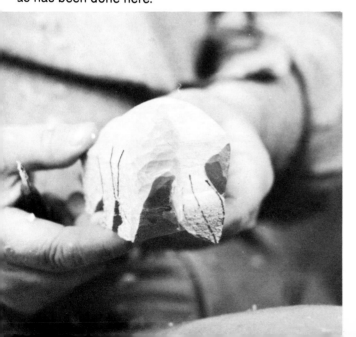 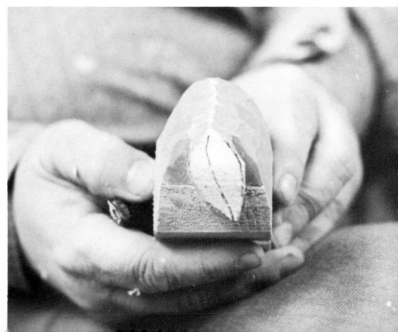

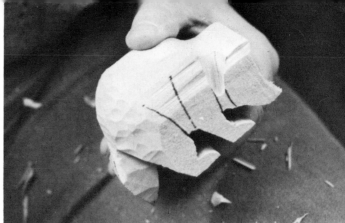

Draw a line from the ear to the back of the jaw bone. This again will serve as a boundary to prevent cutting too far.

Change to a strait wide knife with a turned down blade. Carve out a V shape gully between the shoulder and the jaw bone which can be seen here.

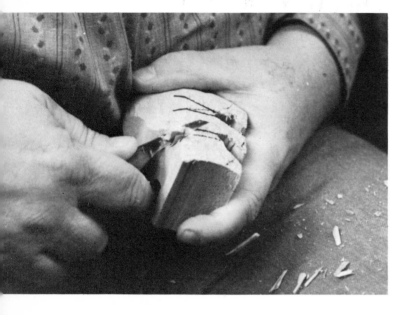

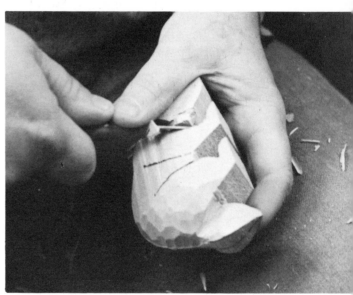

Carve into the actual depth of the neck size. Carving from the top of the neck toward the shoulder.

Carve from the bottom of the carving for the underside of the neck. Remember that coons have quite thick necks.

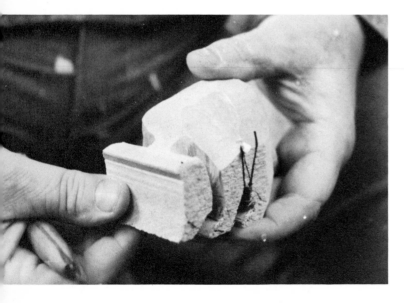

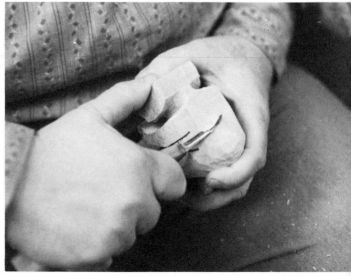

Round off the shoulders with curl cuts along the natural shoulder line.

The carving is done in relation to the slope of the shoulder and the boundary lines.

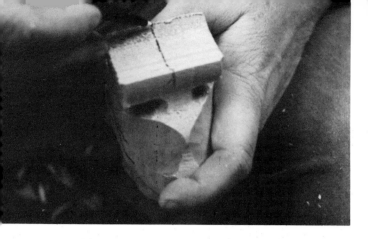

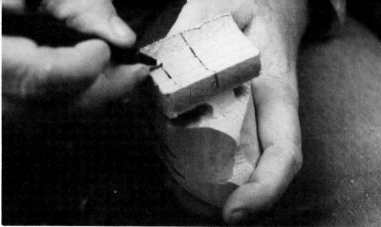

Draw a line down the center of the face as a frame of reference to help keep the carving symetrical.

Use your finger as a gauge to measure how much to take off of each side of the head and draw the necessary line.

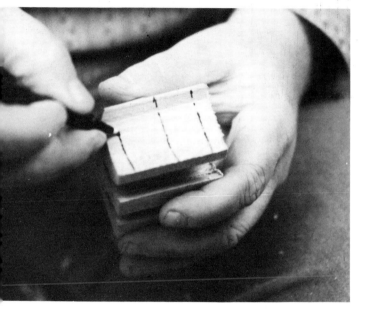

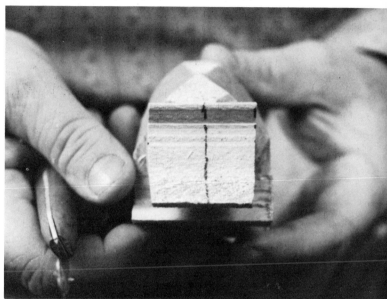

Remove roughly ¼" from both sides of the head as indicated by the lines. Make the head slightly oversized to increase the character of the coon.

The sides of the head have been carved away following the drawn lines.

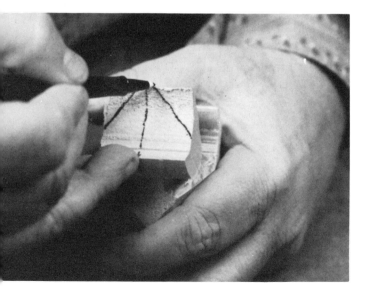

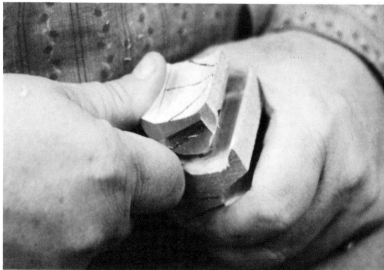

Draw a line along the eyebrow to the end of the nose.

Remove the excess wood.

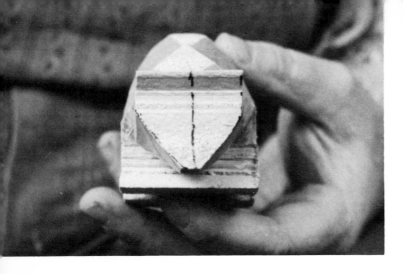

The shape of the face begins to emerge.

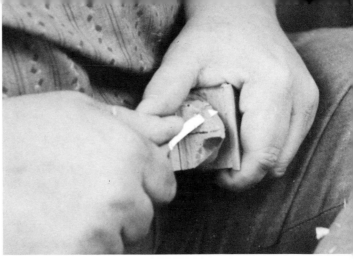

Using the curl cut, define the eye sockets.

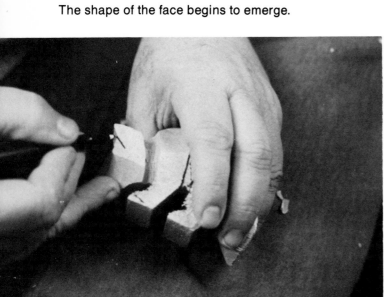

Draw a line to the front of the ear.

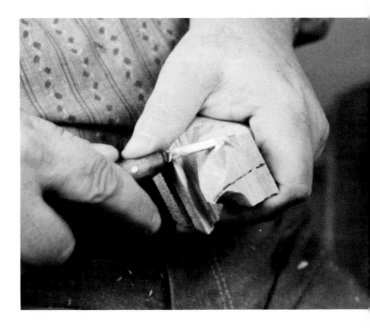

Cut off everything that doesn't look like a coon. Carve from the eye area down to the top of the nose as has been done here.

On either side of the center line drawn earlier on the face, draw an additional line. This will designate where to carve the space between the ears.

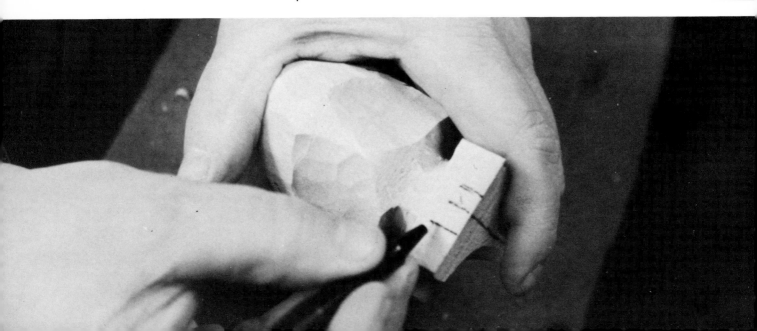

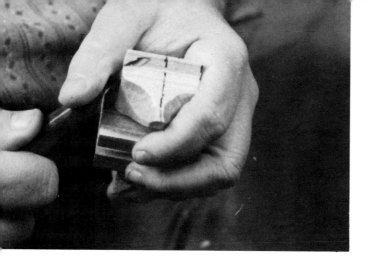

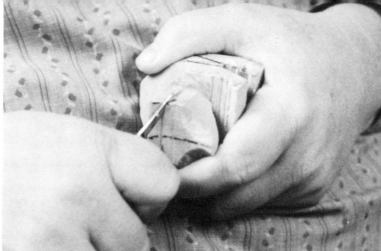

Change to the knife with the thin turned down blade and make a strait incision down the front of the ear.

Round the eyebrow and head away from the ears. Create almost a flat diamond face area.

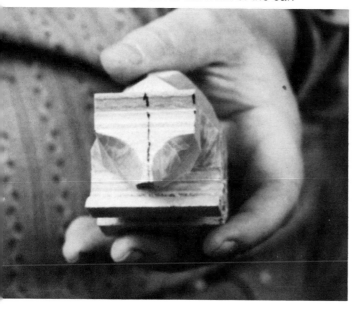

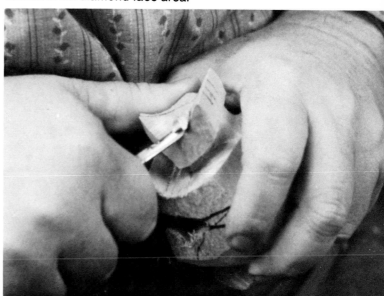

Round out the bottom of the muzzle and create a long thin nose. The face begins to be defined in the carving.

From the lines drawn, carve out the ears. Make a strait line cut at each of the outside lines.

Carve into the lines from either side and remove all the wood between the ears.

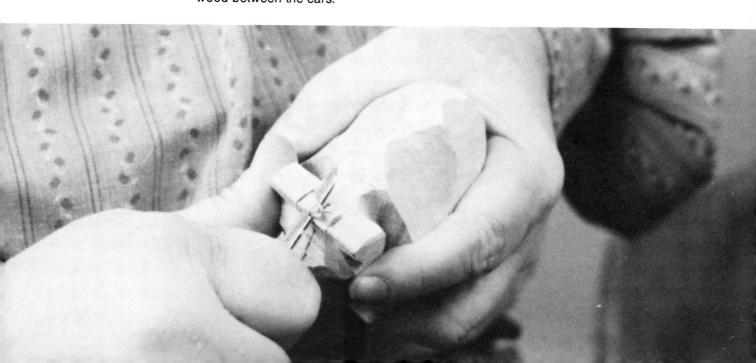

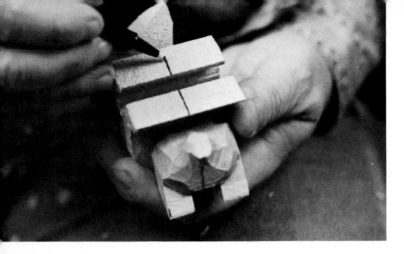

Draw a line down the center of the bottom of the paws.

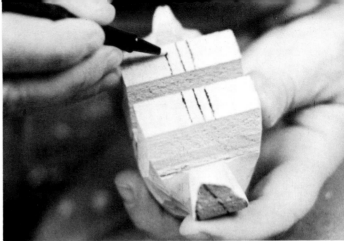

Draw a line on either side of the center line.

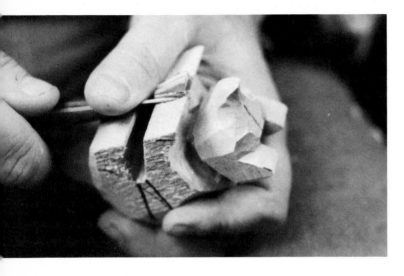

Here it is crucial that the grain is running the length of the coon. If not, it is impossible to chip out this area between the paws and legs. Carve and chip out the V shape between the front and back feet.

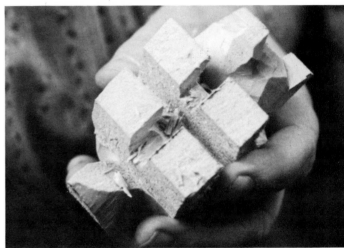

Use a knife with a turned up blade and carve a V between the feet to start opening up the area between the legs.

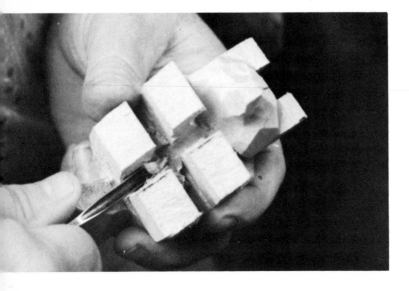

Use the ⅛" gouge to clean out the area between the legs. In the front carve from neck to stomach and in the back carve from tail to stomach. Carve an even line all the way down to the stomach.

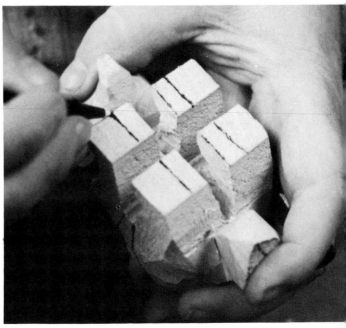

Draw a line about ¼" from the inside of all four paws.

60

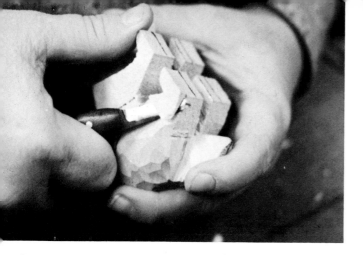

Cut off the outside remaining wood. This brings the feet in closer giving the body a more round appearance.

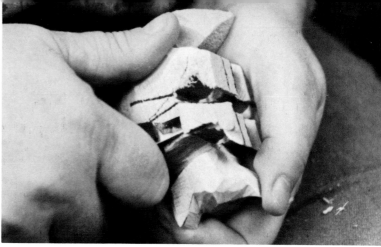

Begin about half way up the leg, carve down towards the paws removing the excess wood from the front and back legs.

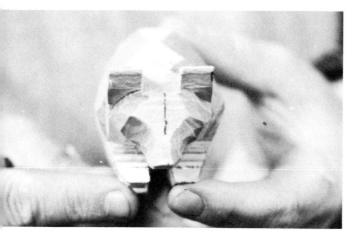

Repeat on the other side of the carving. It should look similar to this. The wood should be popping off because of the direction of the grain. Always put ears at the end of the jaw bone for consistent accurate placement as has been done here.

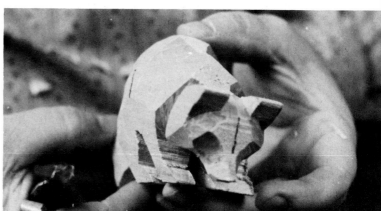

A curling motion was used to shape the back of the ear and contour it into the jaw bone. While carving keep looking at the head and ears to make sure the porportion and location are correct and the way you want them. The eyes are created by using the 3/16" gouge to carve out the eye and socket area. The technique is the same as used in carving the dog's eyes. A stop cut on the end of the nose and a small notch on either side creates the coon's nose.

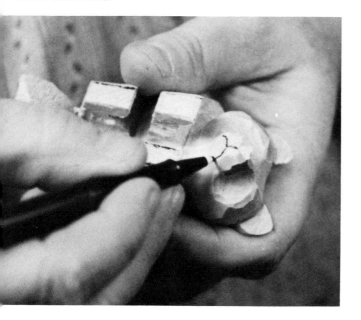

Draw lines for the mouth and lips on the underside of the head.

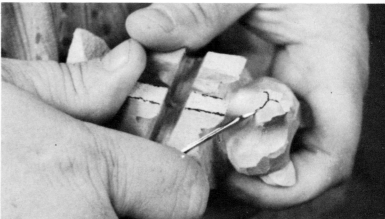

Take the narrow knife with a turned down blade to make the cuts in the lines. Rock all the way down to the end of the lip line.

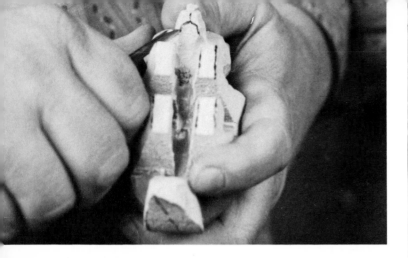

Under the jaw and behind the line, notch out a small lip area with a knife or a veiner. Either tool may be used.

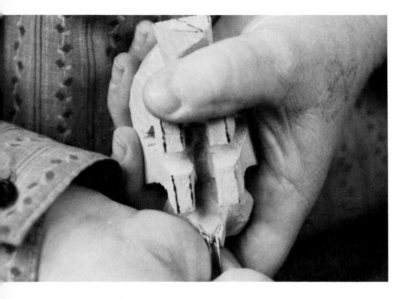

Carve out the lip areas.

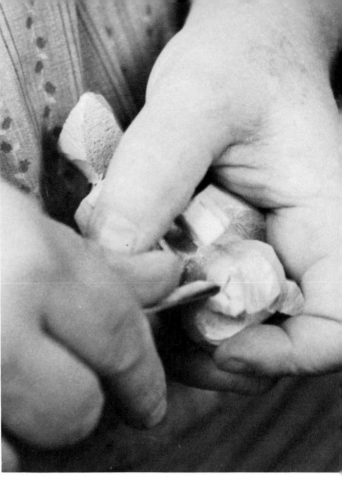

Carve out a clef between the top lip and nose.

Remember to keep the stomach rounded. Keep the area in the middle thick and carve out along the sides. The rounded body and stomach give the illusion of fluffy fur.

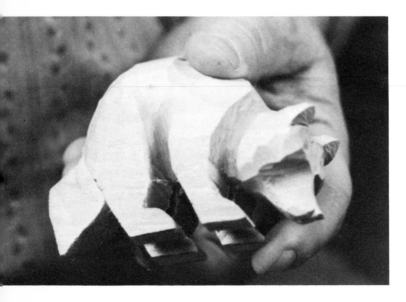

If necessary, reestablish boundary lines on the side of the coon body before starting to carve out the area between the legs and into the stomach.
At the lines cut into the body and chip out the area under the stomach.

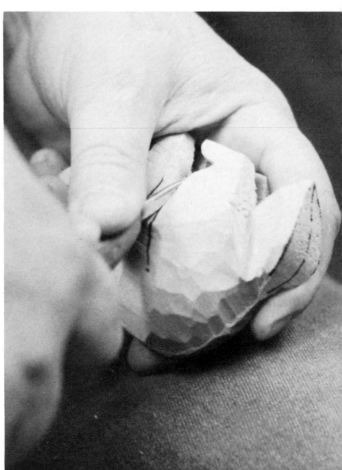

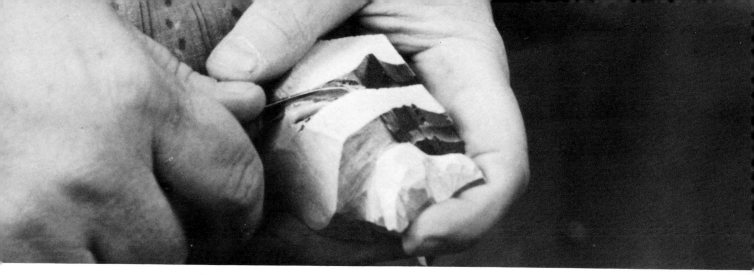

Open up the area on the inside of the front of the back legs and the inside of the back of the front legs. The back feet should be angled out and the front feet should be angled inward.

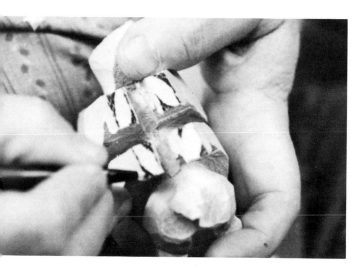

Draw the feet on the bottom of the paws to create a uniform size. Choose the paw that would be the smallest as a guide. The darkened area will be carved away.

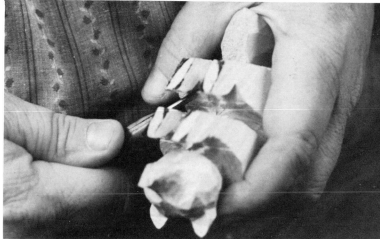

Carve out the inside of the legs and underside of the stomach.

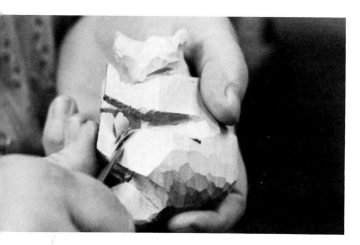

When starting to carve the paws, take small cuts because the grain is such that it makes this more breakable. Take small cuts around the outside of the paws.

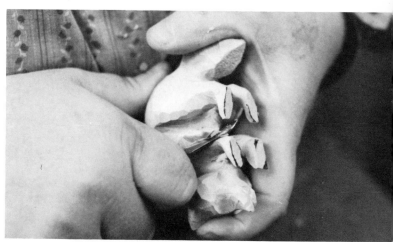

Round off the front legs and all four paws first to keep stablity in the back legs. When holding the carving in the left hand, don't hold too tight, the cross grain in the legs can make them fragile.

63

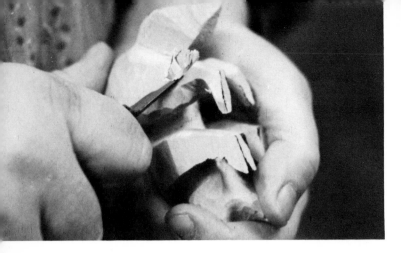

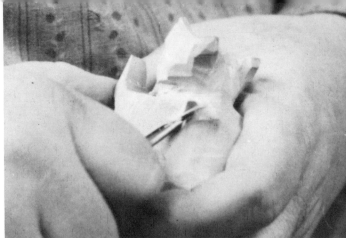

Begin at the paw and carve up toward the hip to round out this area.

Round off the shoulder area and the front legs from the shoulder down to the paws.

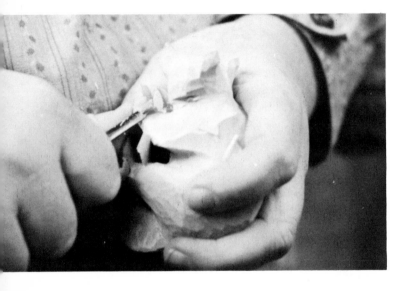

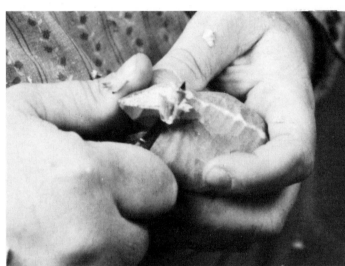

Finish carving the inside of the legs using the knife with a turned down blade. To keep proper proportion and contour of the legs keep turning the coon to keep all areas symetrical.

Round off the tail, keeping its appearance bushy and full. On the front of the tail carve it down toward the bottom.

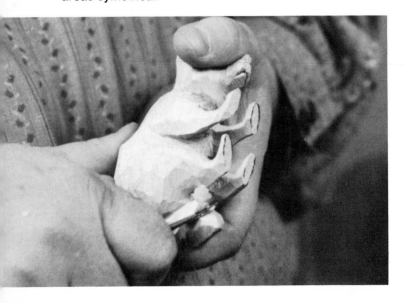

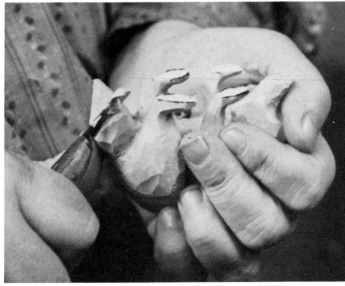

On the back of the tail, carve from the bottom of the tail to the base.

Round the tail to a point at the bottom. Using a knife with the blade turned up, finish off the carving and clean up any uneven areas.

64

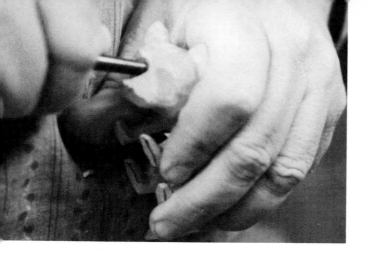 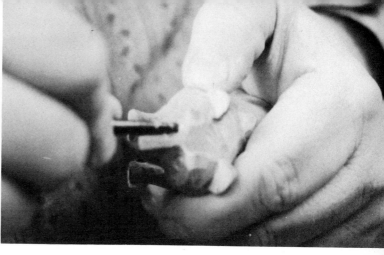

Use the 5/32" nail set and push it in the eye socket space making the necessary impression.

Use the 3/32" nail set in the same way to make the pupil.

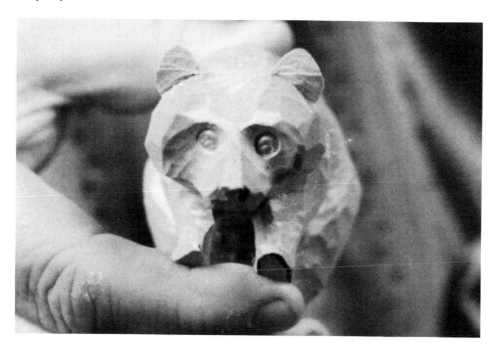

The completed coon carving.

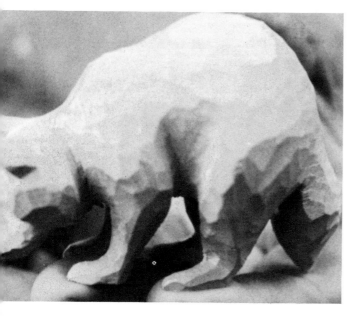

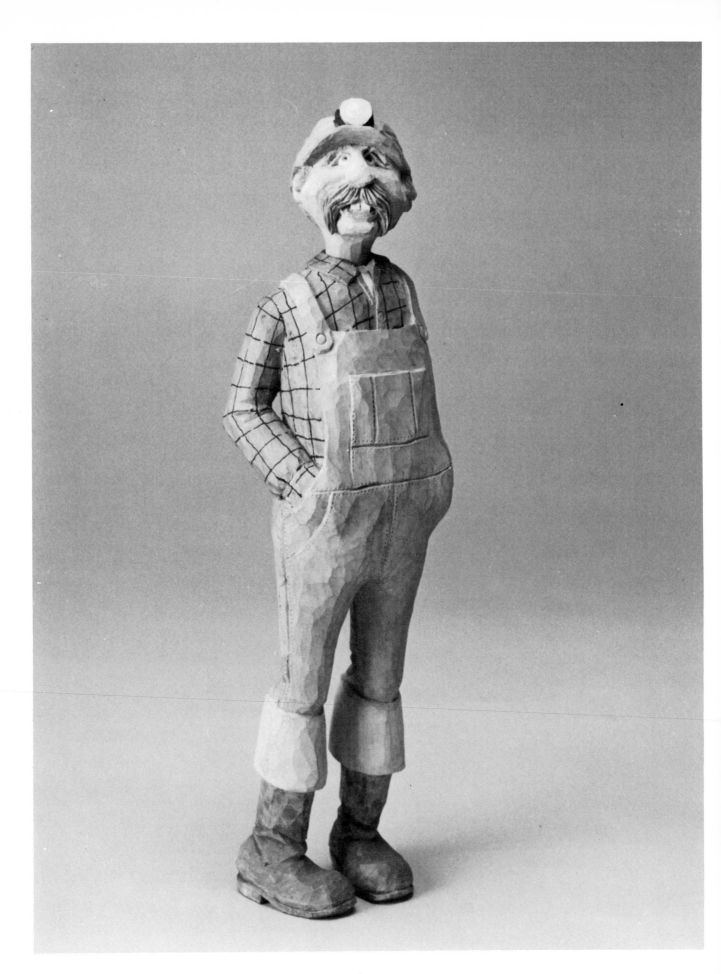

The Coon Hunter

Bandsawing and Drilling

Band saw the tracing of the man's body to create the blank.

With the felt tip pen, draw a line down the center of the body from the crotch to the bottom of the feet.

Completed profile.

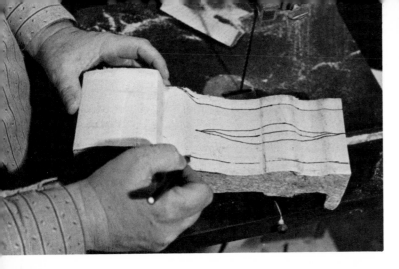 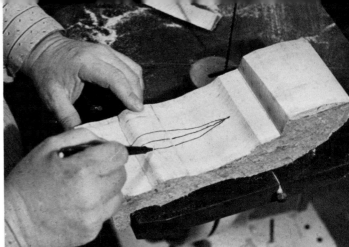

Draw the outside leg lines from the pocket area down to the end of the carving.

Draw a curved line around each side of the center line to create a guideline for the inside edge of the bow legs.

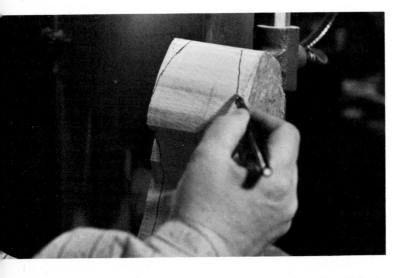 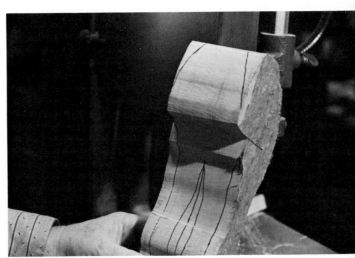

Toward the elbow the area becomes wider. Remember variations create individual characteristics so do not worry if the drawings are not exact. Keep the wood in this area wide for carving.

The elbow area will be the widest part of the carving as the arms need to stick out. The shoulders narrow at the top. Draw the necessary guidelines.

Band saw along the lines between the legs.

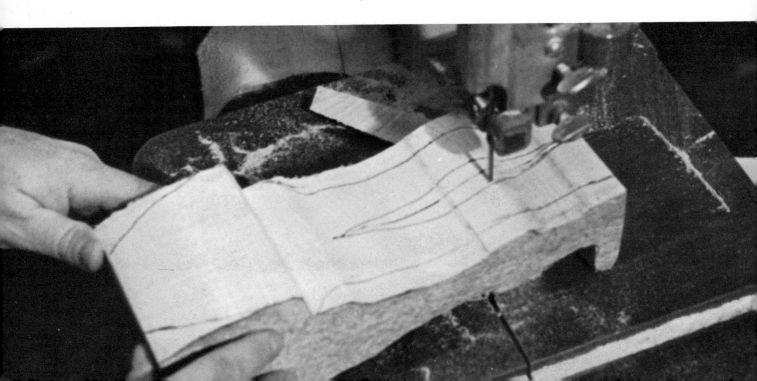

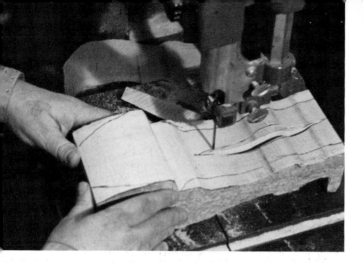

Saw away one side and then the other.

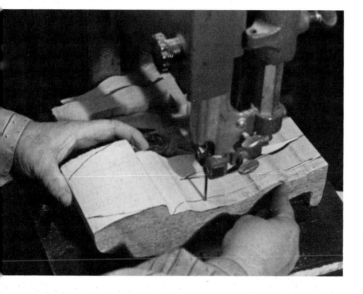

Remove the excess wood along the outside of the legs.

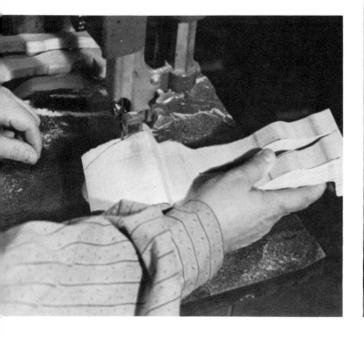

Remove wood along the outside of the arms.

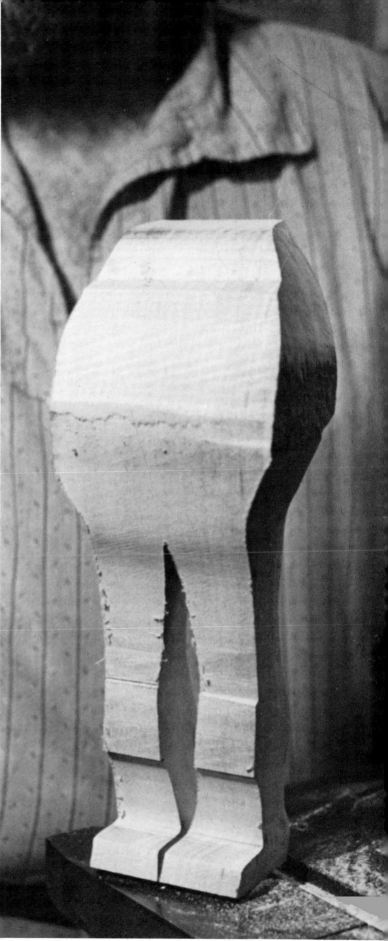

Completed man's body blank.

Saw out the profile tracing of the head.

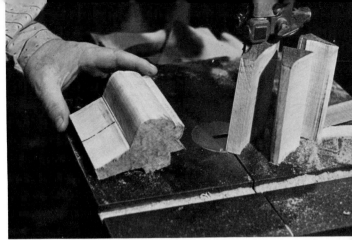

Draw a line down the center of the neck.

Using this guideline draw a line on both sides of the center line down the neck. Be careful not to make the neck too thin, it is better to overcut than to undercut when in doubt.

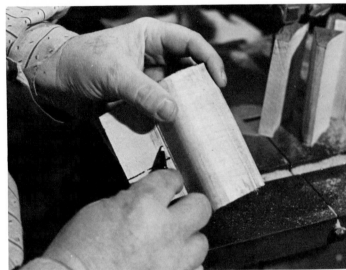

The neck should be as wide as it is thick. Using the end of the pen as a guide, measure the thickness of the neck.

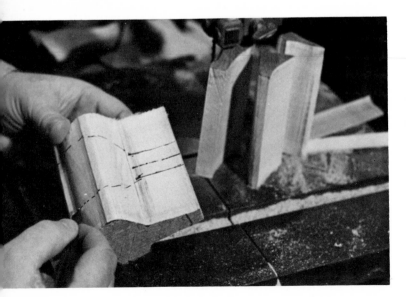

From the neck lines draw the outline of the head.

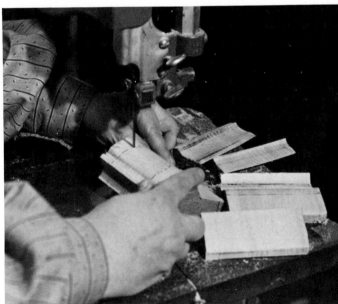

Using the band saw remove all the excess wood on the sides of the head.

Use the width of the neck as a guide to the correct size of flat chisel bit to use in the drill.

Drill into the top of the body, far enough to accomodate the length of the neck, or roughly 1-1¼".

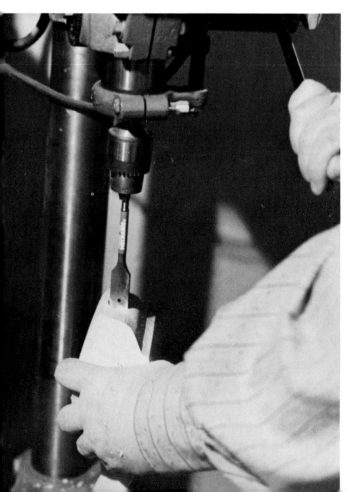

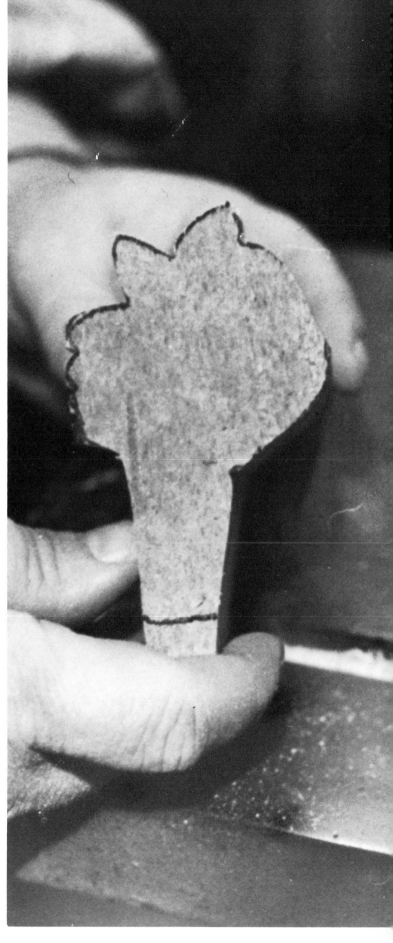

Final blank of head.

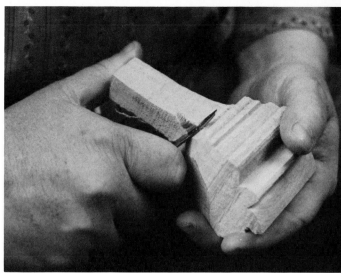

Use a knife of medium width and a turned down blade to carve down the length of the neck as is necessary to fit it into the body. Keep the neck long so there is more to hold on to while carving.

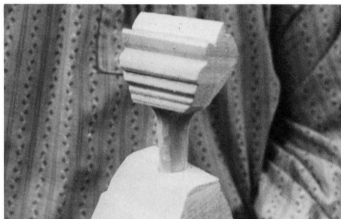

Place the head onto the shoulders once a rough fit has been achieved.

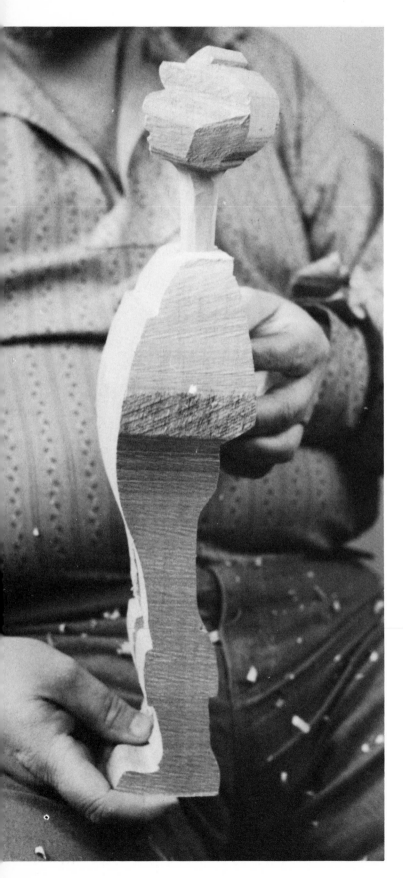

Fit the neck into the hole drilled in the top of the shoulders of the body.

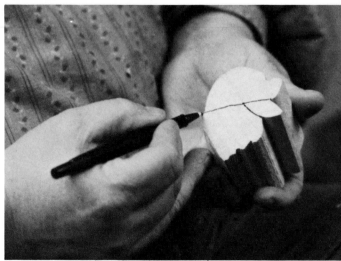

Taking the head only, draw the lines of the hat on both sides. These will be used as guidelines for carving the face.

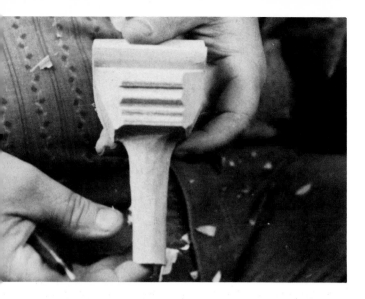

With a turned up blade, begin to carve the side of the face by trimming the cheeks.

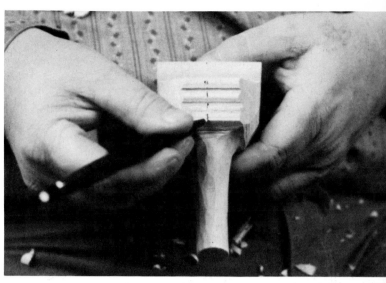

To keep the carving even on both sides, draw a guideline down the center of the face.

Begin to carve the outline of the hat. Make a strait cut at the line marking the bill of the hat.

Carve out the top of the head.

Carve into the stop line at the bill.

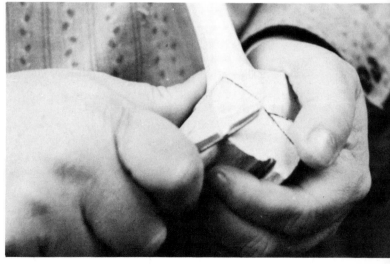

Carve out the cheeks and around the face.

73

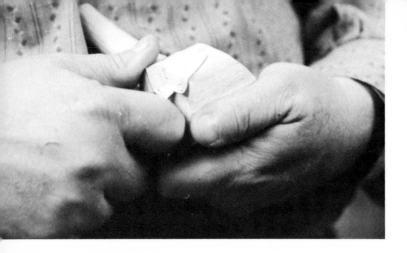

Vary the carving direction to keep the look more uneven and interesting. Avoid carving the cap too flat or too sloped.

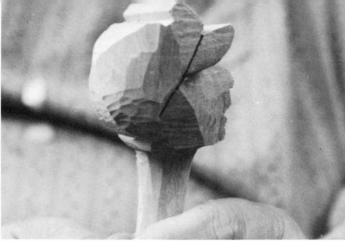

Round out and shape the back of the head. Begin on one side and then work around to the other side.

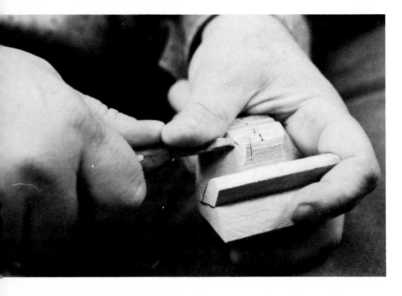

Carve away the excess wood from the face to make the nose stand out.

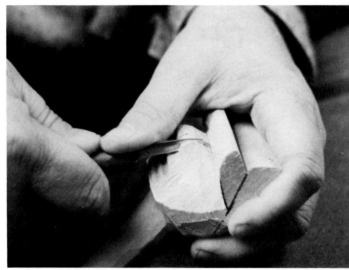

To begin the nose, make a slicing cut ¼" from the center line on both sides.

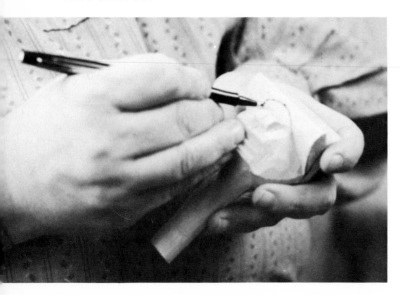

Draw a guideline along the cap that will be carved away to produce the forehead and space for the eyes.

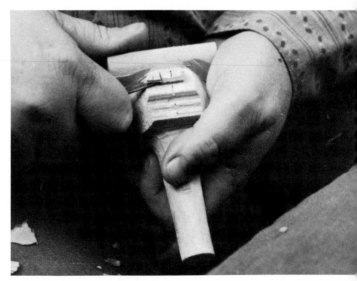

Make the nose wide to allow for shaping.

74

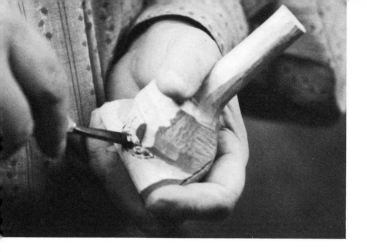

Use the ⅜" chisel to carve out the underside of the bill of the hat.

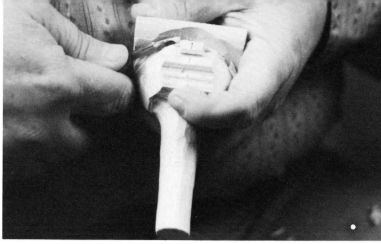

Change to the knife with a turned down edge to clean out and widen the chiseled area.

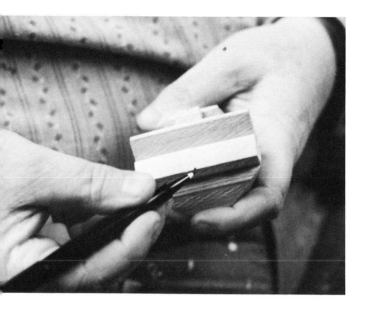

Draw marks on the top of the cap for the positioning of the miner's style lamp.

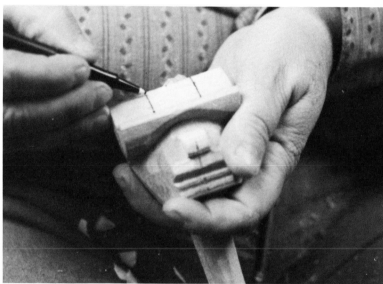

Using your finger as a guide, draw an even line on both sides of the center of the cap.

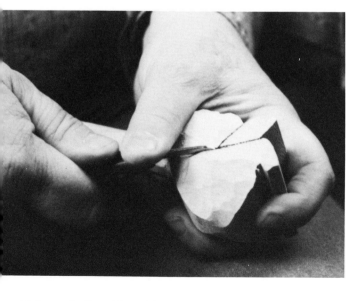

Using a knife with a thin turned down blade, cut all the way around the band of the cap.

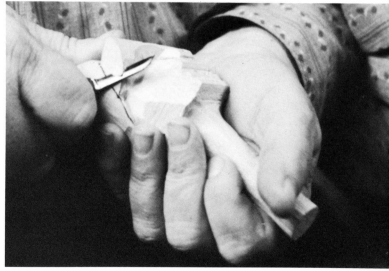

Shape the brim of the bill.

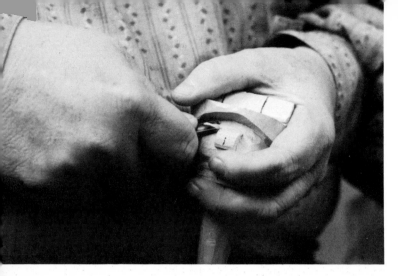

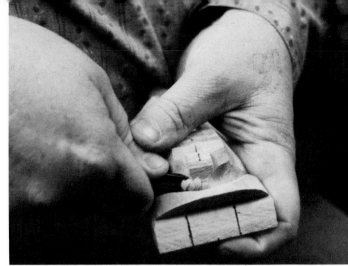

Using the gouge, remove the wood from the sides of the nose.

Take the 3/16" gouge to make the sockets for the eyes. Gouge out the necessary wood.

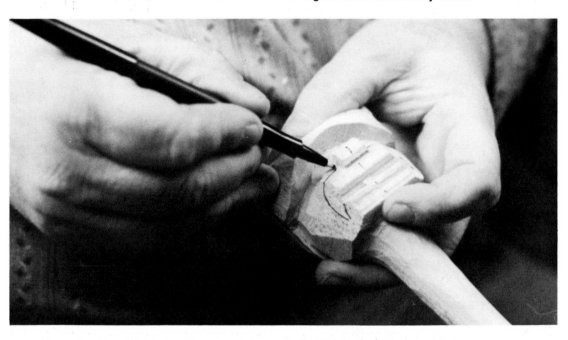

Draw in the mustache. Begin just beyond the end of the nostils.

Outline where the mustache goes on the face.

Cut a straight stop cut on the flat part of the cheek.

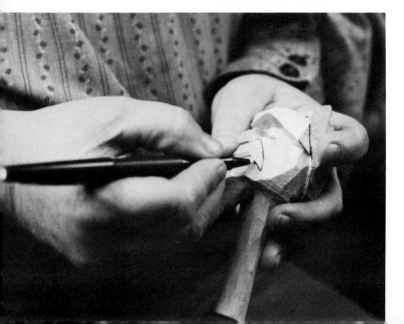

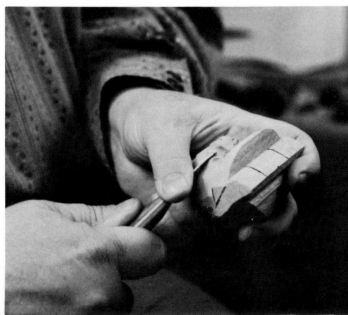

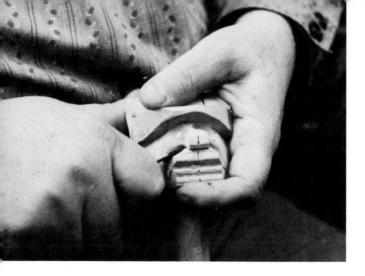

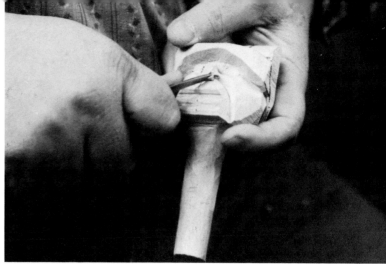

Carve away the wood within the drawn lines and make space for the mustache, indenting slightly above the mouth.

Chip away a notch at the balloon part of each nostril and round out the nose.

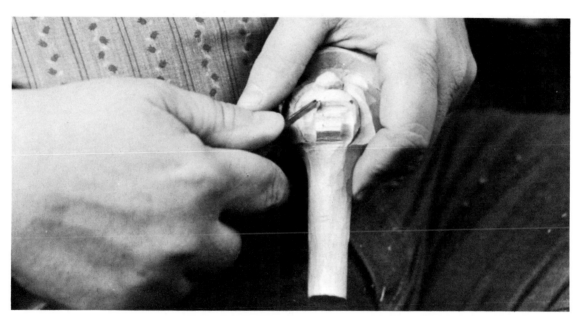

Change to the 3/16" gouge and gouge out the inside edge of the mustache from the nose to the chin.

Repeat on both sides as has been done here.

Using a knife with a turned up blade make a straight cut around the mustache.

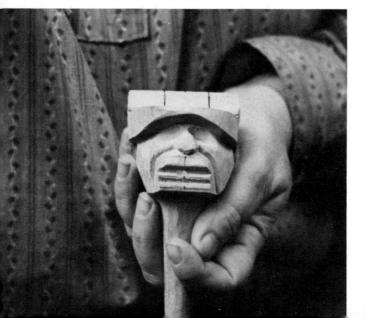

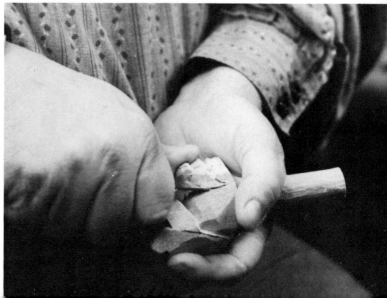

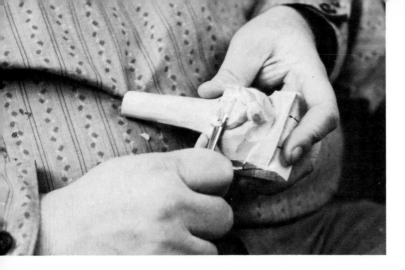

Carve out the mustache area.

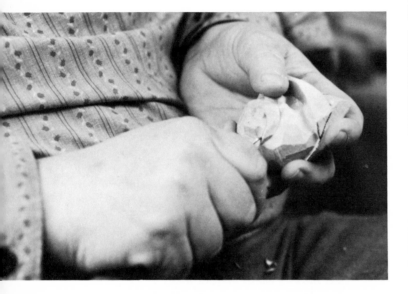

Make a straight cut along the sides of the lips and mustache.

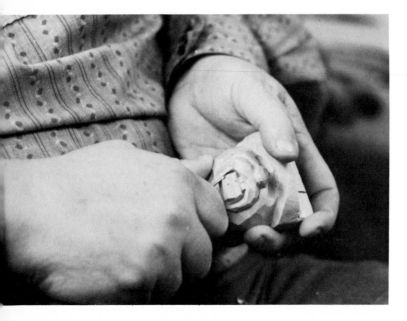

Carve out the excess wood.

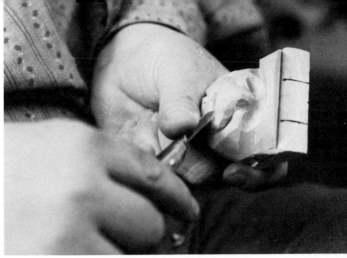

Change to a thin knife with a turned down blade and carve the mouth. Decide whether there will be teeth or just lips. In this case the carving will have buck teeth.

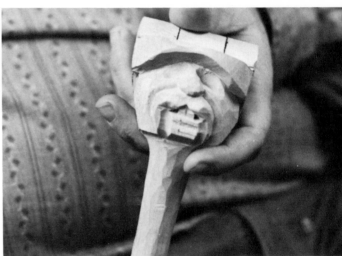

A notch is cut on the other side and a space carved out on either side of the center portion of wood, which creates the teeth. A straight cut in the center of the teeth separates the two front teeth which you can see.

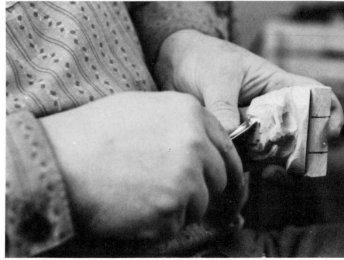

Changing back to the gouge, carve around the lips.

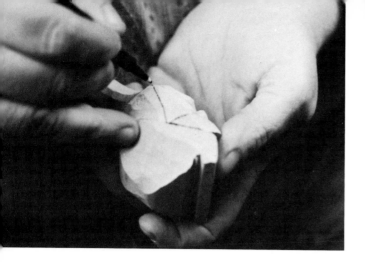

Draw the ears. Make a straight line from the point where the bill meets the cap, down to the throat.

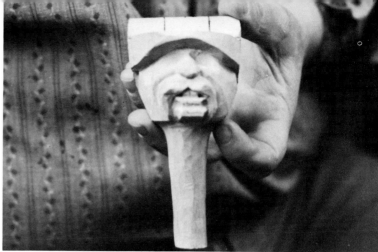

Using a thin knife with a turned down blade, finish the face and mustache as has been done here.

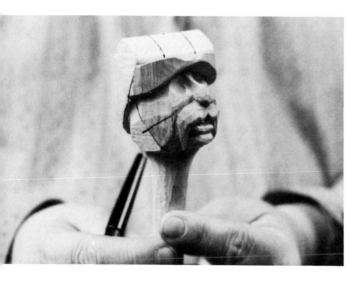

The second line extends from the corner of the bottom of the nostril to the top of the jaw bone.

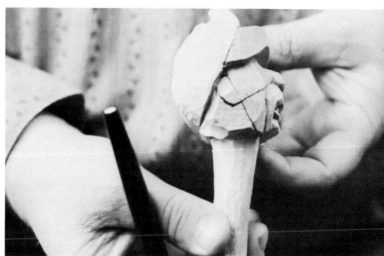

The top of the ear should be in line with the eye. Depending on the size of the ear desired, draw it within the guidelines.

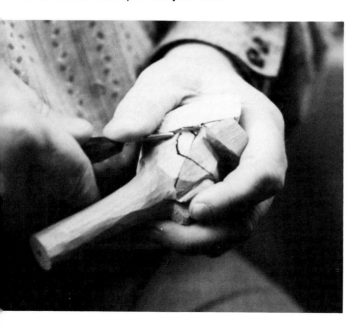

Make a straight line cut behind the ear.

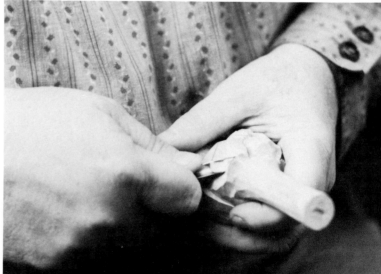

With the 3/16" gouge, carve along the jaw line and create a demarcation between the jaw and neck.

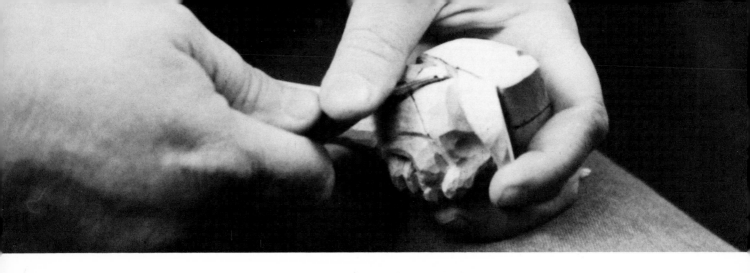

Use a small knife with a turned down blade to notch out the spot just above the ear and below the cap.

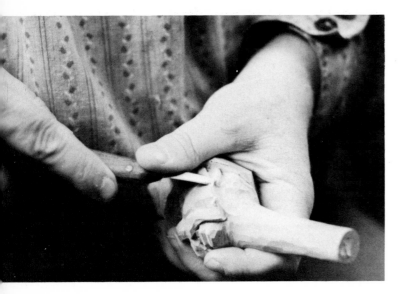

Carve out the shape of the inside of the ear.

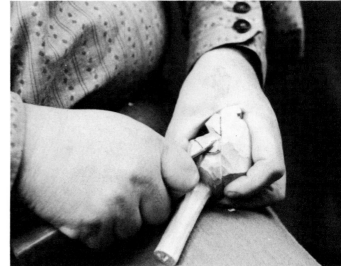

Cut a line straight down the back of the sideburns.

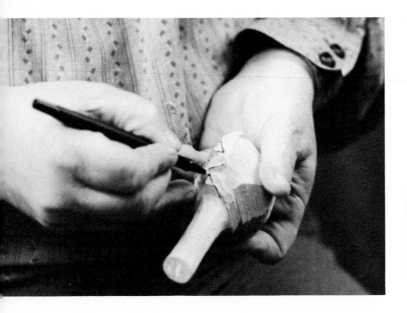

Draw a line from the back of the ear around the bottom of the hairline. This will keep the cutting straight.

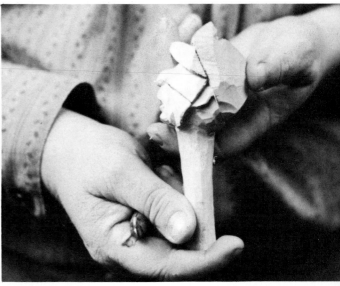

Carve out the back of the ear and jaw.

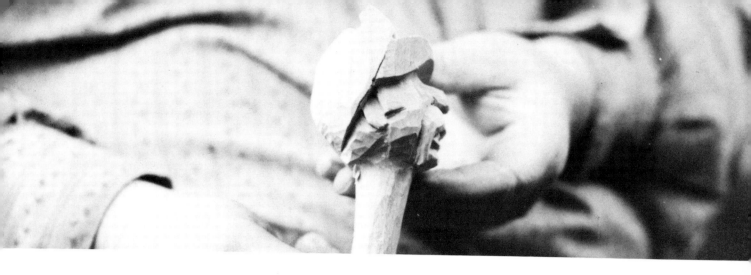

Continue around and carve out the hairline.

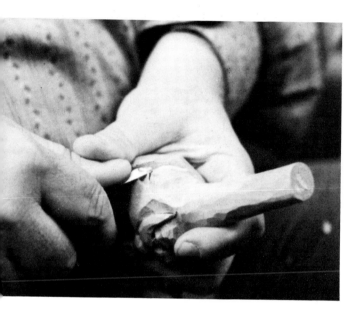

Make a notch for the ear lobe.

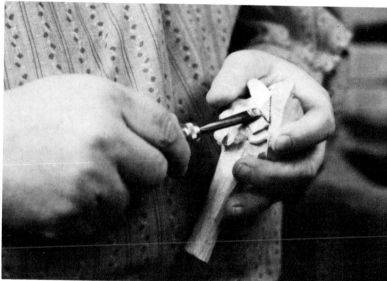

Use the 3/16" gouge on the inside of the sideburns carve up to the bill of the cap. Make an indentation at the side of the top of the head where it meets the cap.

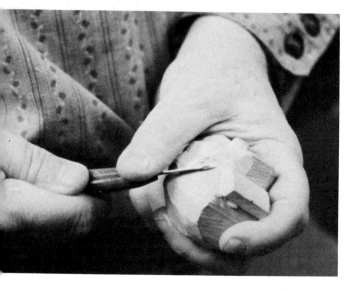

Change to a knife with a straight turned down blade, make a straight cut into the gouged out area at the forehead.

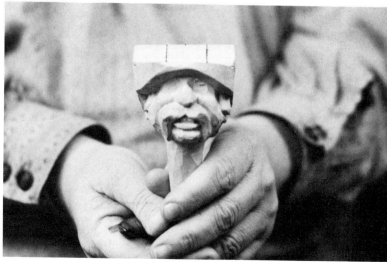

The excess wood around the forehead and brim of cap have been carved away.

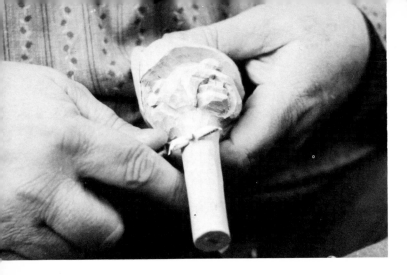

Using a knife with a turned down blade, thin out and shape the neck as is necessary.

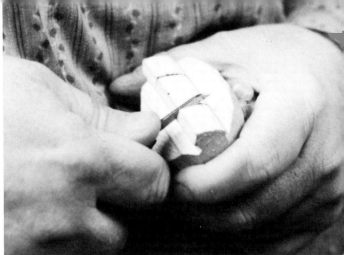

To make the spot light, begin with a deep incision into the lines on the top of the cap.

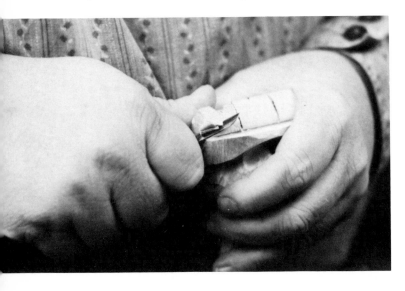

Carve from the outside into the stop lines. A gouge and knife together may be used to whittle away the wood around the outside of the lamp boundaries.

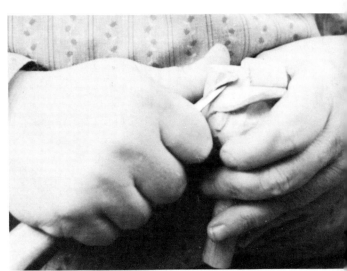

Trim and thin out the cap as needed, make the seam around the cap more prominent.

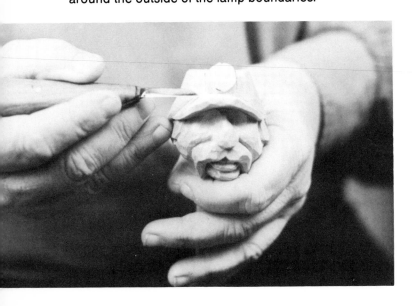

Trim off the excess wood from the top and bill of the cap on both sides.

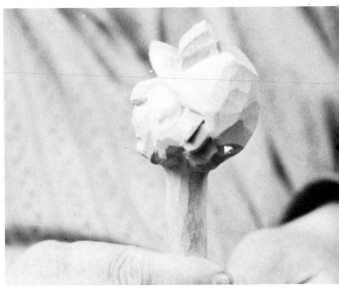

Round out the cap.

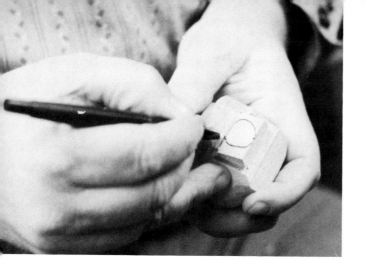

Draw a circle for the front of the light. This can be done freehand or with a compass.

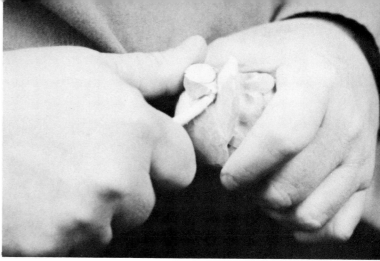

Using a knife with a turned down blade, round out the head light as it sits in its box on the cap.

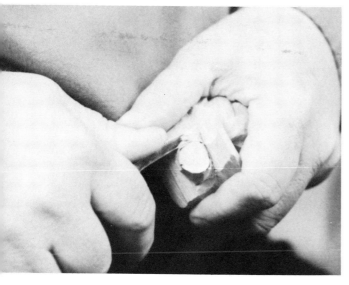

Leave room under the light to carve the box that holds the head light.

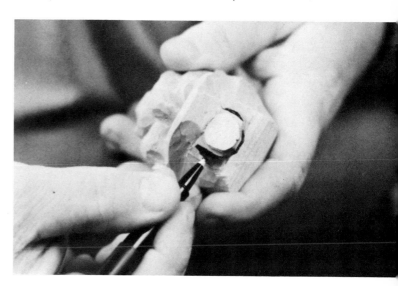

Draw the areas to be cut off on the box. The shaded areas will be carved away.

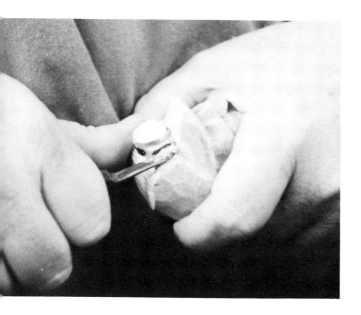

Make straight cuts and chip the shaded areas.

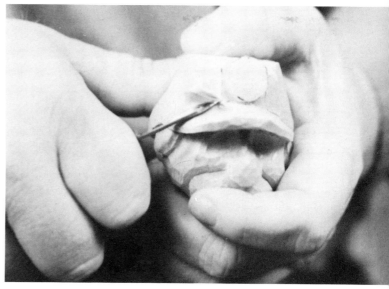

Make any necessary adjustments to the caps to create the desired look.

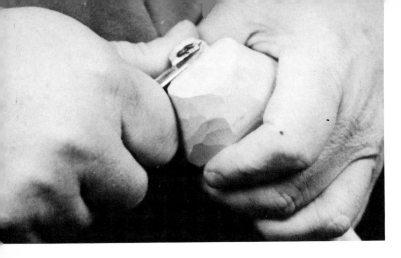

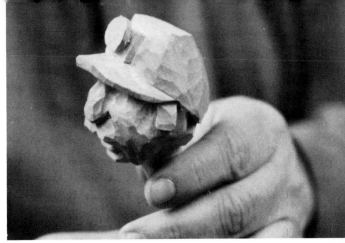

Carve out the top of the light and the box around it. The spot light is used to see coons up in the trees. When a hunter looks up in the tree the light shines up and spots the coon.

The completed cap and spot light.

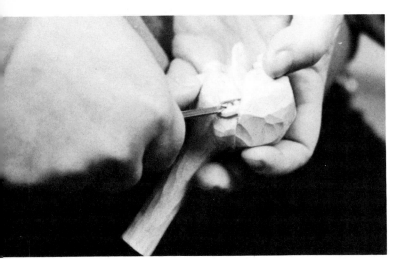

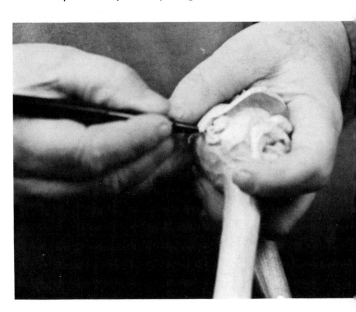

Draw two triangle shapes into the inside of the ears. Notch out the triangles in each ear as is shown.

Carve a line along the outside of the ear lobe. Mark the inside contour of the ear lobe on both ears and carve it in.

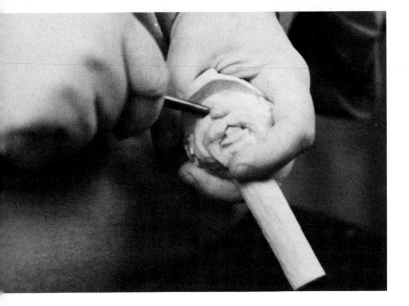

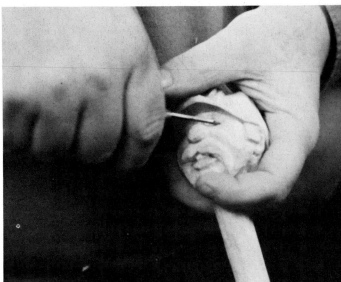

Use the largest nail set to make the eyeballs. Push it into the eye socket and twist it to make the needed impression.

Using a narrow knife with a turned down blade, notch the outside of the eye.

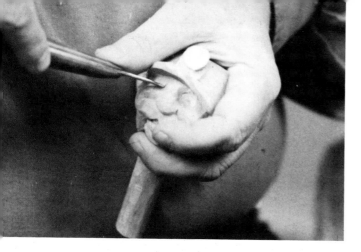

Make a small notch on the inside of the eye to give the eyeball depth.

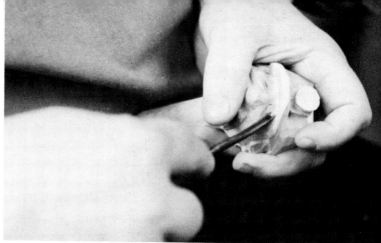

Change to the small veiner and make folds above the eye to create the eye lid.

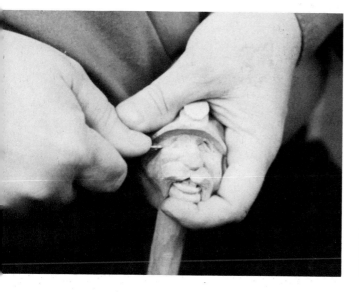

Using a thin knife with a turned down blade add "crows feet" on the outside edges of the eyes. Do not use a veiner for this because it would chip and fuzz up the area. The knife will make clean cuts.

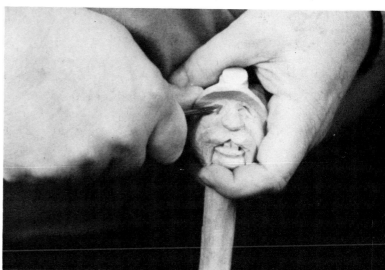

Finish the line that covers the lid on the inside of the eye.

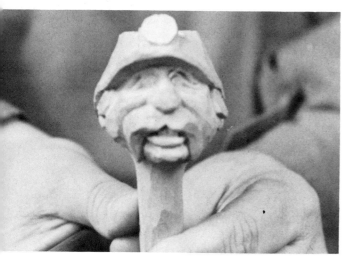

Use a knife with a turned up blade to finish off the cap and round the carving. Remove any saw marks as has been done in this case.

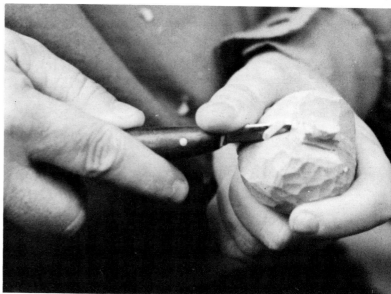

Add folds or creases in the front of the cap to make it look more realistic.

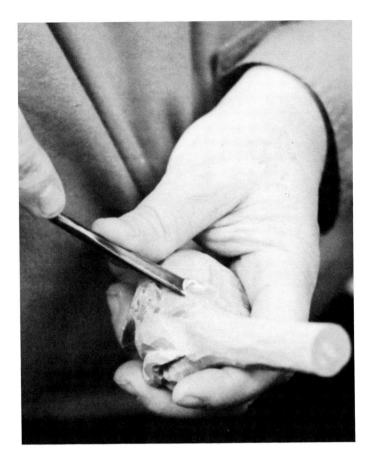

Use a heavy veiner to go around the hairline and highlight dominent parts of the hair.

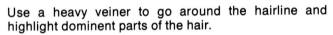

Begin with the large veiner on the middle of the mustache.

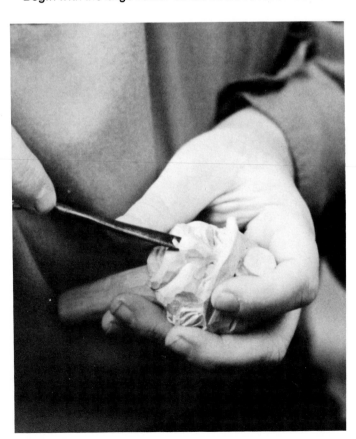

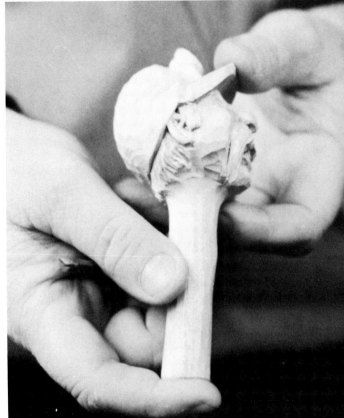

Use the small veiner to add detail around the hair and sideburns, remembering how hair actually falls. On the sideburns, hair grows from the front to the back. Make long flowing cuts in the sideburns. Use the same cutting technique on the hair.

Change to the knife with the turned down blade and trim off wood where the mustache meets in the middle.

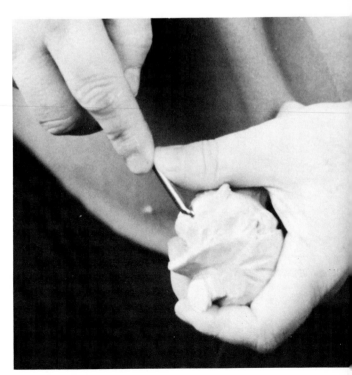

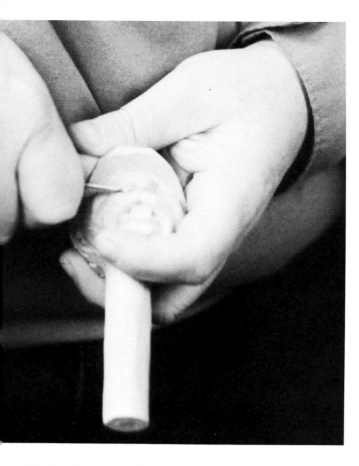

With the thin bladed knife, clean away the extra wood around the nostrils.

The large veiner has been used to complete carving the hair and mustache.

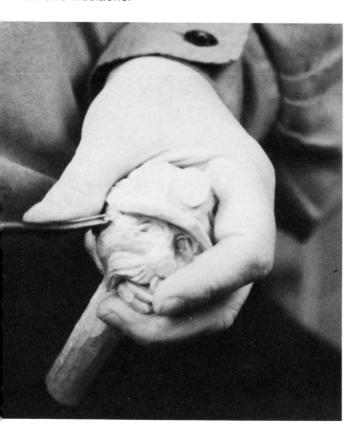

The knife with the turned down blade has been used to shape the flair of the nostrils on both sides.

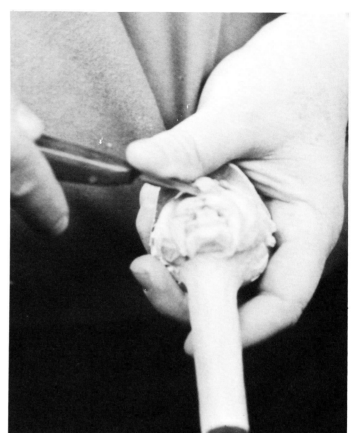

Change to the small veiner to add detail to the hair, mustache and sideburns, remembering to make the lines long and flowing. Little, short marks will appear more like fur. Note: If it is difficult to use the veiner in the wood (meaning the carving is going too deeply or the veiner is following the grain of the wood instead of the intended direction) then the carving is against the grain and the direction should be changed.

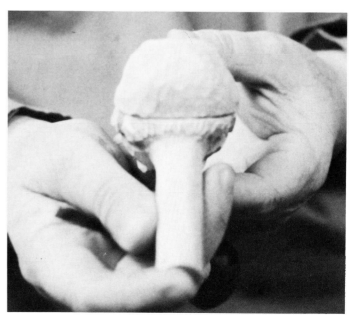

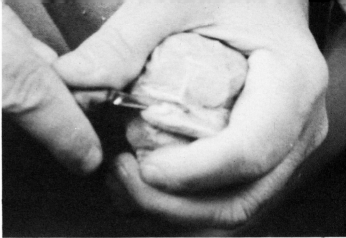

To dress up the cap, use a small narrow knife with a turned down blade and carve down on the top of the cap.

Then carve up on the end of the bill to give it a look of age and use.

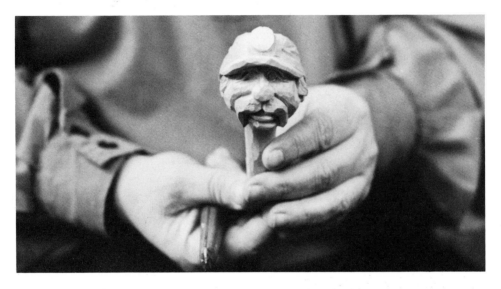

You have created a look of a turned up bill and lower areas around the seam of the cap, giving it the illusion of being well worn.

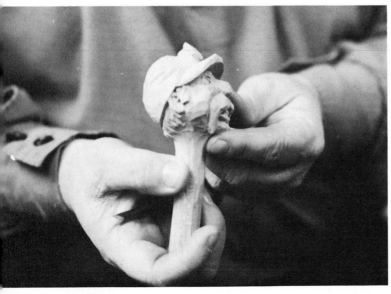

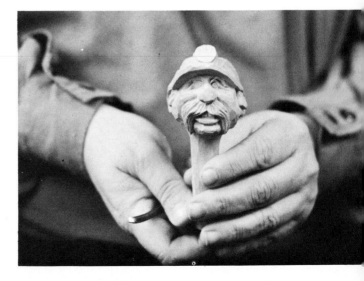

Trim the inside of the brim to give a turned up effect which is evident here.

The small knife with the turned up blade was used to clean up the face and put the finished shapes on the head.

The finished head.

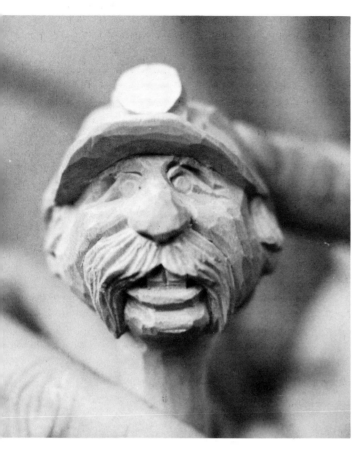

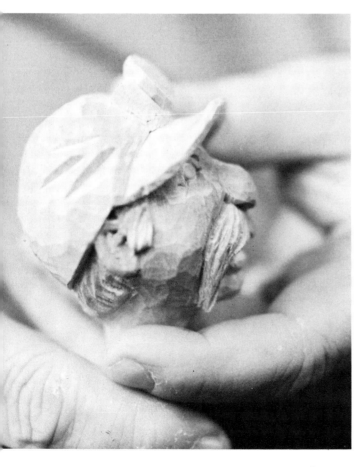

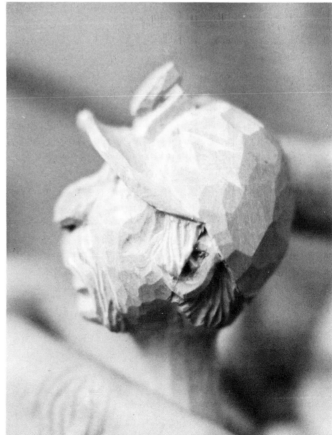

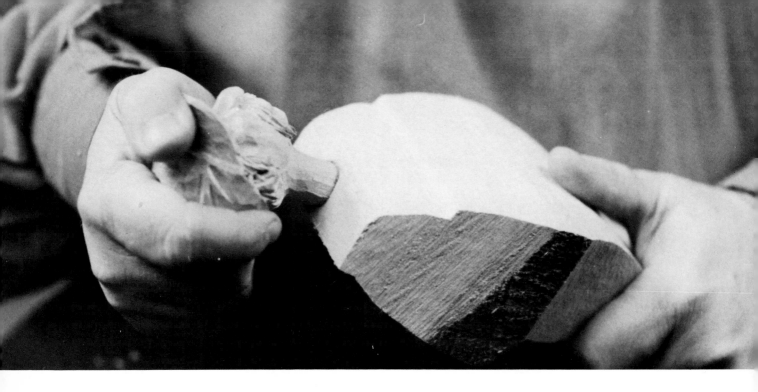

Push the head into the hole at the shoulders of the body. Once it is in as far as it will go, turn and twist it. When the head is then removed from the body there will be shiny areas around the neck where it has rubbed inside the shoulders. These shiny areas or high places need to be carved off.

Begin carving at the bottom of the neck and shave away the excess using a knife with a turned up blade.

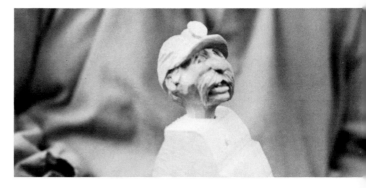

Keep carving until the desired fit is achieved and the neck fits into the body.

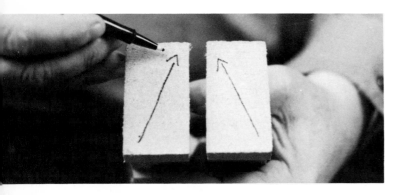

Determine how the feet should be positioned. This carving will have a pigeon-toed look. On the bottom of the feet, draw arrows showing which direction the feet will go.

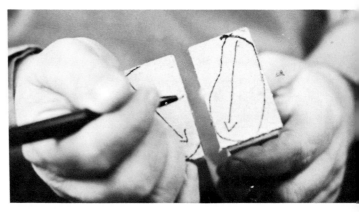

Draw lines showing the rounding off of the heel and how thick the feet will be.

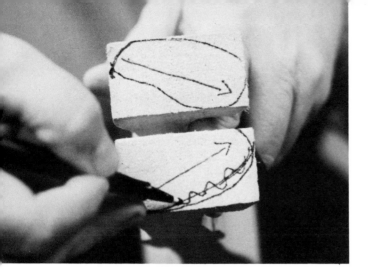

If you draw a line incorrectly, just cross it out with a wavy line and draw a new line.

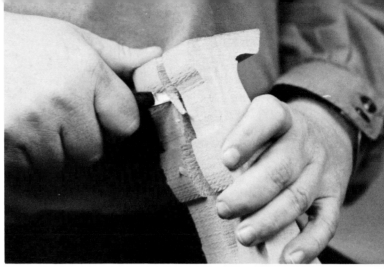

Beginning half way up the boot, carve toward the bottom of the foot. Remove the excess wood outside of the lines.

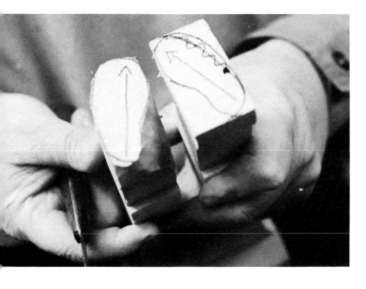

The basic shape of the boot appears.

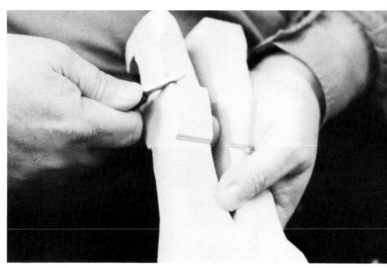

Make a stop cut at the bottom of the cuff of the boot. High boots such as these are turned down at the top to make them more comfortable.

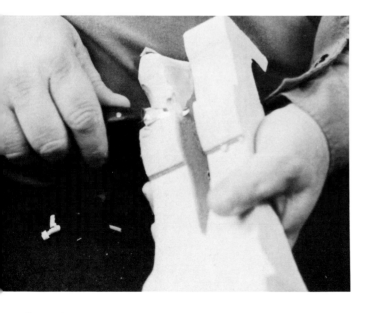

Carve into the stop cut and remove the excess wood from the leg of the boot.

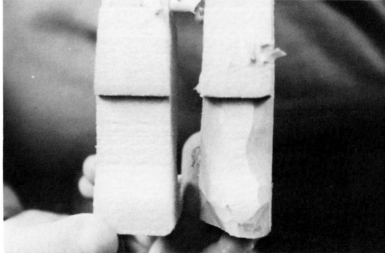

Begin the rough shape of the heel as has been done here.

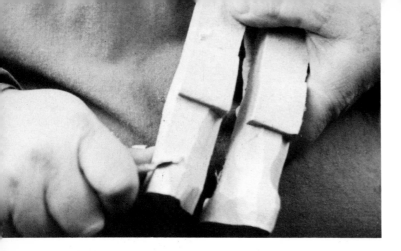

Carve the top of the foot and instep.

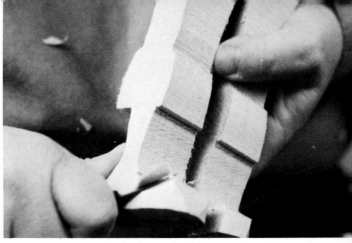

Carve the inside of the legs in the same way as the outside.

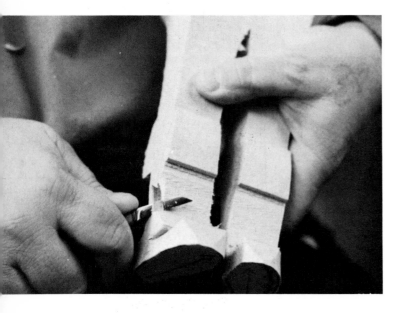

Round out the outside of the front feet once again using the lines on the bottom as guide.

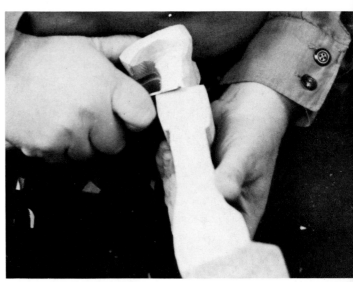

Change to a knife with a turned down end. Carve from the top of the cuff down to the top of the boot and instep of the foot. Keep in mind the overall direction of the foot.

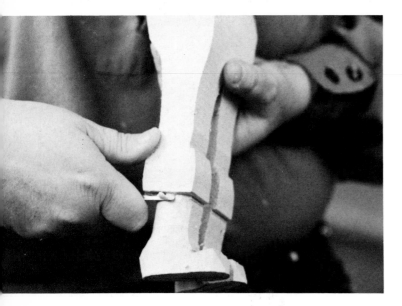

Make strait stop cuts around the turned down end of the boot.

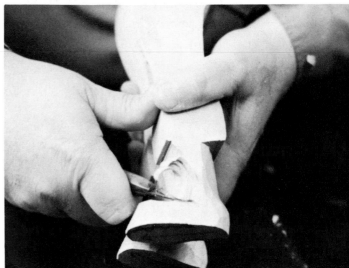

Again working down the boot, carve into the stop cut and shape the boot starting about two thirds the way up the leg.

92

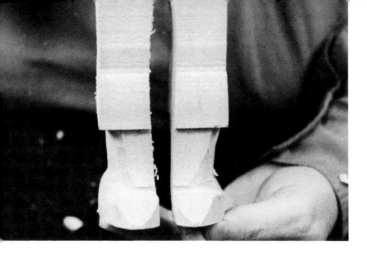

The carved boot leg from the back, notice the contour of the boots.

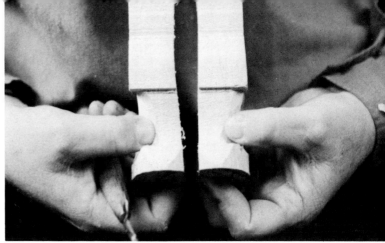

Use the flat front area of the legs as boundaries.

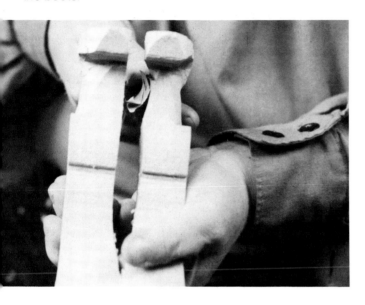

Carve down the inside of the front legs using the ankle and front plane as boundaries.

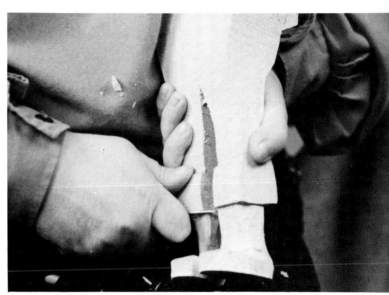

Make a stop cut at the bottom of the turned down part of the boot.

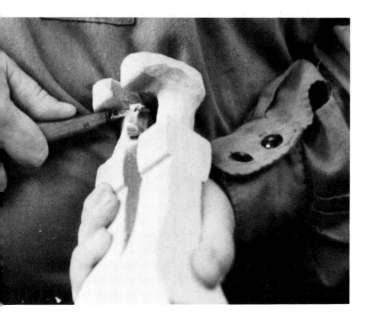

Remove excess wood around the boot leg.

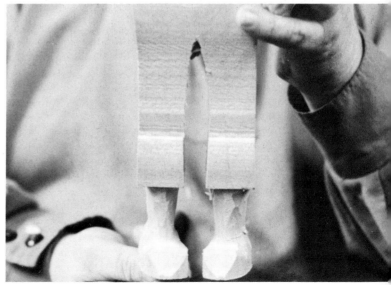

The feet begin to appear pigeon toed and legs are beginning to take on some shape.

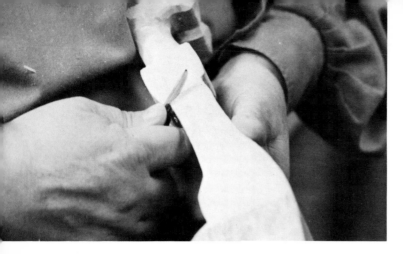

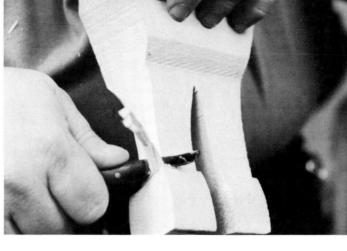

Use a knife with a turned up blade to cut in stops all the way around the top of the boot cuff. The turned up blade allows you the ability to utilize the rocking motion to make strait stop cuts.

Make clear simple slices from the hip area all the way down to the top of the boot.

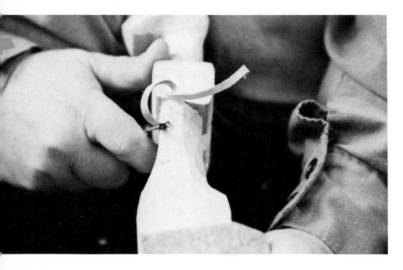

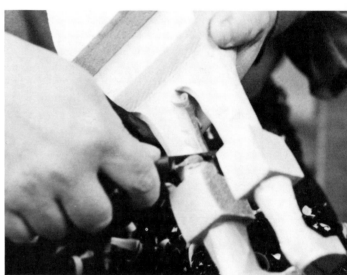

Shape the outside of the legs.

Contour the knee caps and back of the knee to show the heighth of the boot, just below the knee cap.

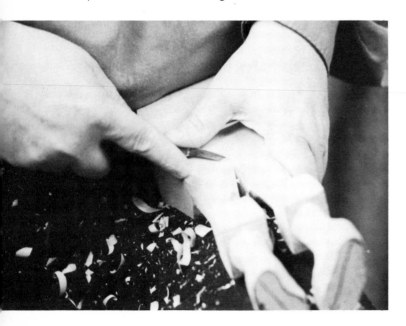

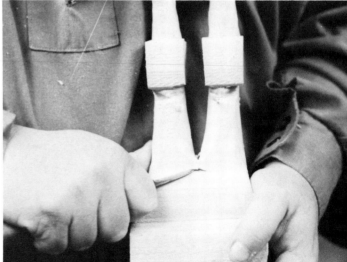

To carve the inside of the legs, begin at the crotch and carve straight down to the top of the boot.

Make two cuts with a flat knife at the back of the crotch to create the seat of the pants and the tops of the backs of the legs.

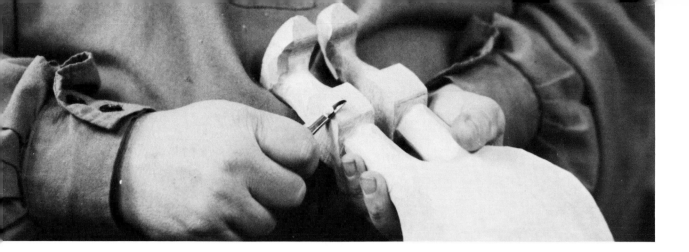

Using a knife with a turned up blade, round off the top of the cuff of the boot.

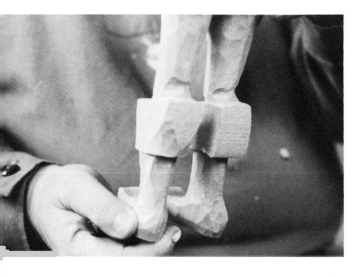

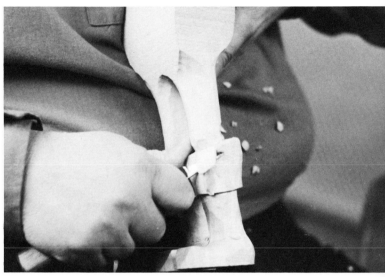

Make the bottom of the cuff a little smaller, and at the same time a straight plane from the top to the bottom of the cuff.

Smooth out the top of the boot cuff.

The finished boot front and back.

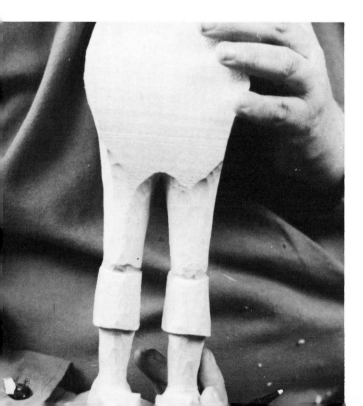

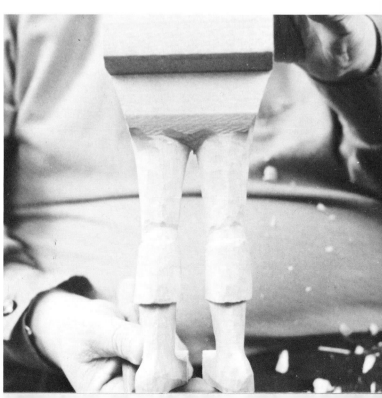

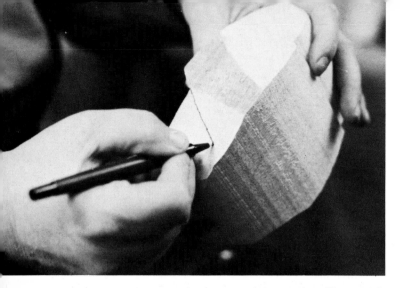 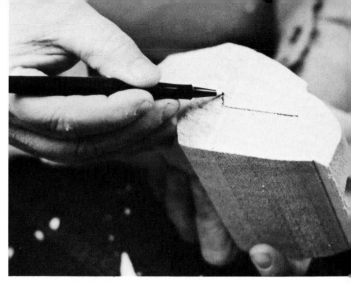

To begin the arms, draw a line starting at the elbow and extending to the wrist.

Use your fingers as a gage to estimate the thickness of the arms, slightly oversized.

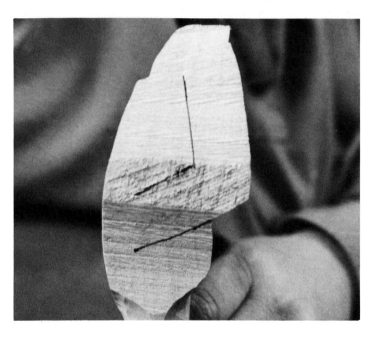

The finished drawing of the arm.

Make stop cuts along the bottom of the arms on both sides

Cut away the excess wood on both sides of the body.

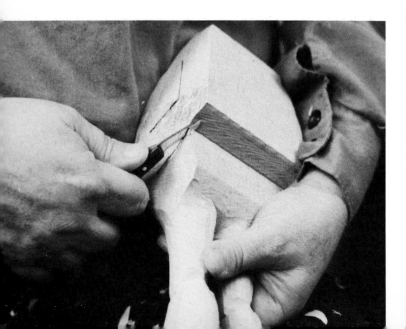 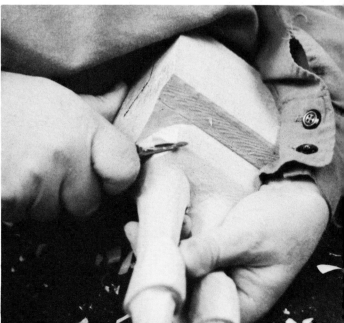

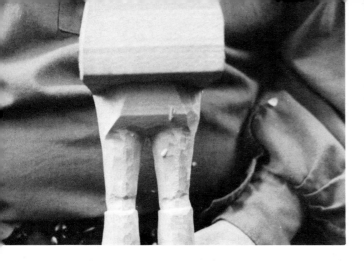

Allow for enough wood in the hip and rear end area for shaping.

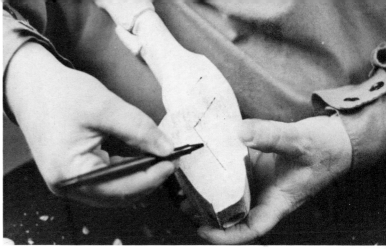

Using your finger as the guide, re-measure the arm.

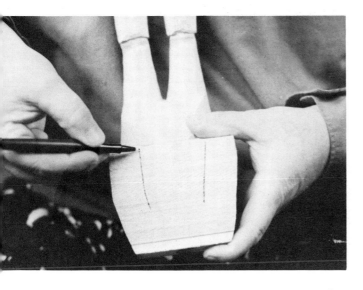

Use this measurement to draw the lines for the back of the arms.

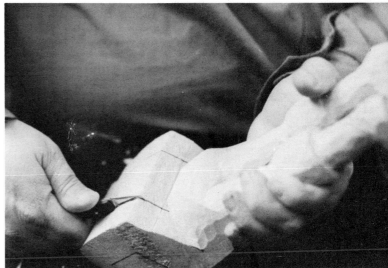

Take the knife with a turned up blade and make stop cuts along the lines in the back of the arm. Use the rocking motion to cut all the way down the length of the stop lines.

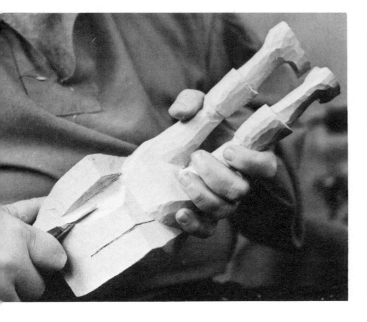

Begin to carve out the elbow and area around the back of the arm.

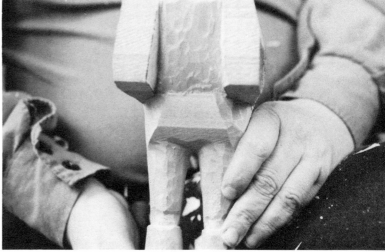

Notice the angle of the back once all the excess wood is removed. The shoulder area is still flat and the elbows protrude from the hips.

97

In removing wood from the front of the carving use the pry bar method to remove a lot of wood quickly.

Using the side lines as guides, begin carving the front of the arms.

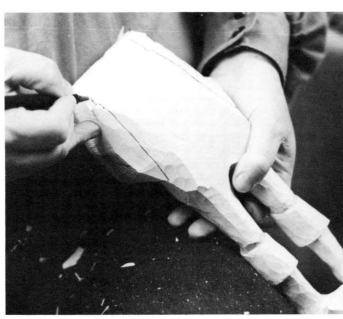

Use a gouge to chisel out the wood in the bend of the elbow, carving from the stop cut out to the front of the carving.

Using a knife with a turned up blade trim over to the bib lines from the recently gouged area at the sides of the body.

Draw a line to designate the front of the bib overalls.

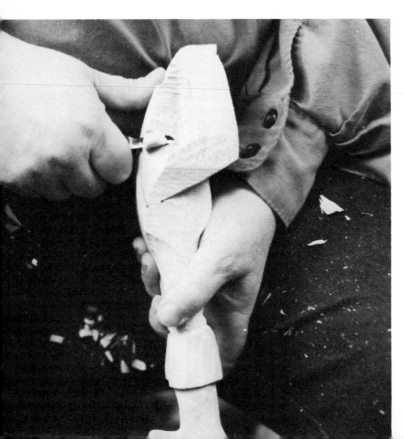

It is a good idea to occasionally put the head back on the body to get the full perspective. In this case the shoulders are too high and square. Draw lines as guides to correct the shoulder contours.

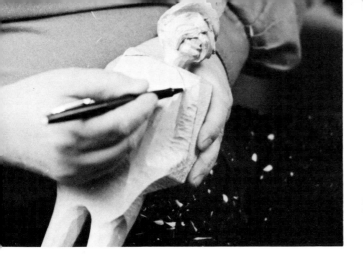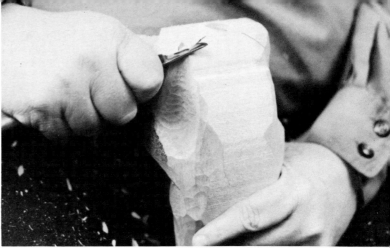

Draw the shoulder lines on the front as well as the back of the figure.

Using a knife with a turned up blade, begin to round the shoulders.

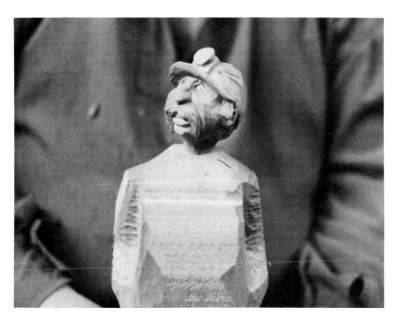

A "warble" shouldered look can be turned to the advantage of the carver. Make one shoulder a little lower and the head looking to the side of the longer shoulder which is dropped slightly. This creates a slumped look on one side brought on by a slouching stance.

Begin to round out the arms at the front.

Here the arms are a little too wide and new guidelines need to be drawn to correct the proportion.

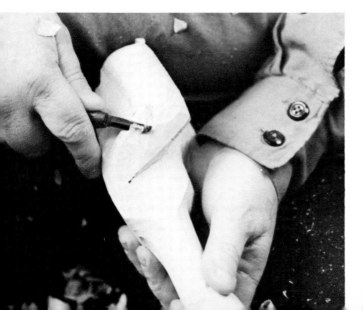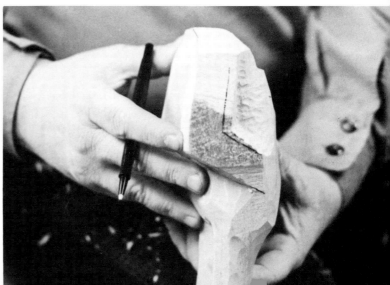

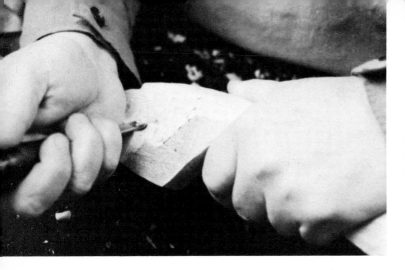

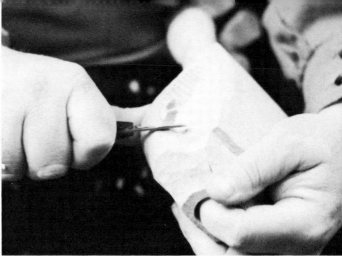

Change to the gouging tool and carve away the excess wood at the crook of the elbows.

Using the knife with the turned up blade, finish rounding off the arms. Smooth out the gouge marks.

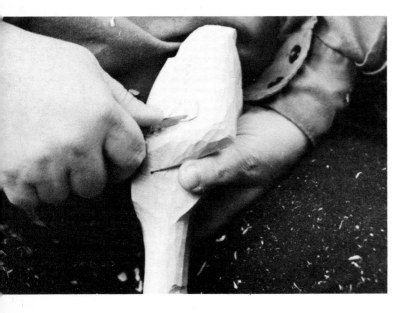

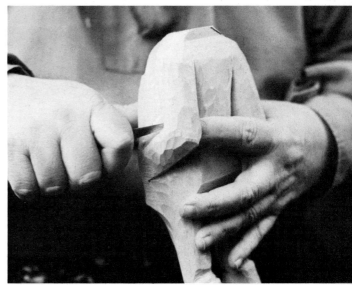

While rounding the inside of the front of the arms, cut deeper into the area between the body and the crook of the arm using straight simple cuts.

Cut all the way through and create an open area.

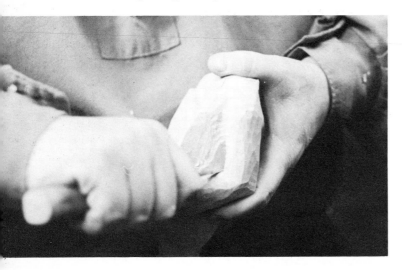

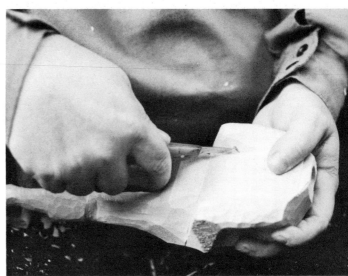

Change to a knife with a turned down blade and continue opening up this area and clearing away the wood.

When you are about half way through change and begin carving from the back into the elbow area.

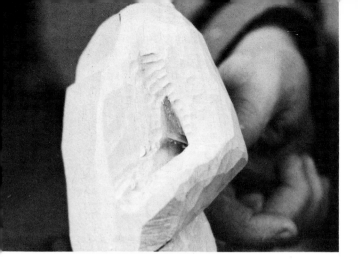

Keep carving until you are all the way through the area between the arm and the body.

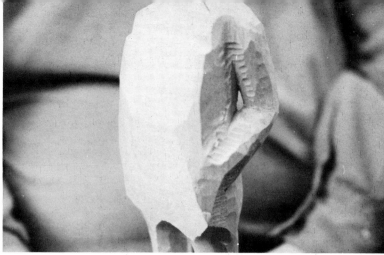

Continue to open up this area until the desired dimension is achieved.

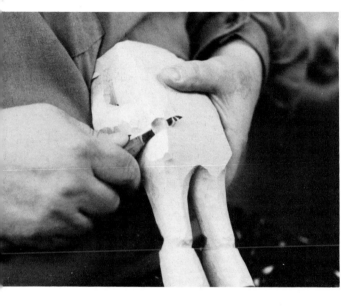

Begin to carve the area where the hands would be inside the pockets.

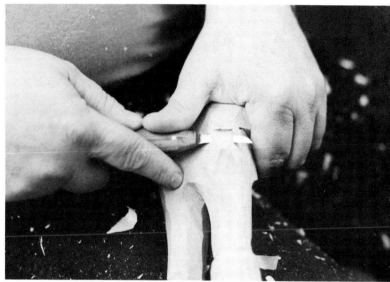

Make the pockets bulge as though hands were really inside.

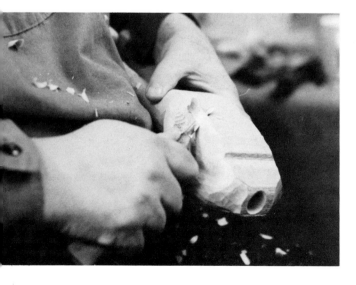

Round out the chest area slightly on the sides of the pockets.

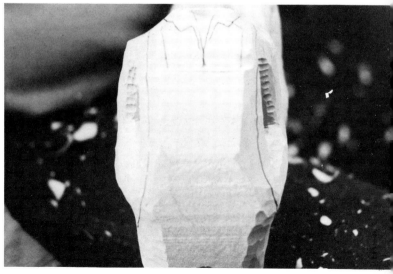

Draw the front of the bib overalls.

101

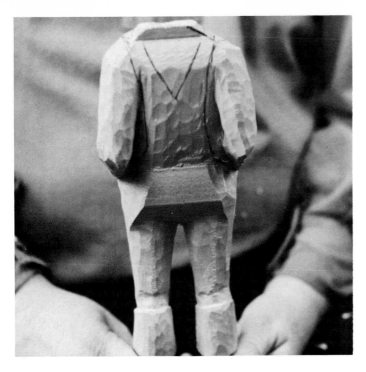

Draw the back of the bib overalls.

Use a knife with a turned down blade to cut deeply along the bib lines and make stop cuts.

Change to a knife with a turned up blade and begin carving by the hands. Cut into the stop lines.

Cut into all the stop lines around the arms making a groove to designate the edges of the overalls.

Use a knife with a turned up blade to carve the surface of the front and back of the overalls.

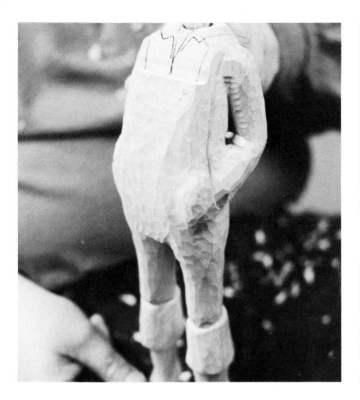

While carving keep the basic anatomy lines in mind. The carving must look human and realistic as it does here.

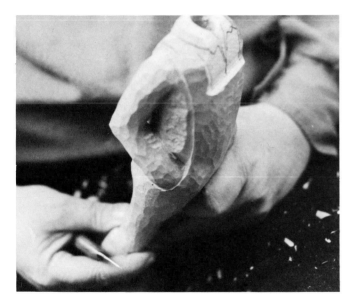

Completed overalls.

Using a knife with a turned down blade, begin to carve the shirt collar.

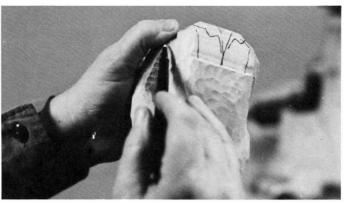

Mark any needed adjustments.

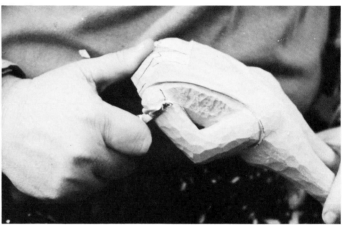

Carve any necessary contour changes.

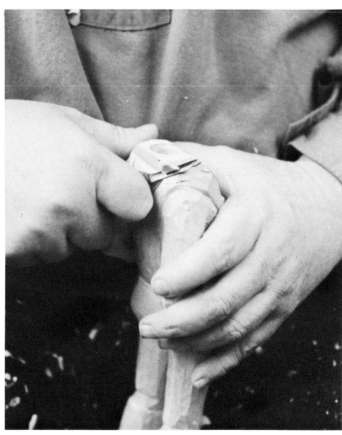

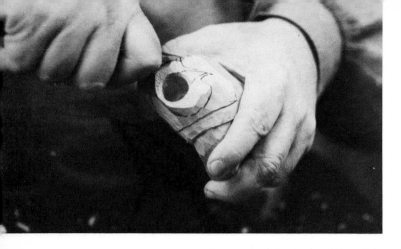
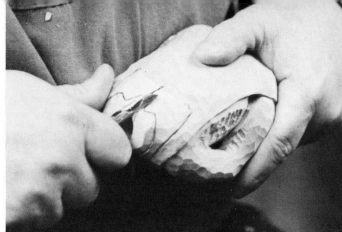

Changing to a knife with a turned up blade, make stop cuts along the straps of the overalls.

Make stop cuts along the bib of the overalls and collar of the shirt.

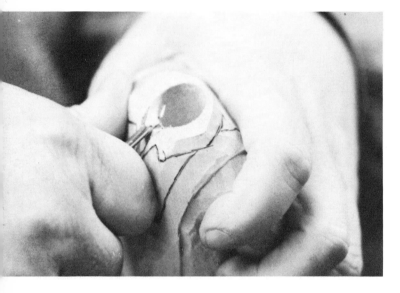
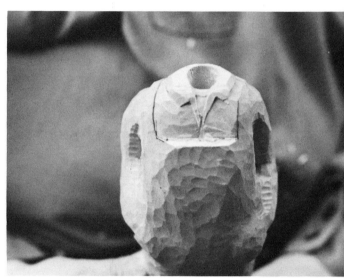

Use a knife with a turned down blade and a sharp point to notch out the neckline at the front of the shirt.

Lower the top of the neck hole slightly to look like a t-shirt. Carve the neck band of the t-shirt. This will disguise the area where the neck is inserted into the body.

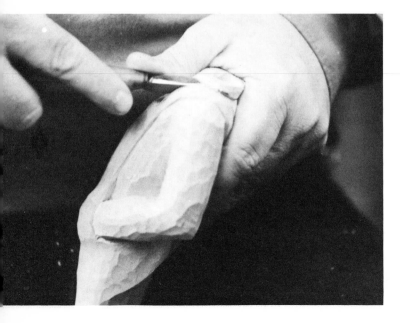
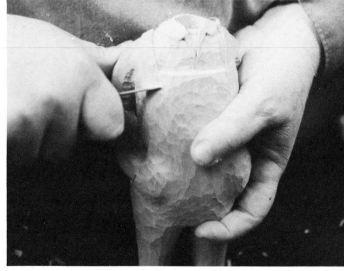

Carve around the collar, cutting into the stop lines.

Using a knife with a turned down blade, begin to carve and clean up the shirt and the bib.

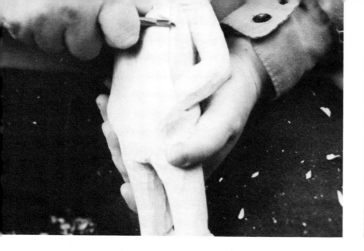

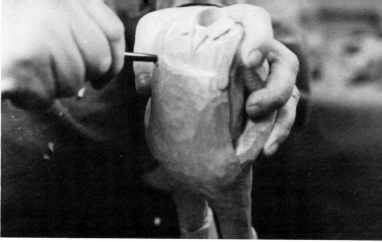

Make any minor adjustments necessary and shave off the remaining drawn lines, to finish the overalls.

Using the largest nail set 5/32", make the fasteners on the straps of the overalls.

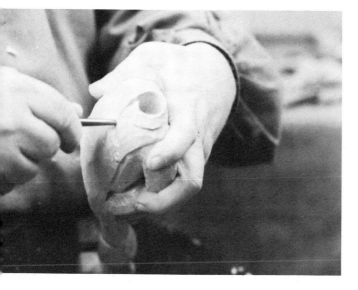

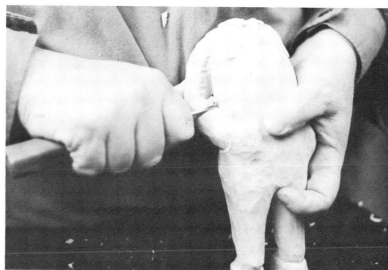

Change to the 4/32" nail set to make the shirt buttons.

Clean-up the shirt sleeve and put wrinkles in the bend of the elbow.

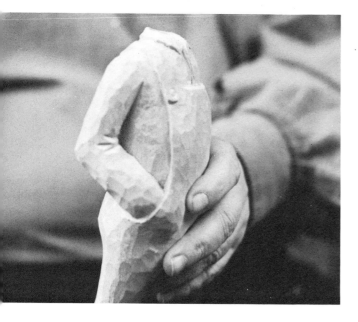

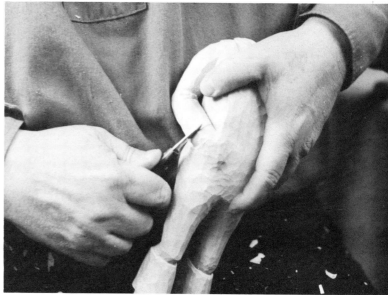

Finish the sleeve and examine the carving for areas that need changing.

Make a stop cut at the seam of the cuff.

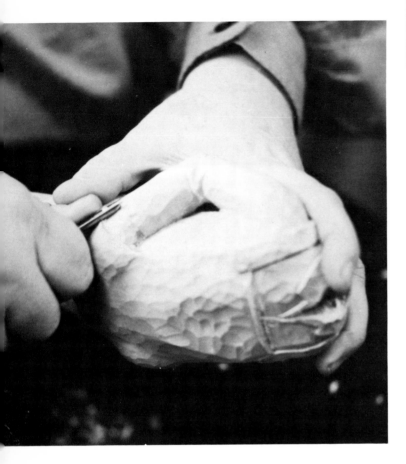

Carve from the wrist to the cuff and remove extra wood creating a raised area for the cuff of the shirt.

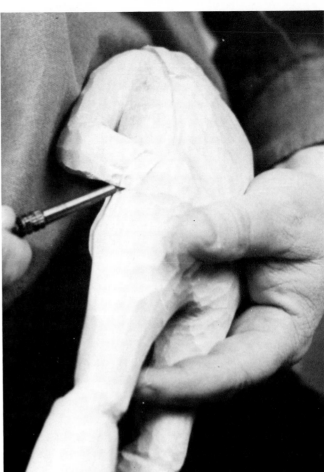

Using the ⅛" gouge make folds and gathers on the sleeve of the shirt.

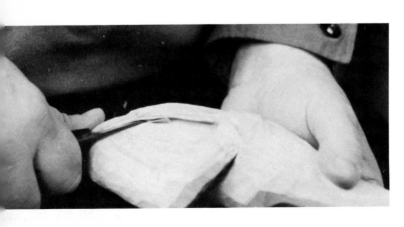

Cut a stop cut along the bib of the overalls to make it more defined.

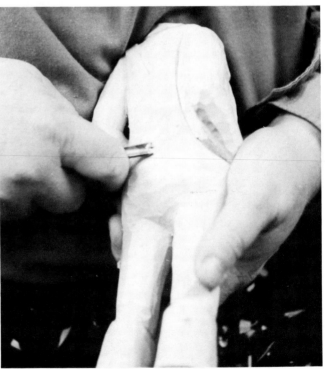

Use the gouging tool to further define the small of the back.

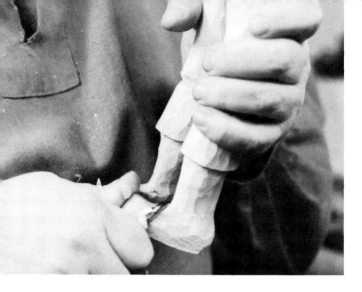

Round off the toes of the boots, continually changing back and forth between knives.

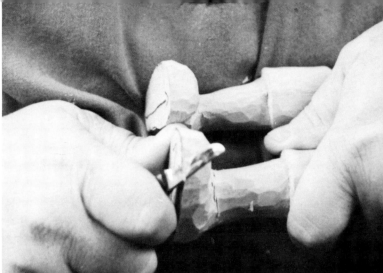

Keep rounding until the desired look is obtained. Because the carving is pigeon toed the toes of the boots will be rounded up just slightly.

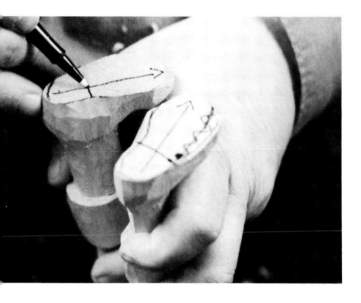

Draw the soles of the shoes on the bottom of the boots.

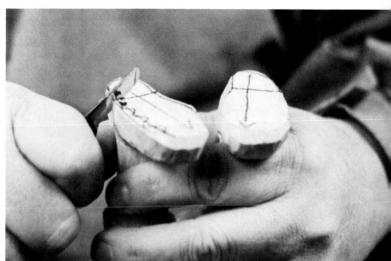

Only cut away as much as will be seen, to keep a solid base for glueing.

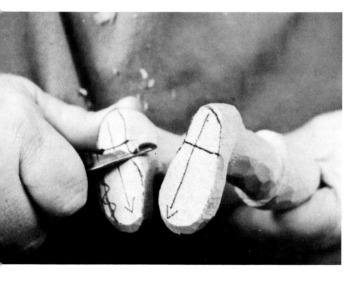

Notch out area where the sole of the shoe stops and the heel begins.

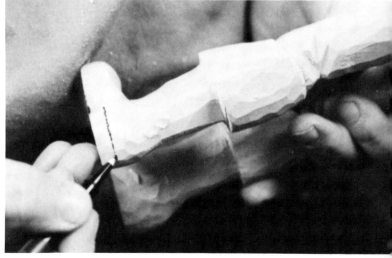

Draw a line around the outside of the heel.

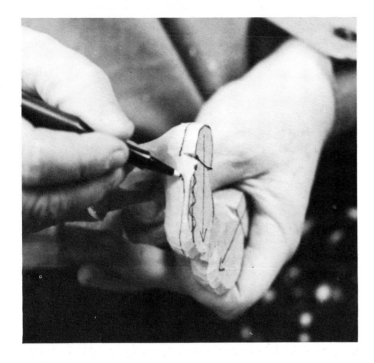

Also draw a line around the outside bottom edge of the soles of the boots.

Mark folds in the boots

Using a knife with a turned up blade cut a score along the line around the shoe using the rocking motion.

Carve in the folds.

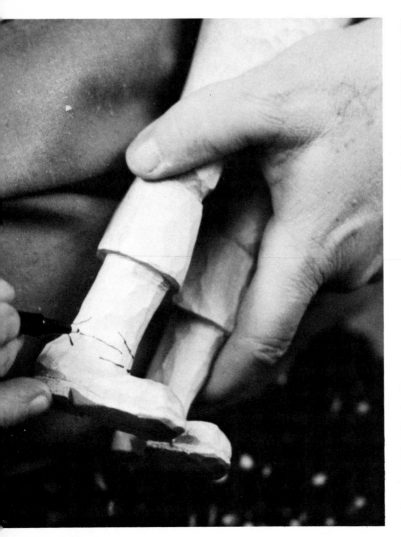

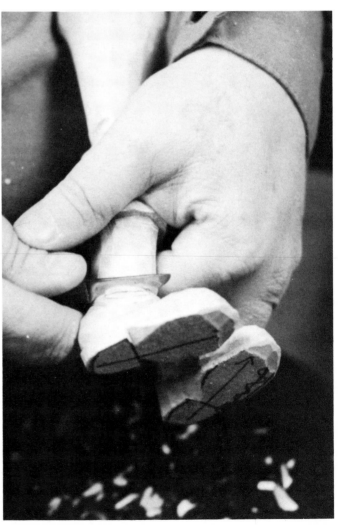

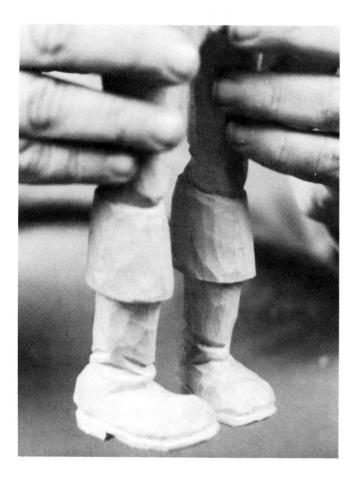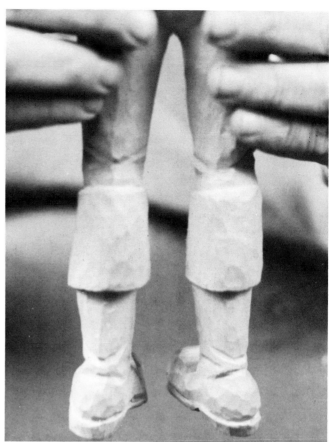

Completed boots front and back.

Draw the seams of the overalls.

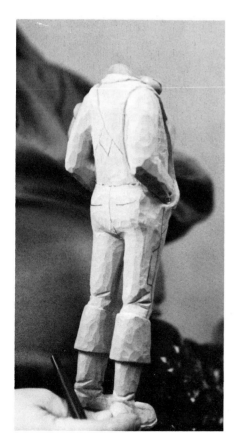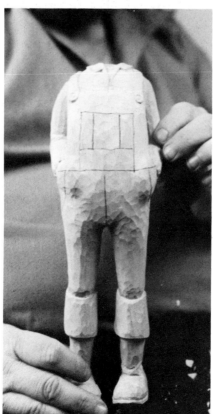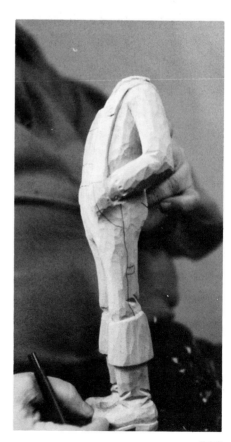

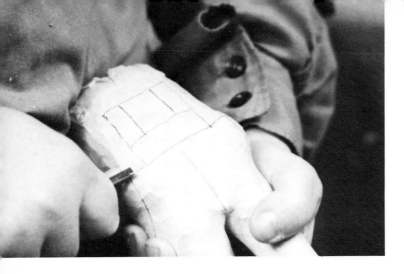

Using the gouging tool, gouge out along the seam lines.

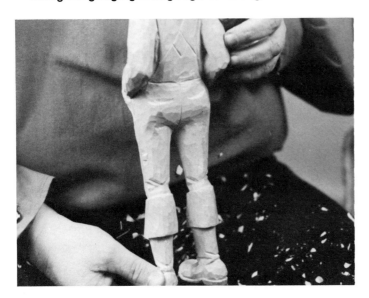

Finished seams.

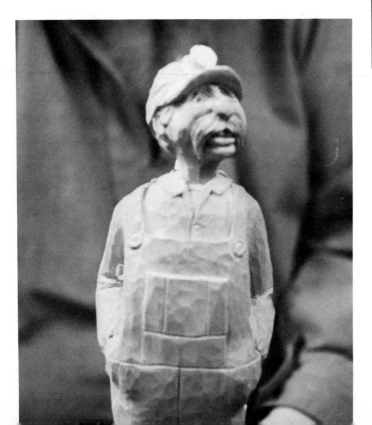

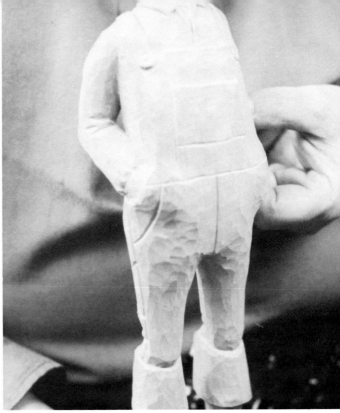

Finished seams.

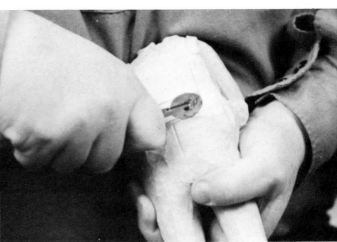

Using a pattern tracing wheel from the sewing kit, run it slowly along the cuts in the seams pressing firmly to leave a patterned indentation.

The finished carving of the man.

Making the Base

The base being made here can be used for some or all of the carvings that have been described. Variations in size and decoration, will depend upon the desired final appearance. Tom has provided an example of the type of base he frequently makes. He feels that putting a carving on a base strengthens it. It gives stability to every leg to tie them all together on a stand.

The base should be a sturdy piece of thick wood with bark around the sides. Use the band saw to cut it into the desired shape and remove any bad places in the wood.

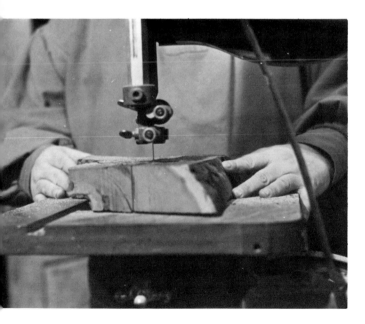

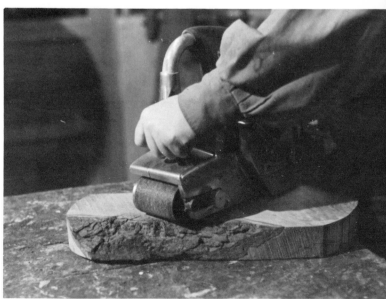

Use a belt sander to smooth the top and bottom of the wood base.

Find a root or limb to use as a tree in the setting.

Note the angle of the bottom and make it even with the top.

Use the band saw to cut it to the specific length and dimensions needed.

Balance the surroundings with the carvings and the size of the finished work.

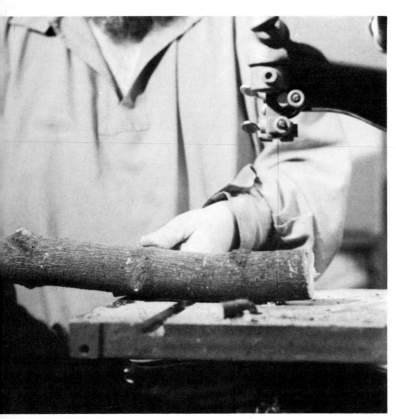

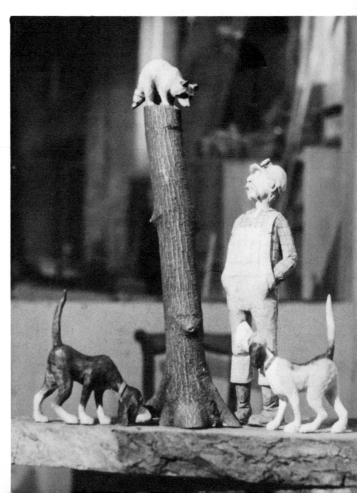

112

Painting Instructions

To prepare for painting the carvings, several supplies must be obtained. Use a *Flair* fine point marking pen as it is the only type of marking pen that is compatable with turpentine base paint. A #5 natural bristle brush will be used to paint the large areas. The goal is to use a brush that is comfortable and will hold a good amount of paint. A smaller #0 natural bristle brush is used to paint very small areas and details such as the pupil of the eye. Keep plenty of paper towels on hand.

The actual paint used is Alkyd Color or oil paint by London, which comes in tubes. Alkyd paint is between an oil and a water base paint. Here the paint will be mixed with turpentine creating a thin oil paint wash or stain which dries quickly. If there is no hurry for the paint to dry, actual oil paint thinned with turpentine can be used allowing for a drying time of at least twenty-four hours. Turpentine should always be used as an extender with either Alkyd Color or oil paint.

Do not add Linseed oil to the paint as it will cause the oil paint to set on the outside of the wood instead of penetrating into the carving. Whether using oil or alkyd paint, only turpentine should be added. Buy regular spirit turpentine.

Jars are needed to mix the paint, the small six ounce juice jars works very well. To accommodate the colors needed for these carvings, twelve jars will be used. In addition, one jar should be filled with turpentine for cleaning the brushes, and another jar will eventually be your "grey jar". The colors necessary to paint the carvings in this book are, Blue-French Ultramarine, Burnt Umber, Raw Sienna, Burnt Sienna, Lamp Black, Titanium White, London Red or Vermillon Red, Yellow-Cadmium Yellow Light, Flesh tint, Dark Grey, and Flesh II. The specific colors for each carving will be listed in the individual painting instructions.

After painting, a Krylon Matte Finish #1311 is applied and finally Krylon Acrylic Spray Coating—Crystal Clear #1301 is used to finish the carvings and protect the painted surfaces. The Krylon Matte Finish #1311 is also very good to use with oil paint. Spray on the oil paint while it is still wet and it will help it to dry. A couple of coats sprayed on the oil paint will dry it in about a day as opposed to two weeks or a month. This is especially true if the pure pigment is used. The spray should be lightly applied. These are all products Tom uses and has found, over the years, to be best for his purposes.

As the brushes are repeatedly cleaned in the turpentine, the paint residue from all of the colors will settle at the bottom of the bottle. When the wash bottle has become contaminated, let it settle and pour off the excess turpentine leaving the residual paint which is a good medium gray color. The turpentine that has been poured off can be used again to clean brushes. Tom's moonshine days gave him a lot of experience pouring from one jug to another, so pouring from one paint jar to another is even easier. The less experienced pourer may need a little practice.

To mix the colors, pour four ounces of turpentine in a jar. Squeeze out one to two inches of paint from the tube and mix it into the turpentine. Replace the cap on the jar and shake it to mix the color. The paint should be the consistency of a water like stain or wash. If too much turpentine is used, let the paint settle and pour off the excess turpentine. A darker stain can also be achieved by doing this.

There are some thoughts to keep in mind as one begins to paint. Use only one color at a time. The same color can be used on several carvings at once and the risk of putting the brush in the wrong color will be greatly reduced. Paint freehand. There is no right or wrong way to color the carvings. Nature creates each animal and person as an individual and the carvings should appear the same way.

A residue with heavy pigment will accumulate in the lid. This can be used if stronger color is needed. The concentrated paint from the bottom of the jar can be put in the lid of the bottle if it is needed later in the painting, and the paint in the jar mixed with the brush.

Use a wet brush while painting because the wood will soak up the moisture quickly. Remember, any mistake can be carved off. According to Tom his painting style is one of controlled sloppiness which works best for him. It is better to begin painting the light colors and progress to the darker ones. It is easier to keep the paints and brushes clean with this method.

In general, only one coat of color will be needed unless it is too light. A darker shade can be created simply by applying a second coat of paint. Different colors can be layered one on top of another to create new shades.

The final step in the painting process is to spray the finished carving. Krylon Acrylic Spray Coating covers the best without dripping. It can be purchased at any paint supply store. If oil paint has been used to color the carving, be sure to allow enough time for the paint to dry before applying the spray. A mixture of tungoil and petrolium distillion such as Formby Tungoil Finish can also be used.

Once the painting has been completed for the day it is necessary to thoroughly clean and condition the brushes. Begin by cleaning the brushes with turpentine. They should be so clean that no color residue is left on the towel as they are wiped dry. After this is done, Tom recommends that the brushes are further cleaned with specific cleaning compound for that purpose. He has used, *The Masters Brush Cleaner and Preserver,* which he finds to be the best. It is very simple to use and the instructions are on the container. This particular cleaner also lasts a long time and can be used to reshape brushes as well as condition them.

The mixed paint will settle in a matter of hours and must be stirred or shaken before each use. However, it is good to note that for a deeper color, the brush can be dipped to the bottom of a settled bottle of paint and used on carvings for more intense color. The settled layers of paint can be used to give different intensities of color by dipping the brush shallowly into the bottle or deeper for more color.

Paint Samples

Raw Sienna	Burnt Sienna	Burnt Umber
Titanium White	Grey Jar	Dark Grey
Lamp Black	Yellow-Cadmium Yellow Light	London Red/Vermillon Red
Blue-French Ultramarine	Flesh II	Flesh Tint

Treeing Walker Dog Painting Instructions

The colors of paint to be used on the Treeing Walker Dog are; Raw Sienna, Burnt Umber, Titanium White, Lamp Black and London Red.

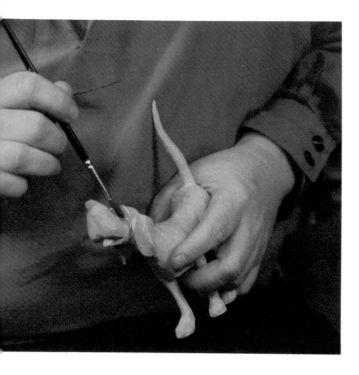

Begin painting the Walking Dog eye patches with raw sienna using the #5 brush.

Paint sienna on both sides of the hound's body and over the shoulders. Hold the hound upside down to allow any runs in the paint to drip on an area of the back which will be painted a darker color later.

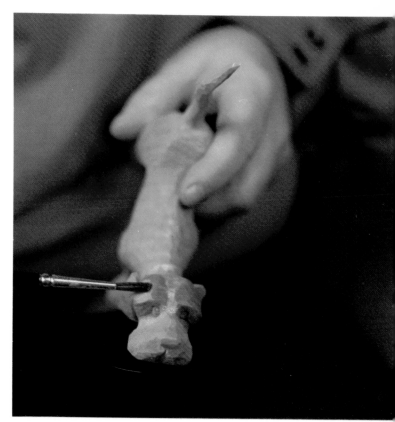

Continue to paint the area over the eyes and on the back of the head.

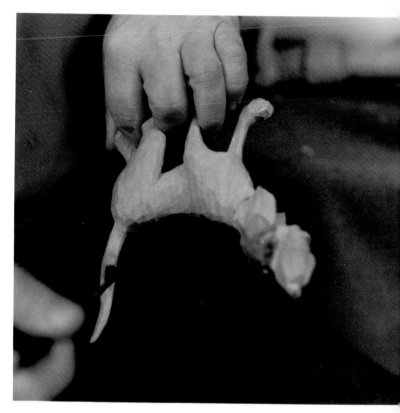

Color a sienna spot on the hound's tail.

115

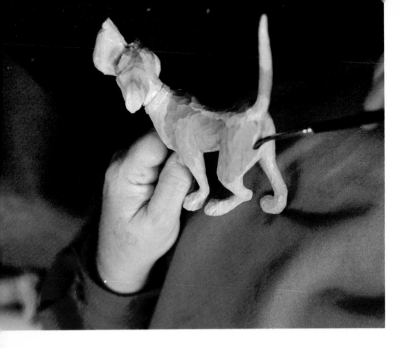

Continue the color around the hips and back of the legs.

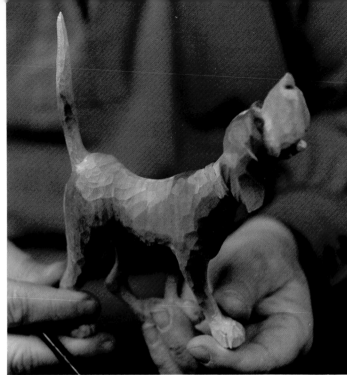

The completed sienna color wash.

Paint the collar using your fingers to brace and steady the paint brush.

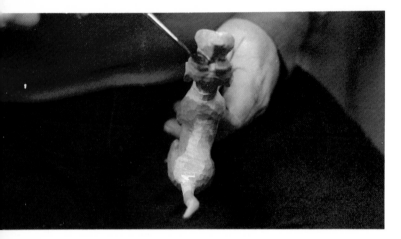

Using a cleaned brush, change to burnt umber paint and color the eye patch area again.

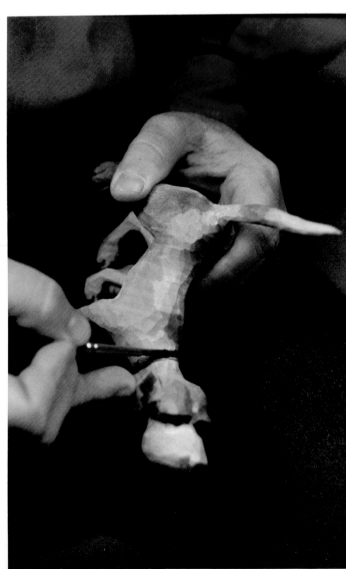

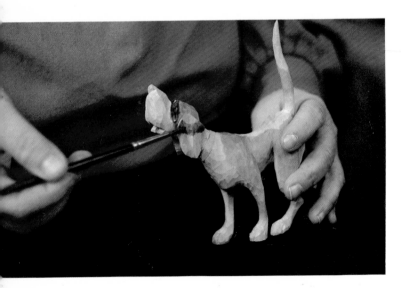

Continue down the middle of the ears.

Continue painting along to the top of the shoulders.

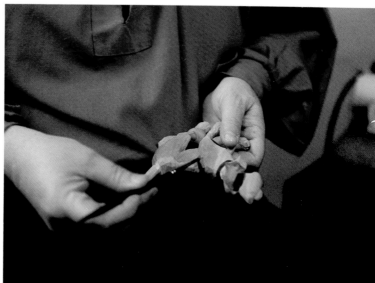

Fill in color along the hip area above where the sienna color has been painted allowing the washes to blend naturally looking like fur blending from dark to light along the body.

Clean the brush and change to white paint. White paint is hard to see while painting the carving. Look over the carving the next day as once the paint has dried it shows up clearly and any spots missed will be apparent. Paint the hounds muzzle white. A bald-face hound has white fur from the muzzle, between the eyes and over to the back of the head.

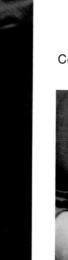

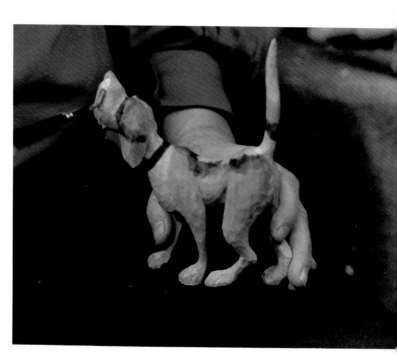

Paint around the bottom of the sienna spot on the tail with burnt umber.

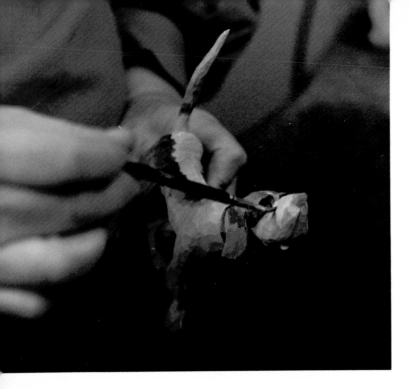

Paint the underside of the neck and the entire muzzle.

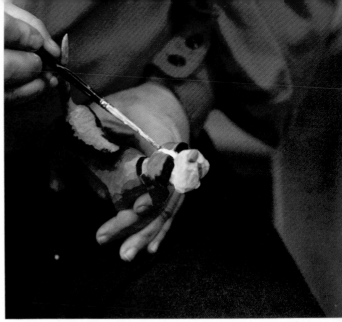

Continue to paint between the eyes.

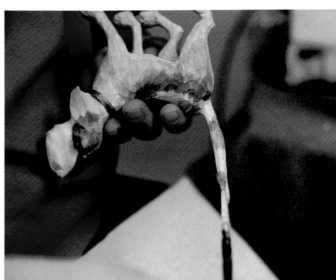

Turn the hound upside down to avoid any runs in the paint and paint the tip of the tail.

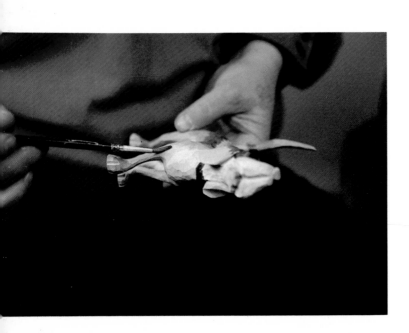

Extend white paint down the front of the chest to the shoulders.

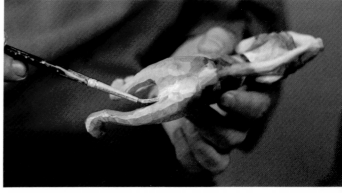

The base of the tail and inside hind legs are also painted white.

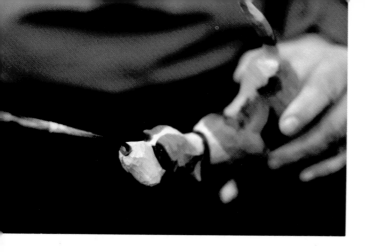

Changing to black paint, color the tip of the nose.

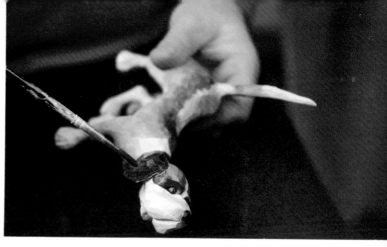

Paint the ears.

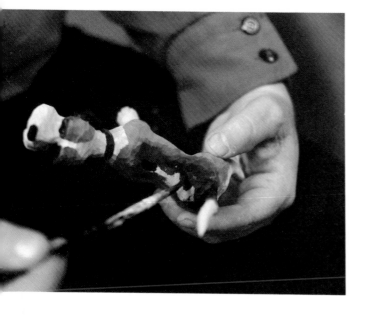

Paint the saddle of the hound's back and base of the tail.

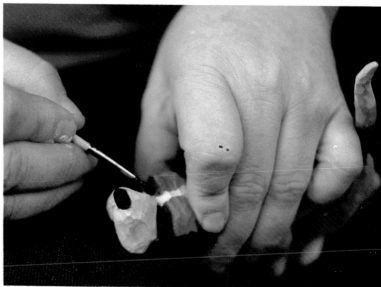

Using the small #0 brush with a heavy concentration of black, paint the hounds pupils. To create a more lifelike appearance add an "EEN I TINEY" speck of white in the eyes to give them a glint.

With a clean #5 brush paint the tongue red.

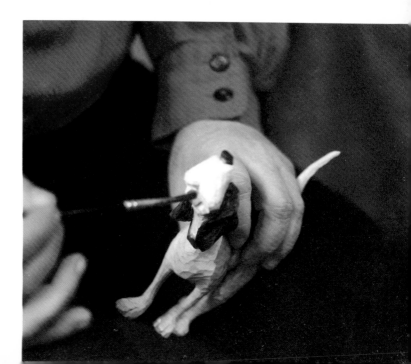

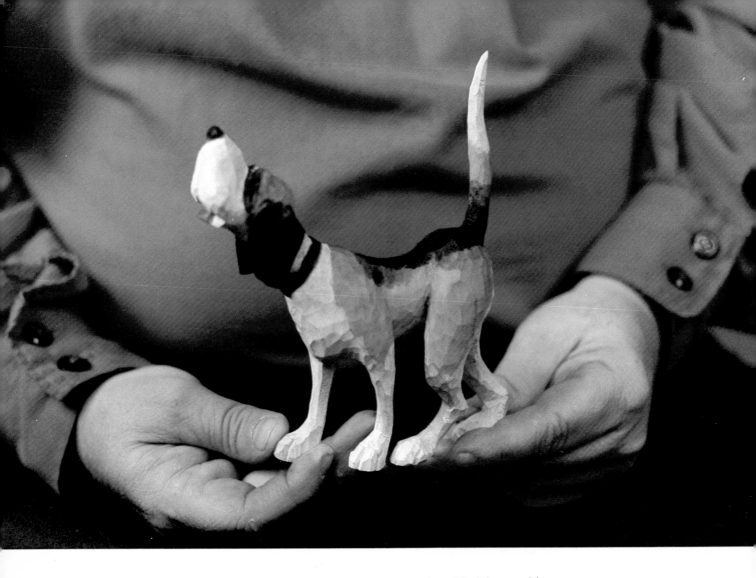

The completed dog. Once the paint has dried thoroughly, about two hours, spray the carving with Krylon Matte Finish, followed by a coat of Krylon Acrylic Spray coating.

Black and Tan Hound Painting Instructions

The colors used to paint the Black and Tan Hound are; Raw Sienna, Burnt Umber, Titanium White, Lamp Black and Burnt Sienna.

Begin painting with a clean #5 brush, and raw sienna. Paint the face.

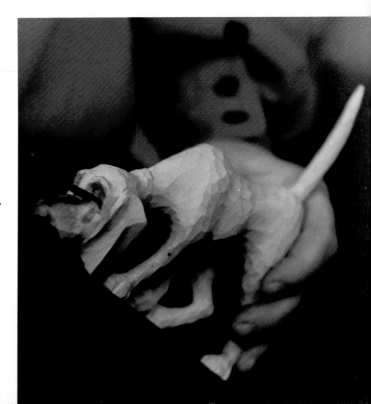

Paint the lower half of the legs of the hound and the feet with raw sienna also.

The stomach is also colored with raw sienna as well as the underside of the neck.

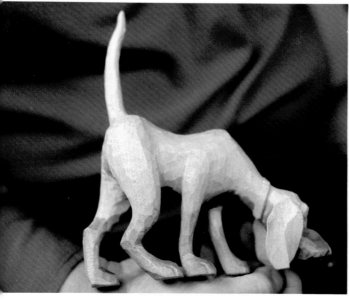

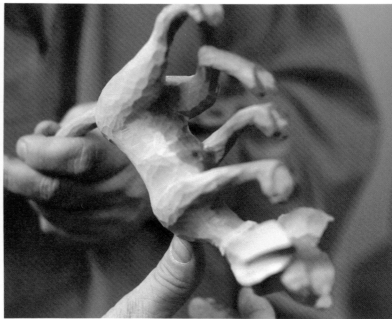

Using burnt umber paint, darken the eye socket. Once the eye has dried put a touch of white in the pupils to give them a glint and lifelike appearance.

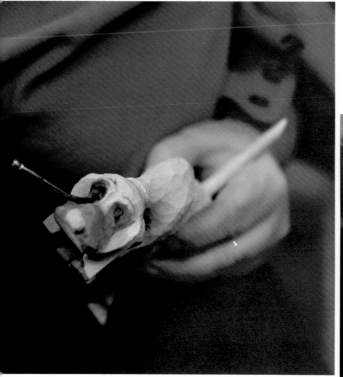

Switch to black paint and paint the remaining unpainted areas of the body.

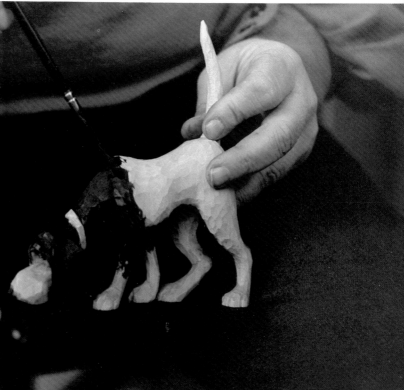

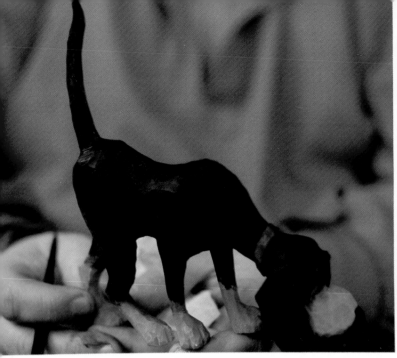 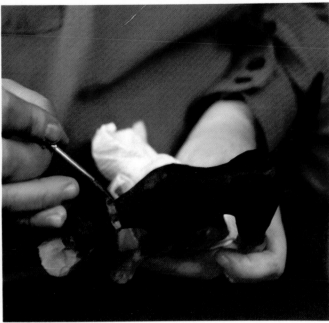

Paint a black wash down over the brown wash on the legs to the elbow area, leave the stomach brown. Use actual photos of the particular dog you are painting as a guide to painting the markings of the coat.

Clean the brush and paint the collar burnt sienna.

The completed dog. Once the paint has dried thoroughly, approximately two hours, spray the carving with Krylon Matte Finish. When this has dried apply a final coating of Krylon Acrylic Spray.

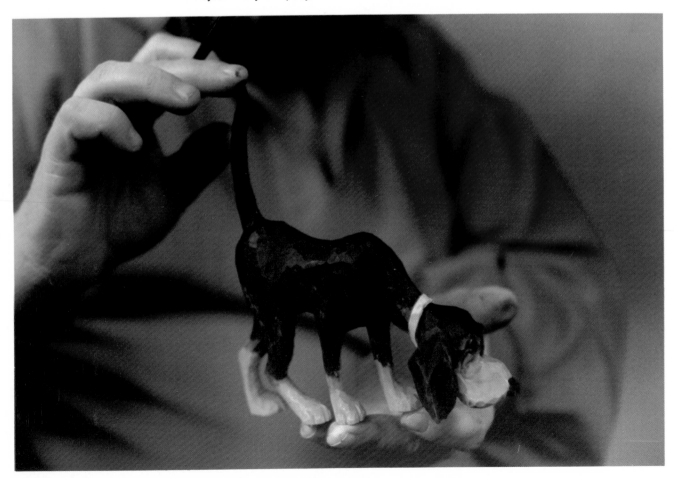

Coon Painting Instructions

The colors used to paint the coon are; Raw Sienna, Lamp Black, and Titanium White.
Painting

Starting with a clean #5 brush, cover the entire coon body and head with sienna paint.

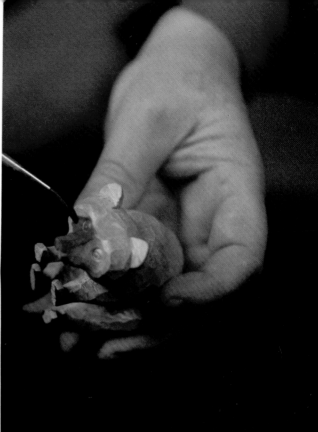

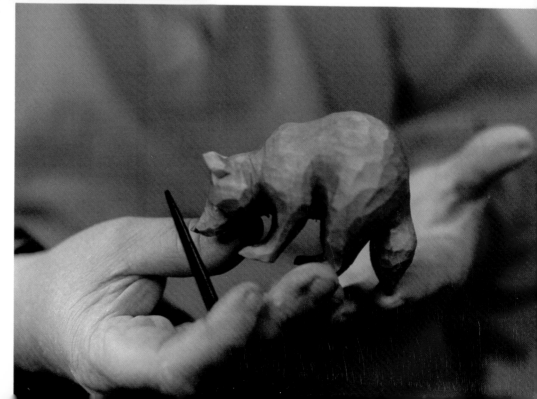

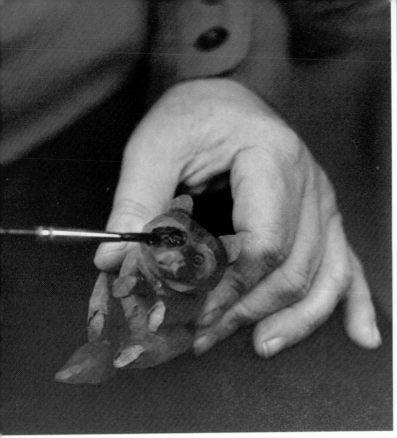

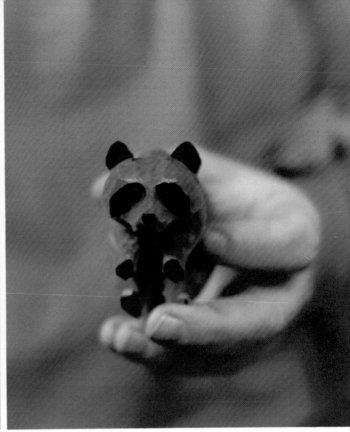

With black paint, and the same brush begin the face with the eye patches.

Continue coloring the ears and nose.

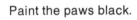
Paint the paws black.

Paint black stripes around the tail.

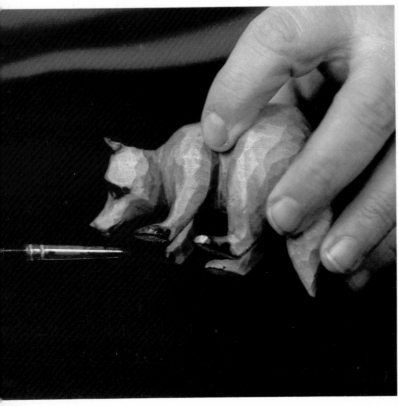

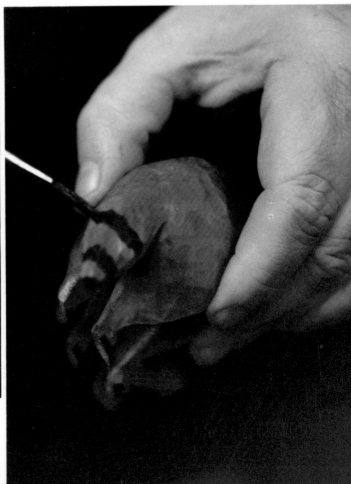

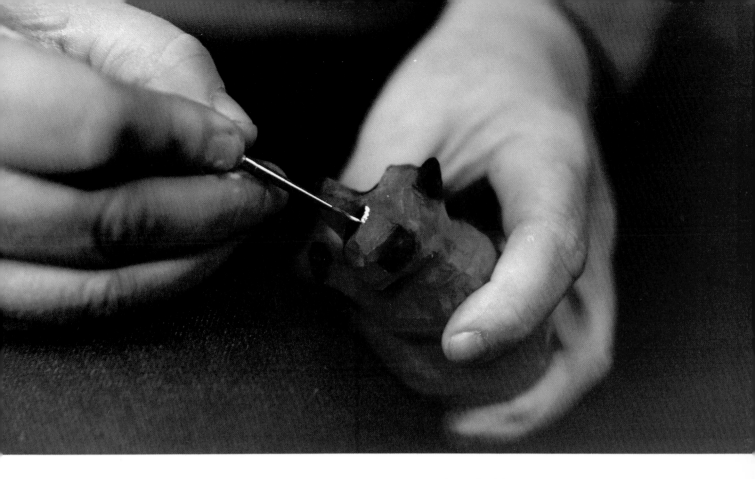

Using the #0 brush and a high concentration of white from the lid of the jar, paint around the tops of the eyebrows.

Highlight the rings around the tail in white.

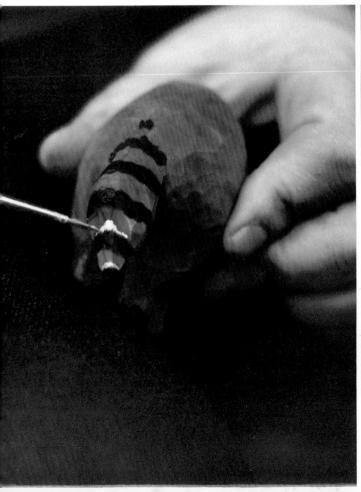

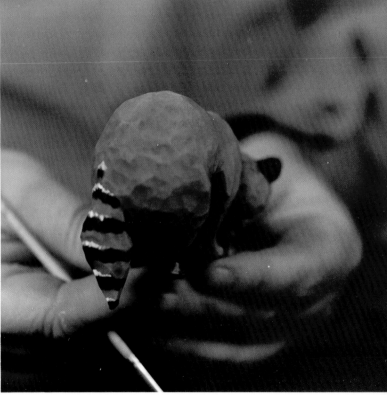

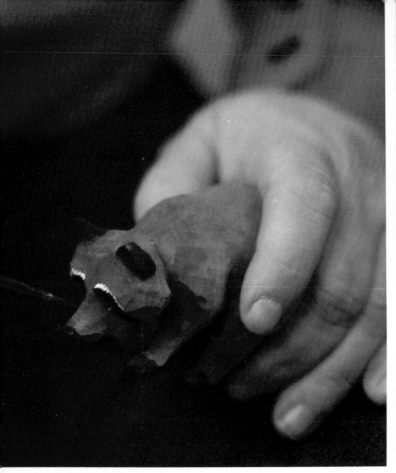

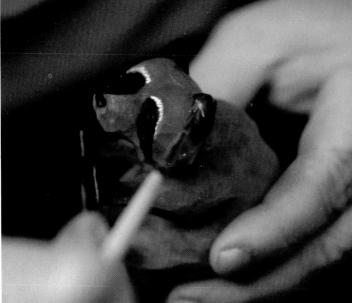

Also add a white tint around the inside of the ears.

With the thin mixed white paint, add a white tint around the muzzle.

White should be added on the top of each paw.

The completed coon. Once the paint has dried thoroughly approximately two hours, spray the carving with Krylon Matte Finish. Once this has dried, follow with a coating of Krylon Acrylic Spray.

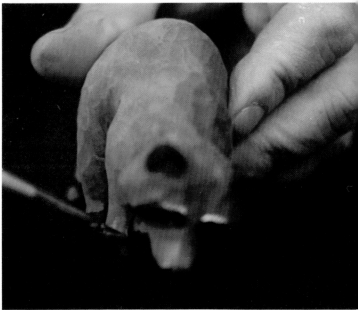

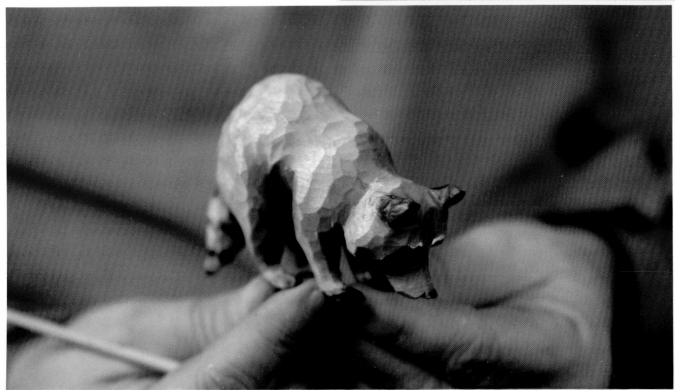

Coon Hunter Painting Instructions

To paint the Coon Hunter, the colors of paint to be used are, Flesh, Raw Sienna, Red, Burnt Sienna, Dark Gray, Light Gray, Titanium White, Cadmium Yellow, Lamp Black nad Ultramarine Blue.

Begin by mixing flesh color and raw sienna paints to create the more tan, brownish look of a rugged outdoor skin tone. Combine the colors by eye, realizing that the more sienna that is added, the darker the tone will become. Start painting using the #5 brush and the newly created rugged skin tone. This color will be used on the face and neck.

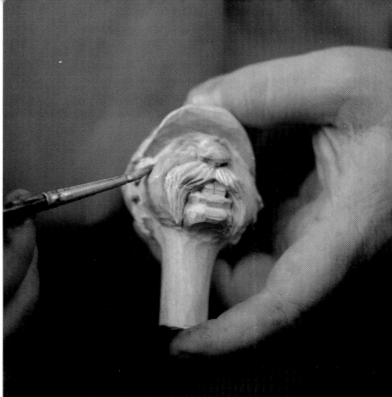

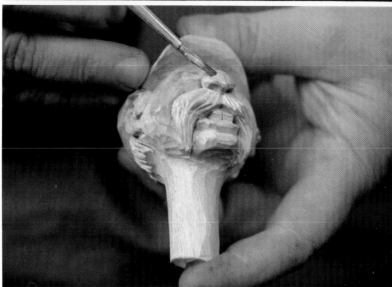

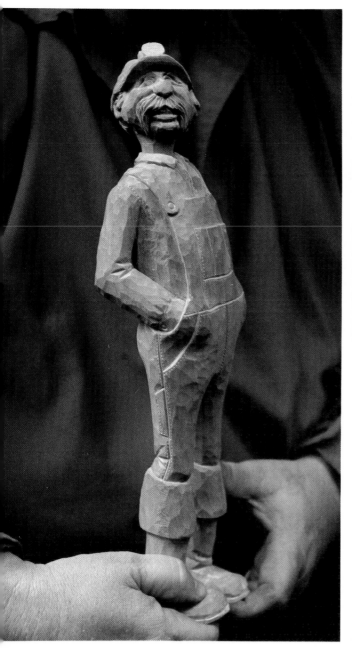

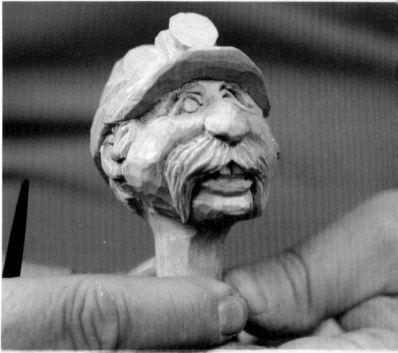

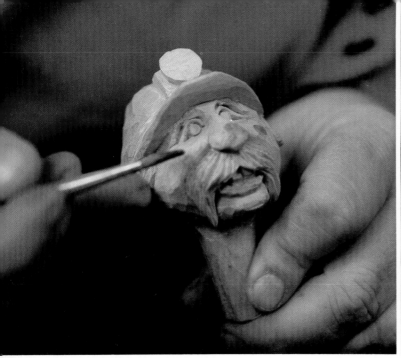
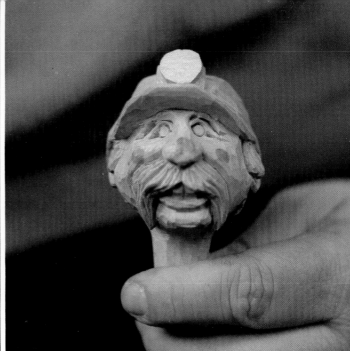

Use red to give blush to the cheeks and nose.

Red can also be used lightly on the back of the neck, to create the authentic "red-neck" appearance.

Also use red to stain the mouth, being careful not to overdo, just paint the lip surfaces.

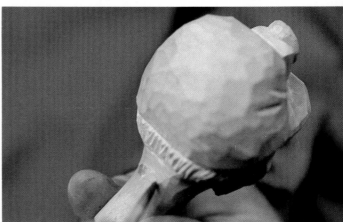

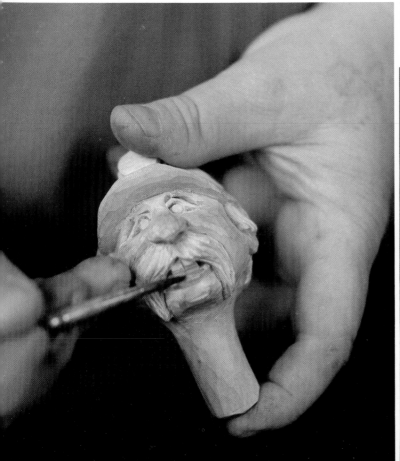

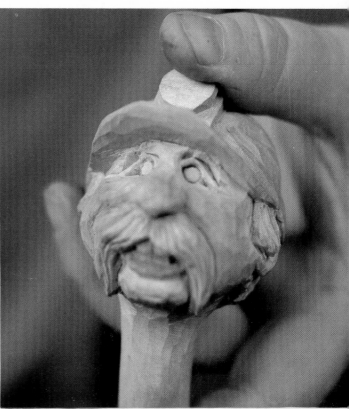

The overalls worn by coon hunters are a very heavy material, much like the duck cloth of hunting clothes. Tan is the typical color. Paint the overalls with raw sienna using the #5 brush.

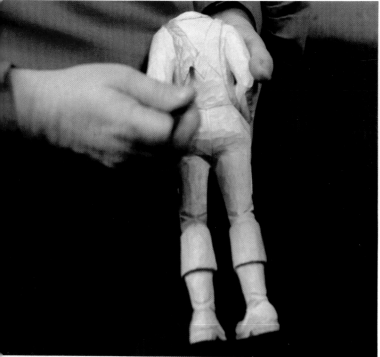

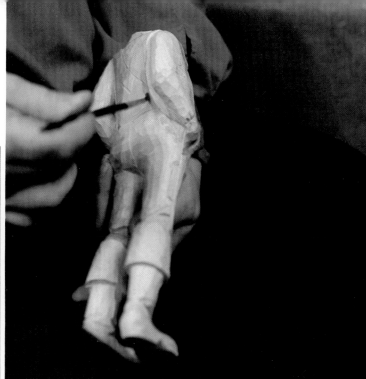

Begin the overalls by carefully painting around the perimeter edges first.

Once the edges are covered the rest of the overalls can be quickly filled in.

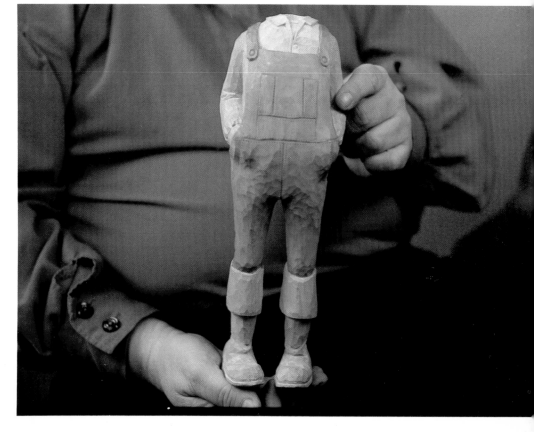

Paint the cap the same color as the overalls. Again begin by doing the edges and bill of the cap first.

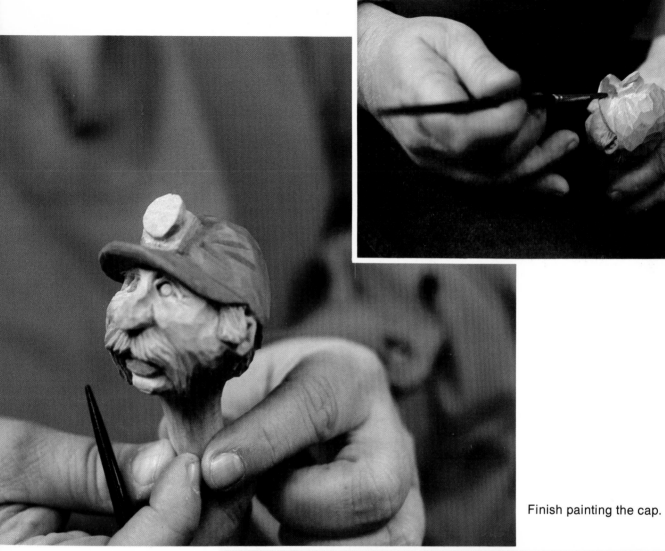

Finish painting the cap.

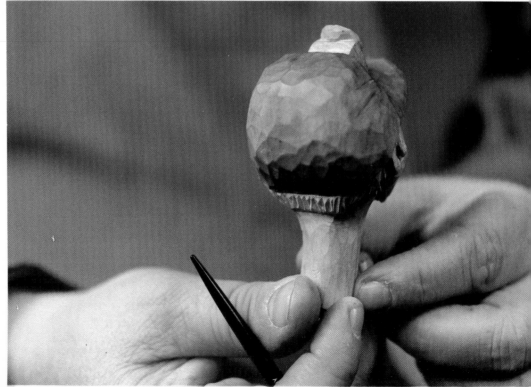

Paint the mustache with a coat of yellow.

Use the same color for the sideburns and hair.

Also paint the eyebrows.

Paint a second coat of burnt sienna over the yellow coated mustache.

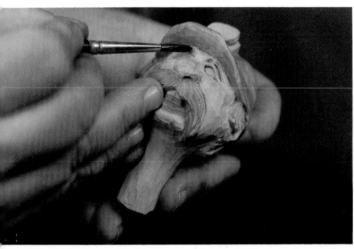

Finish the sideburns, hair and eyebrows in the same way.

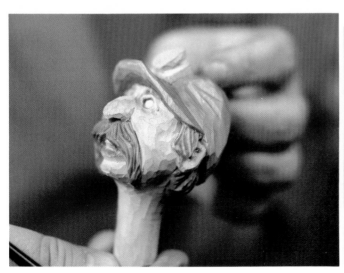
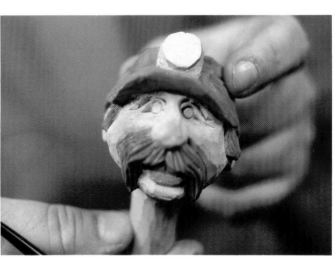

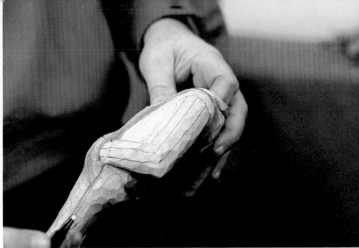

Using the *Flair* marking pen, mark the plaid of the shirt. Start at the center of the arm and use your fingers as a guide along the outside.

Decide the size of the plaid and make the lines the appropriate length first and then width.

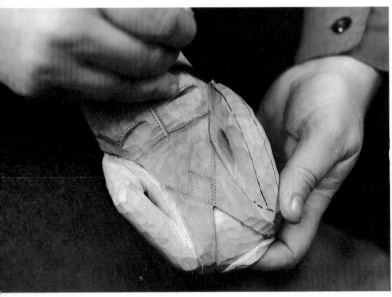
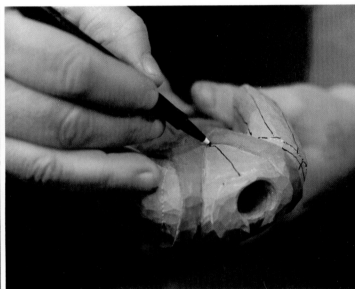

Draw in the seams at the shoulder and arm.

On the back of the shirt, begin in the middle and make a line right down the center of the back.

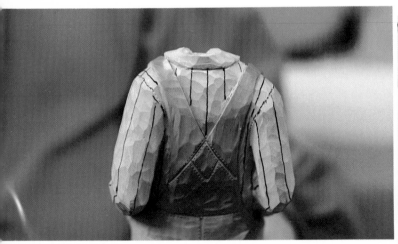
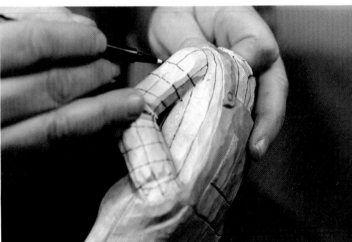

Continue making the rest of the plaid lines, drawing the verticle ones first.

Draw the horizontal lines of the plaid.

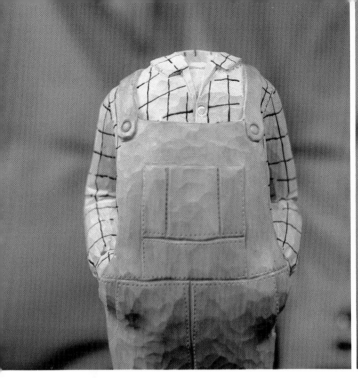 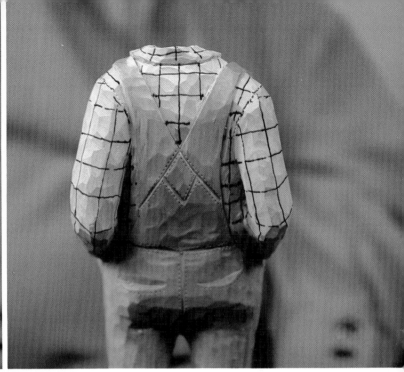

Be sure to draw lines on all areas of the shirt.

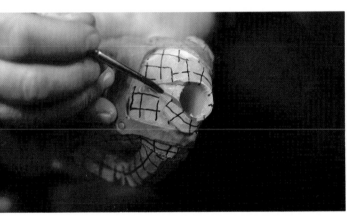

Beginning around the edges, paint the shirt red. Do not be concerned about painting over the buttons or shirt details because they will be colored in later.

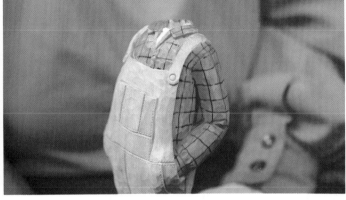

Finish filling in and paint the entire shirt.

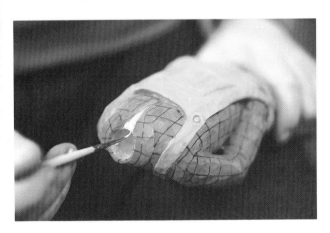

Changing to the #0 brush and a heavy concentration of white, paint the neckline of the t-shirt.

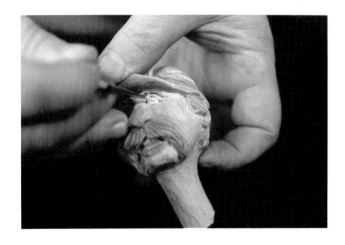

Paint the eyeballs white.

White is used for the front teeth.

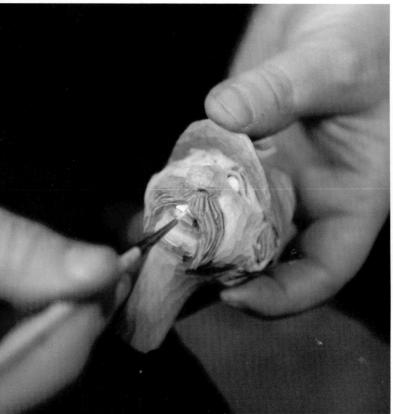

The boots will require two shades of grey. The top area of the boot which has been folded over is a lighter grey and the outside of the boot itself is darker. Begin with the outside of the boots, covering them with a dark grey wash.

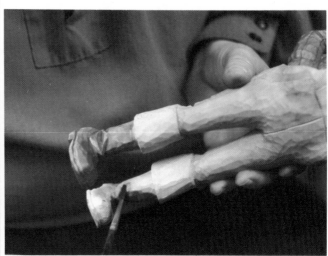

Use a lighter grey wash, possibly your "grey jar" will be the appropriate shade, and cover the top, folded portion of the boots.

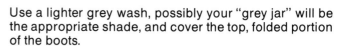

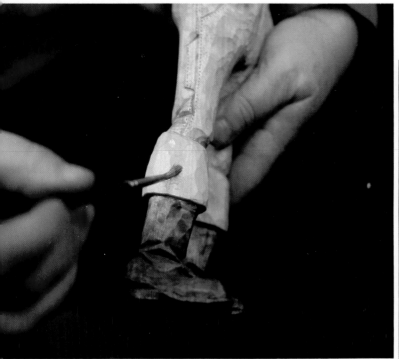

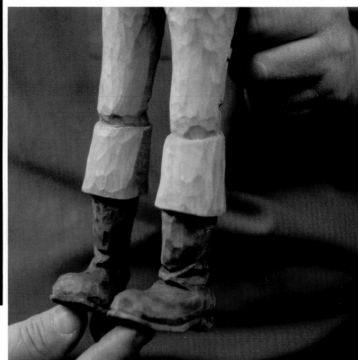

Paint the headlight yellow with your small brush after cleaning it well. The yellow will fill the porous areas and keep the paint from bleeding. When you have a dark and light color painted next to each other, paint the light color first to keep the dark paint from bleeding into the lighter area.

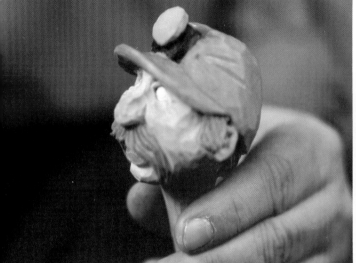

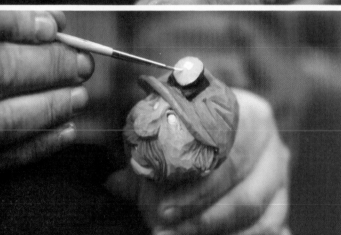

Still using your small brush, change to black paint for the light box on the top of the cap, but do not paint right up to the edge of the light to avoid paint running into the lighter area.

Complete the black painting on the light box.

Using pure blue pigment from the bottom of the bottle, place a little in the lid of the paint jar. Add some pure white paint right next to the blue pigment and blend the two together to obtain the right blue color for the iris of the eyes.

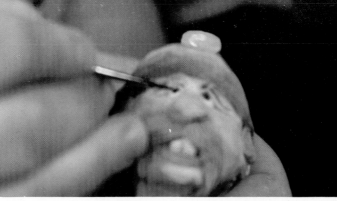

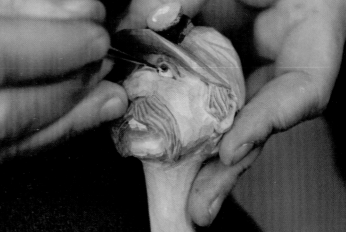

Using the #0 brush, color the iris' of eyes blue.

Use black paint to paint the pupils.

The final touch for the eyes is a little spot of white in the iris to give them a glint and lifelike appearance.

The completed figure of the man. Once the paint has dried completely, roughly about two hours, apply a spray coating of Krylon Matte Finish. Finally spray the carving with Krylon Acrylic Spray to seal the paint and finish.

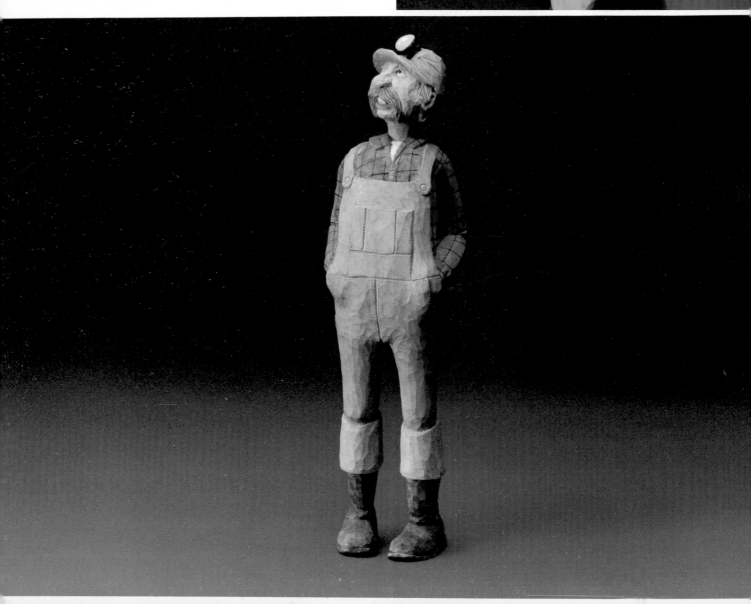